MOVING PICTURES

CONTEMPORARY PHOTOGRAPHY AND VIDEO FROM THE GUGGENHEIM MUSEUM COLLECTIONS

MOVING PICTURES

CONTEMPORARY PHOTOGRAPHY AND VIDEO FROM THE GUGGENHEIM MUSEUM COLLECTIONS

GuggenheimMUSEUM

Published on the occasion of the exhibition
Moving Pictures: Contemporary Photography and Video from the Guggenheim Museum Collections

Organized by Lisa Dennison, Nancy Spector, and Joan Young

Solomon R. Guggenheim Museum, New York
June 28, 2002–January 12, 2003

Guggenheim Museum Bilbao
October 8, 2003–May 18, 2004

The exhibition in Bilbao has been made possible by **bbk**

Technological collaborator **PHILIPS**

ISBN: 0-89207-269-5

Guggenheim Museum Publications
1071 Fifth Avenue
New York, New York 10128

Available through
D.A.P./Distributed Art Publishers
155 Sixth Avenue, 2nd floor
New York, New York 10013
Tel.: (212) 627-1999 Fax: (212) 627-9484

Distributed outside the United States and Canada by Thames & Hudson, Ltd., London.

Design: Asymptote
Production: Melissa Secondino, Christine Sullivan
Editorial: Meghan Dailey, Elizabeth Franzen, Stephen Hoban, Edward Weisberger

Printed in Germany by Cantz

CONTENTS

During our ongoing partnership with the Guggenheim Museum Bilbao, the Solomon R. Guggenheim Museum has been privileged to showcase works from its permanent collection in the incomparable Frank Gehry building on several occasions. We are now pleased to present *Moving Pictures*, an exhibition of contemporary photography, film, and video from our collection, which was exhibited to great critical acclaim in New York in 2002. We are particularly grateful for the opportunity this presentation in Bilbao has afforded us to thoughtfully consider and document a specific portion of our contemporary holdings in this catalogue.

I would like to thank exhibition curators Lisa Dennison, Nancy Spector, and Joan Young for their insightful transformation of an already revelatory exhibition into a fresh and exciting new show for Bilbao. I would also like to thank the architecture and design firm Asymptote for their elegant design of the exhibition installation and accompanying catalogue. I especially wish to extend my gratitude to Juan Ignacio Vidarte, Director General, and the staff of the Guggenheim Museum Bilbao for their essential support and collaboration in planning this exhibition.

This exhibition would never have come to fruition without the support of the Guggenheim Museum's acquisition committees, namely the International Director's Council, Photography Committee, and Young Collector's Council, as well as the generosity of several individual patrons whose gifts have enriched our collection. I would like to single out Frederick B. Henry, whose recent donation of over 275 works from The Bohen Foundation has added significantly to our new media holdings, the fruit of which may be seen here. Together, their inspired efforts have produced an internationally significant collection of today's most trenchant art forms. We are proud to be able to feature their contributions in this exhibition.

Thomas Krens, *Director*
Solomon R. Guggenheim Foundation

ACKNOWLEDGMENTS

We would like to recognize Director General Juan Ignacio Vidarte and his staff at the Guggenheim Museum Bilbao for their enthusiastic support of this exhibition. We are grateful for their guidance and collaboration.

We would also like to extend our most heartfelt thanks to Glenn Furhman, Dakis Joannou, Frank and Nina Moore, and Jennifer and David Stockman, who have generously lent works from their collections to enrich the presentation of this exhibition in Bilbao.

An exhibition of this scale could not have happened without the sustained support of Thomas Krens, Director of the Solomon R. Guggenheim Foundation, and numerous members of the Guggenheim staff. We are grateful to Karen Meyerhoff, Managing Director for Collections, Exhibitions, and Design, for her attention and expertise. We would also like to recognize Janet Hawkins, Consulting Registrar, for skillfully coordinating the transportation of artworks in the exhibition. Paul Kuranko, Multimedia Support Specialist, has been invaluable for the installation of the film and video works in the show. Susan Greenberg, former Curatorial Collections Assistant, coordinated the original presentation of this exhibition in New York. For their support and advice, we especially thank Tracey Bashkoff, Associate Curator for Collections and Exhibitions, and Kara Vander Weg, Assistant Curator. We are grateful to John G. Hanhardt, Senior Curator of Film and Media Arts, for his illuminating essay and to Maria-Christina Villaseñor, Associate Curator of Film and Media Arts, Katherine Bussard, Meghan Dailey, Kelly O'Brien, Daniel R. Quiles, and Nat Trotman for their thoughtful entries on each artist. We also thank Elizabeth Levy, Director of Publications, and Elizabeth Franzen, Managing Editor, for their able supervision of all aspects of the production and content of the catalogue.

We would also like to thank our colleagues at numerous galleries and private collections for accommodating myriad research inquiries and requests: Georgia Franklin, Artemis Greenberg Van Doren Gallery, New York; Ethan Sklar, Tanya Bonakdar Gallery, New York; Sherri Caraccia; Patty Coogan; Laetitia Rouiller, Niklas Svennung, Galerie Chantal Crousel, Paris; Brian Sholis, D'Amelio Terras Gallery, New York; Deitch Projects, New York; Julie Braniecki, Gagosian Gallery, New York; Rosalie Benitez, Max Falkenstein, Carter Mull, Barbara Gladstone Gallery, New York; Catherine Belloy, Rose Lord, Leslie Nolen, Andrew Richards, Marian Goodman Gallery, New York; Cornelia Providoli, Galerie Hauser and Wirth, Zurich; Natasha Polymeropoulos, The Dakis Joannou Collection Foundation; Chana Budgazad, Casey Kaplan Gallery, New York; Amy Gotzler, Sean Kelly Gallery, New York; Kelly Padden, Kennedy Boesky Photographs, New York; Claudia Friedli, Galerie Peter Kilchman, Zurich; Clare Coombes, Justyna Niewiara, Lisa Rosendahl, Clare Simpson, Lisson Gallery, London; Victoria Cuthbert, Jeffrey Peabody, Matthew Marks Gallery, New York; Josie Browne, Max Protetch Gallery, New York; Julie Chiofolo, Regen Projects; Kristina Ernst, Andrea Rosen Gallery, New York; Anna Kustera, Tilton Kustera Gallery, New York; Angela Choon, Eugenie Lai, Russell Williams, David Zwirner, New York.

The exhibition and this accompanying catalogue were designed by Lise Anne Couture and Hani Rashid of Asymptote with great insight into the curatorial process and a keen understanding of contemporary art. We would like extend our appreciation to them and members of their able staff, Teresa Cheung, Tobias Keyl, and Jill Leckner.

Lisa Dennison, *Deputy Director and Chief Curator*
Nancy Spector, *Curator of Contemporary Art*
Joan Young, *Assistant Curator*
Solomon R. Guggenheim Museum

INTRODUCTION

Lisa Dennison, Nancy Spector, and Joan Young

While a museum is a repository of singular objects—whether acquired en masse through the bequest of a private collection or sequentially over time—these objects can be combined and recombined to narrate different stories. Such stories can recount the evolution of an art-historical movement or the development of a specific medium. They can illustrate broad political and/or social themes or focus on one particular cultural moment. In the best of situations a museum collection can avail itself of multiple interpretive structures, be they exhibitions or publications, which explore any number of possible narratives. Often these narratives become apparent only in retrospect, after a collection has been assembled and enough time has passed to reveal the significance and resilience of certain themes or aesthetic tendencies. The exhibition *Moving Pictures*, which focuses exclusively on photography, film, and video in the Guggenheim Museum's permanent collection, evolved in such a fashion.

As a fundamental tenet of its vision, the Guggenheim does not departmentalize according to medium or chronological division. It is a museum of Modern and contemporary art in all mediums, spanning the end of the nineteenth century to the beginning of the twenty-first. During the past decade, acquisitions have focused largely on the art of the present in an effort to build a contemporary collection that equals the depth and breadth of the Modern holdings at the museum's core. When planning for *Moving Pictures*, a full-museum, contemporary exhibition drawn from the permanent collection in 2002, it quickly became apparent that the Guggenheim had amassed a wealth of material that utilized the reproducible mediums of photography, video, and film—more than enough to fill the museum's rotunda. The preponderance of photo-based work in the collection reflects the fact that some of the most culturally trenchant art created during the 1990s and early 2000s engages directly with these mediums.

During the late 1960s and 1970s, a major paradigm shift occurred within postwar visual culture: photography and the moving image were absorbed into critical contemporary art practices. Throughout the 1970s, artists such as Marina Abramović, Vito Acconci, Dan Graham, and Robert Smithson employed photographic strategies to extend and test traditional, medium-specific categories such as painting, sculpture, and fine-art photography. Additionally, the new, relatively inexpensive and portable technology of video and its unique ability to employ instant playback and live and closed-circuit installations allowed artists such as Nam June Paik and Bruce Nauman to examine issues of representation to an unprecedented degree. Multichannel video installations and film projections further expanded the conceptual and aesthetic parameters of the moving image.

The presence of photography, film, and video in the most radical art practices of this period corresponded to their ubiquity in all forms of popular representation: television, advertising, cinema, and print journalism. Artists turned to these mediums—which bridged such distinct categories as mass culture and high art, technology and culture—in order to contest the notion of the autonomous art object. Photography, film, and video functioned as means for achieving these goals, enabling artists to create works that privileged information or documentary evidence over personal expression, or conversely, called into question notions of objective recorded reality, underscoring the dominance of mass media and its skewed representations. For many early feminist artists such as Ana Mendieta and Hannah Wilke, these mediums represented yet-to-be-claimed territory, offering them new means with which to render their own subjective experiences.

By the end of the 1970s, artists like Sherrie Levine, Richard Prince, and Cindy Sherman turned to photography as a vehicle through which to critique photographic representation itself, using processes of appropriation and simulation. While this practice came to define much postmodern art of the 1980s, its legacy for the 1990s was essentially the license to indulge in pure photographic fantasy, image construction, and cinematic narrative. Today's generation of artists working with reproducible mediums has inherited the multiple strands of this genealogy, drawing upon performative, conceptual, critical, and directorial strategies.

When *Moving Pictures* was presented in New York, it attempted to establish a genealogy for the veritable explosion of photography, film, and video in the art of the 1990s by situating its roots in the art of the 1970s. This prologue included a selection of works from the late 1960s and 1970s, including Paik's pioneer *TV Garden* (1974) and Nauman's now iconic film *Art Make-Up 1–4* (1967–68). In its revised and expanded presentation at the Guggenheim Museum Bilbao, *Moving Pictures* focuses exclusively on the art of the present and the variety of approaches utilized by artists working with film, video, and photography today. Rather than following a chronological trajectory, as did the exhibition in New York, the installation in Bilbao is arranged according to thematic categories, which propose ways to understand and differentiate some of the prevalent sensibilities that have come to define the most contemporary of art forms. As is the case with most group exhibitions, categories tend to be subjective and indicate more of a curatorial viewpoint than they do individual artists' intentions. While any number of works could simultaneously fall under the rubric of more than one category, the exhibition is divided into five sections designed to evoke the following themes: Narrative Fantasy, Performance and the Body, History, Memory, and Identity, The Constructed Image, and The Empirical Eye.

NARRATIVE FANTASY

After decades of conceptually oriented art, much of which interrogated codes of photographic representation, a generation of artists emerged during the 1990s that incorporated pure fantasy in their work. Storytelling, or the narrative structure itself, has served as a medium in its own right, providing artists with a new kind of raw material with which to craft their photographic and filmic imagery. The final work results from the artist's complete fabrication of a scene or scenario for the camera. During the 1970s much conceptual photography parodied fine-art photography's romance with reportage and its claims to truth by imitating the look of photojournalism. This was achieved through what has been described as a "directorial mode," involving the construction of mise-en-scènes solely for the purpose of being photographed. Artists such as Sherman and Laurie Simmons employed this strategy but referenced specific cinematic tropes rather than documentation in their fabricated pictures. Today, however, artists freely invent their own cosmologies, borrowing from a variety of narrative sources ranging from Renaissance altarpieces to Web-based video games: Matthew Barney, Gregory Crewdson, Anna Gaskell, Pierre Huyghe, Mariko Mori, Pipilotti Rist, and Sam Taylor-Wood each create completely imaginary universes in their elaborately staged photographs, films, and videos.

PERFORMANCE AND THE BODY

Many artists active in the early 1970s turned to their own bodies as both subject and medium. Eschewing the accepted hierarchy of artistic forms—painting, drawing, and sculpture—as well as an art market dependent on the production of objects, artists embraced performance as a transgressive practice. For feminist artists, embodied art offered a means through which to challenge the canon and to foreground their own subjectivity. For others, performance, or "body art" as it was known, became a vehicle through which to explore perception, temporality, process, and behavior—all central tenets of 1970s Postminimalism. The vehicles most suited to chronicle and display the ephemeral nature of performance were photography, film, and video, which could capture the artist in action and preserve his or her image indefinitely. In many cases, the photograph or film functioned as an ancillary record of a preconceived episode staged for the camera's recording eye. A number of the artists who employed this strategy—Acconci, Eleanor Antin, Jürgen Klauke, Nauman, Dennis Oppenheim, Adrian Piper, and Lucas Samaras, among others—structured their work around the presentation of self, either physically altering their own bodies, performing some predetermined task, or acting the part of a fictional character.

Performative strategies today, such as those practiced by Janine Antoni and Patty Chang, still revolve around issues of the body and related themes, including endurance, sexuality, and gender difference. Informed by the AIDS pandemic that began during the 1980s and continually escalating violence throughout the world, some performative art is now explicitly elegiac, as seen in the recent work of Abramović, a pioneer in the field of performance. Other examples of performative work explore the sensate aspects of bodily experience, as Ann Hamilton does in her intimately scaled videos of discrete body parts.

HISTORY, MEMORY, AND IDENTITY

During the 1990s many artists began examining how representation has traditionally inscribed difference and "otherness" in terms of sexual orientation, racial identity, and ethnicity, thus opening a new threshold in cultural consciousness. This expanded field of investigation embraced the voices of those suppressed by the status quo, those denied agency under the law, and those whose subjectivity has been threatened through bigotry, homophobia, and social intolerance. Historically, hegemonic systems have been predicated on the identification of an oppositional force, a cultural "other"—often located within its midst—against which the system can define itself, thus protecting its cohesion and power.

The cultural other takes many forms: In former apartheid-ruled South Africa, it was the Black; in democratic, Western societies, it is often the Queer. Coupled with the increasing globalization of world culture, this investigation of otherness has resulted in a new awareness of multiple voices and multiple histories worldwide. The Euro/American-centric culture that for the most part dominated twentieth-century art history is now only one component of a vital, transnational world culture that is ever expanding. Numerous artists have devoted their work to understanding the representational systems that inform identity and history in their respective cultures, from William Kentridge's poetic animated films on the ravages of apartheid to Michal Rovner's abstracted photographs and videos of

countries in the Middle East with contested borders. While Glenn Ligon focuses on the construction of "blackness" and "queerness" in his photographic rethinking of Robert Mapplethorpe's erotic images, Iñigo Manglano-Ovalle explores the notion of identity through the processes of genetic mapping in his DNA photographs. Kara Walker turns to the history of slavery in the United States to explore racial stereotypes, combining the quaint practice of silhouetting with projected imagery.

THE CONSTRUCTED IMAGE

From the family photo-album to photojournalism, the photograph has been considered a reflection of objective reality. At the same time, photography's ability to record fiction has also been an operative part of its history. While some artists utilize photography, film, and video to "document" narrative fantasies, others are motivated by an architectural impulse and fabricate environments in various scales for the sole purpose of photographing them. James Casebere has been building miniature model houses and towns since the late 1970s, creating anonymous dwellings for the camera to record. His more recent photographs depict the uncanny environment of institutional interiors—asylums, penitentiaries, etc.—again crafted in miniature. Similarly, Oliver Boberg builds small-scale industrial structures for his photographs. Thomas Demand takes his inspiration from news clippings, creating one-to-one scale environments that emulate banal places in which momentous events have occurred, such as Bill Gates's college dorm room or a desk for ballot counting in Florida during the contested 2000 United States presidential election. He then photographs these now-historic sites, rendering them mundane but mysterious in their elusive content. While Miles Coolidge does not construct his environments, he has photographed "fake" locations such as Safetyville, a miniature town in Northern California where children are taught how to follow pedestrian traffic rules.

THE EMPIRICAL EYE

Much Conceptual photography of the 1970s emulated the dispassionate appearance of documentary photography in an effort to shift the focus from aesthetic concerns to the objectifying nature of information systems. But the work itself almost inevitably involved the direct intervention of the artist. Examples range from Bernd and Hilla Bechers' typological categories to Jan Dibbets's and Robert Smithson's direct manipulation of the landscape. Inheriting this legacy, artists today freely manipulate their representations of the empirical world. Artists like Olafur Eliasson, Elger Esser, Rika Noguchi, and Thomas Struth process their subject matter, often the natural landscape, through preordained conceptual systems. In addition to observing nature, artists have turned their attention to documenting the urban condition and its inextricable relationship to private and public space. They have focused on the aesthetics of corporate architecture, the development of suburbia, the notion of international tourism, and the industrial landscape. Andreas Gursky and Jörge Sasse, for example, use digital processes to alter their images of the spaces of daily reality, such as supermarkets and industrial parks. Other

artists such as Gabriel Orozco and Thomas Flechtner directly intervene in the environment, subtly shifting components of the found world and establishing their quiet presence in it. In the video installation *When Faith Moves Mountains* (2002), Francis Alÿs reveals how, under his direction, hundreds of volunteers actually moved a mountain.

Portraiture figures prominently in the history of photography, whether as self-representation or the documentation of others. Many contemporary artists such as Nan Goldin, Catherine Opie, and Wolfgang Tillmans have utilized the conventions of portraiture to record their own individual communities, giving visual form to subcultures that have often gone unrepresented in mainstream culture. Artists like Rineke Dijkstra approach portraiture from the tradition of typological depiction, selecting subjects according to profession or location, as in Dijkstra's series of bathers posed on beaches around the world. Thomas Ruff borrows from one of the most generic forms of portraiture—the passport or ID photo—to create his monumental images of human faces. In the realm of video Douglas Gordon has explored cinema's representation of cult personalities with his manipulations of Hollywood footage.

The installation of *Moving Pictures* at the Guggenheim Museum Bilbao progresses from theme to theme, with entire galleries devoted to each category. In this accompanying catalogue, however, the artists are arranged alphabetically as a nonhierarchical, organizing principle. The two accompanying essays explore the separate histories of the moving image and photo-based art, respectively, but also touch upon how these two inextricably related mediums intersect. Likewise, in the installation, photographs intermingle with projected images and videos displayed on monitors. It is through the intersection of these reproducible mediums and the various themes evoked by the individual works on view that the complex, multivalent meanings of contemporary art may begin to emerge.

The catalogue entries on the individual artists were written by Tracey Bashkoff, Katherine Bussard, Susan Cross, Meghan Dailey, Susan Greenberg, Dan Quiles, Kelly O'Brien, J. Fiona Ragheb, Nancy Spector, Nat Trotman, Maria-Christina Villaseñor, and Joan Young using sources that include *Guggenheim Museum Collection: A to Z* and the extended labels written for the New York venue of *Moving Pictures*.

PICTURING MOVEMENT, PAST AND PRESENT

John Hanhardt

Finiche! Only a fadograph of a yestern scene.
—James Joyce

A camera filming itself in a mirror would be the ultimate movie.
—Jean-Luc Godard, quoted by Robert Smithson

The title of this exhibition, *Moving Pictures*, connotes (re)moving images from their customary points of stasis. The invention of photography, which was announced in 1839, came about through efforts to chemically fix the fleeting shadows that had appeared in the camera obscura since the Renaissance. While comprised of individual, still images, the miraculous new invention was anything but immobile. The visual embodiment of arrested time led to movement in the form of cultural and artistic change. Throughout the late nineteenth century, the uses of photography steadily multiplied, just as examples of the medium circulated with ever increasing frequency. At the same time, the emergence of photography coincided with a growing leisure class in search of spectacular entertainments. The cinema was anticipated by theatrical representations of historical pasts and fantastical presents—in dioramas and panoramas and in devices from the magic lantern to the praxinoscope, all of which explored the moving image within its own imaginary space and structure. The miniature theater of the pre- and early cinema and the later establishment of the movie house (and, by the mid-twentieth century, home movies) defined a growing presence of the cinematic within public and private lives.

The development of roll film and the projector in the late nineteenth century brought movement to the fore, providing a new dimension for the representational arts. No longer was the photographic medium restricted to the still image. Nor was the creative deployment of movement reserved solely for the stage. Movement entered the frame and the edited time of film. In the hands of filmmakers, this technical phenomenon vastly expanded pictorial and narrative expression. As the cinema emerged as entertainment and developed into an acknowledged art form, it released a power that impacted all of the arts. How we construct the visual text—whether it is moving or still, abstract or representational—is inextricably linked to the history of the moving image, which exists at the center of modern and postmodern culture.

By the late twentieth century, the cinematic imaginary—or the power of the moving image to construct a complex mise-en-scène in tandem with the viewer's imagination—had infiltrated new technologies, from video to television, from interactive systems to the Internet. In recent years, digital technology has impacted all forms of visual representation, bringing an ever-larger cultural presence to the moving image. Such technology- and media-fueled shifts are evident in museums and galleries, where artists have increasingly introduced film, video, and moving-image digital imagery into the stillness of the art space. The prominence of moving-image installations has restaged fundamental precepts of art making and dissemination, including how the artist produces and displays the artwork; how the viewer encounters it (in darkness or in light, on the wall, on the floor, even virtually, and, of course, any combination or variation thereof); and how it circulates as a commodity. There is also the important issue of duration: how the artist constructs the piece with and in time, and the decisions the viewer makes during the viewing experience.

A number of factors have contributed to the expanded interest in moving-image installations. Technological developments, such as improved video projectors, larger monitors, and LCD and plasma screens, have brought increased ease, flexibility, and visual efficacy to presentations outside the movie house or black-box space. In addition, a number of key experimental filmmakers and video artists, such as John Baldessari, Hollis Frampton, and Ken Jacobs, became influential teachers, shaping the current generation of artists already versed in digital technology and popular culture. In a parallel development, art historians have turned to the late twentieth century as an area of research, writing the first histories of Conceptualism, a movement in which the documentary capacities of photographic media have figured significantly.[1] And art professionals have been drawn to the emergence of powerful moving-image works that reflect current cultural and theoretical interests, challenge the conventions of art making, and allow for the commissioning of new pieces.

The proliferation of film and video in contemporary art is inseparable from the histories of cinema and television, but often the transfer of moving-image media to more traditional visual-art contexts overlooks this crucial historical anchor. The moving-image artist has sought to carve out a suitable space within the viewing traditions of the stationary art object. The photograph is a visual slice of the world, composed and functioning as a concrete memory of its actualization. In contrast, the language of the moving image—framing of the shot, editing of duration, and structuring of movement—articulates a composition in time. Film embodies a continuous present that unfolds on the screen as a visual text in real time (the running time of the film) and the elaborately constructed past, present, and future time(s) that describe the film's narrative or nonnarrative disclosure. Between photography and film exists the rich dialectical tension of stasis versus movement. Yet by the early twentieth century, photography had gained artistic legitimacy by conforming to the conventions of painting.[2] Despite the distinctive characteristics of the cinematic experience, it is the still image—from painting to photography—that has shaped the reception of the moving image in visual art contexts.[3]

The art world is an economy linked and empowered by galleries, museums, schools, magazines, and journals. Likewise, film and television have large and complex systems of production, distribution, and exhibition. Filmmakers have historically fashioned opportunities under the rubrics of a variety of oppositional concepts or movements including avant-garde, independent, underground, and experimental film; New American Cinema; and structural, or materialist, film. These varied practices have as their shared correlate single-channel video art, which became a viable medium for artists in the mid-1960s with the release of the Sony Portapak.[4] From the 1950s into the early 1980s, artists working in multimedia installation and such genres as documentary, narrative, image processing,[5] and animation were supported by grassroots organizations devoted to alternative media production, distribution, and exhibition networks. These resourceful groups—for example, Raindance, Ant Farm, Videofreex, and TVTV—were artist-run and invariably noncommercial. Independent film artists located their work in relation to modernist art movements associated with filmmaking, particularly Surrealism, Dada, and Constructivism. To a lesser or greater degree, film- and videomakers interacted with visual artists in various interdisciplinary groups, movements, and events, including Fluxus, Happenings, Performance, Minimalism, and Conceptualism. Working beyond these references and relationships, film and video artists recognized the politics of popular culture and saw the media arts as a means to theorize and reorient art away from the production of the unique, commodified object.

In the 1980s and 1990s, as installation and video art established greater visibility in museums and galleries, and as the digital economy surged, the media organizations of the previous generation—its festivals and distributors and means of support and development—began to disappear. To some degree, these groups were absorbed by alternative arts spaces that benefited from government support at the same time that they became more professionalized and less and less artist-run.[6] Economic forces, increasing political conservatism, and technological factors further contributed to this changing climate. Paradoxically, when artists emerging in the 1980s and 1990s turned to the moving image and rediscovered at least a partial view of the previous generation of moving-image makers, the communities of independent film and video had already begun to recede into the past.

The shift from experimental media contexts to more traditional visual art spaces has resulted in a partial account of some important moments in the history of film and video art. In particular, the contributions of structural film have been largely overlooked. Although related to Conceptualism, which has received significant academic and museological attention, structural film has distinct characteristics. Emerging in the 1960s and 1970s, structural filmmakers investigated the unique formal characteristics of the moving image, often juxtaposing it to the workings of the photograph. The movement also mined the complexities of phenomenology, perception, and the nature of consciousness. A reconsideration of the interchanges found in structural film (and related developments in Conceptualism)—between movement and stillness, framing and mirroring, narrative and fragment—offers new insight into some of the most compelling film and video installations emerging today.

Michael Snow, frames from
Wavelength, 1966–67

THE STILL AND THE SLOWED

For a number of structural filmmakers, the projected film has functioned as the metaphorical and literal container of the photograph. In Michael Snow's epic *Wavelength* (1966–67), the camera takes forty-five minutes (the full length of the film) to gradually zoom across a loft space. The beginning and ending of this movement are determined by the capacities of the lens, which is at its widest setting when the film starts and at its shortest when it ends. Paralleling this bracketing of mechanistic limits is the film's soundtrack, which includes a sound wave that progresses from its lowest tone (50 cycles per second) at the beginning to its highest (12,000 cycles per second) by the closing moment. Snow's mise-en-scène includes a few people performing actions within the room, which are witnessed as bits of narrative that pass in and out of the camera's path. In the span of the zoom, there are also shifts in visual "texture": color, exposure, and day-to-night changes, negative and black-and-white images, and so on. Amid these narrative and formal fragments, the camera

Hollis Frampton, still from *Nostalgia*, 1971

maintains its movement across the space. The end point of its path is a photograph of ocean waves. This seascape remains palpably immobile as the celluloid moves through the projector. At this final, narrowest point, the motion picture camera is fixed on a representation of vastness. This ending is a commentary on the limitless power of the moving image to contain and reframe a photograph in all of its haunting muteness.

In reflecting on this dynamic interaction between the still and moving image, another key film in the structural mode is Hollis Frampton's *Nostalgia* (1971). One of the great artists of the late twentieth century, Frampton possessed a cool intellect and an ironic cast of mind, which shaped his art making and writing. He not only investigated the formal exigencies of film but also trained his cinematography on the photograph. While acknowledging the photograph's capacity as a receptacle of memory, *Nostalgia* demonstrates the triumph of the moving image over the photograph. In this thirty-six minute black-and-white film, individual photographs appear in succession on a hot plate. As each gradually burns and disappears, we hear a narrator—in fact, the voice of Michael Snow—describe the next photograph. The action of destroying the visual evidence of the recounted image dramatizes the interaction of memory and imagination with the aural and visual trace. With its spare serial structure, *Nostalgia* is an elegant meditation on both the fixed and partial nature of the photograph, which remains dependent on verbal description. As fleeting as sound, the visual component is consumed by fire—a metaphor for time's inexorable progress as embodied in film.

The advent of video in the mid-1960s brought new challenges to the moving image. Connected to film by the fundamental parameters of space and time, video also has distinct formal concerns and technological capacities. While early video was indebted to the work of experimental filmmakers such as Snow and Frampton, it quickly sought to investigate its differences from other media.

One of the first artists to embark on the exploration of the unique formal and expressive qualities of video was Peter Campus. In his video *Three Transitions* (1973), he contemplates the self through three transformations of the video space. The predominant effect used is chroma-keying, a technique for replacing one image with another.[7] In each phase of the work, vestigial references to the photograph surface and disappear like apparitions. This is particularly evident in the second and third transitions. In the second, Campus appears to wipe his face (a video self-portrait in real time, displayed like a floating photograph) with his hand, erasing the image that then magically resurfaces. In the third and final transition, he sets fire to his self-portrait, destroying it and leaving behind only a blank screen. As in Snow's and Frampton's structural films, the photograph is framed and ultimately

Peter Campus, still from *Three Transitions*, 1973

overpowered by the moving image but nonetheless maintains a ghostly, echoing presence.

Another category of photographic echo—the movie still—is humorously investigated in John Baldessari's video *Ed Henderson Reconstructs Movie Scenarios* (1973). In this work, Baldessari—a Conceptual artist and influential teacher based in Southern California—asks his sometime collaborator, Ed Henderson, to provide impromptu interpretations of a series of movie stills. From the visual clues he finds in the images, which suggest standard genres (horror movies, westerns, musicals, melodramas, etc.), Henderson concocts narratives that feed off a combination of the shared knowledge of pop culture and his own improvisational ingenuity. The limited visual information provided by the still, which exists as a fragment of a

John Baldessari, still from *Ed Henderson Reconstructs Movie Scenarios*, 1973

fragment of filmic time, becomes the inspiration for the imaginary construction of the "full story"; the narrator can only offer a partial, unreliable view of a larger whole. Henderson's explanations allow Baldessari to establish the dependence of the stills on the moving image and highlight the role of language within the visual arts. Description and interpretation become inevitable components of an artwork's reception. Although we "talk" an image into existence as we experience or "read" it, the moving image ultimately confounds the limits of verbal description. In order to be understood, actions and events often need to be visualized.

Some of the experimental film- and videomakers working primarily outside museum and gallery contexts have supported their practice through occasional employment in the mainstream film and media industries. To make *Standard Gauge* (1984), the filmmaker Morgan Fisher collected an array of 35-mm (i.e., "standard gauge") film strips, which act as souvenirs of his commercial movie work. Like Baldessari, Fisher has been inspired by his proximity to Hollywood. Yet Fisher's "tour" of his industry experiences is a fragmented narrative in contrast to the seamless ones of conventional cinema. He shows the strips being placed on an improvised light table that both fills and mirrors the movie screen. The pieces of film—leader, tests, rejected scenes, title sequences—were all discarded materials obtained by Fisher when he was employed as a film editor. Through manipulation of his visual

Morgan Fisher, still from *Standard Gauge*, 1984

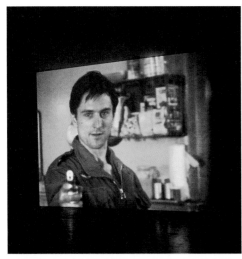

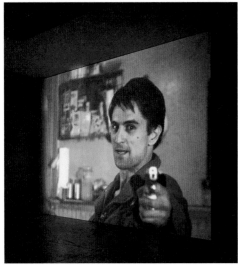

Douglas Gordon, *through a looking glass*, 1999

materials and through voice-over, Fisher enacts an intimate deconstruction of the cinematic apparatus. Minus the fluidity provided by the projector, the film strips exist as hybrids of the photograph and the moving image. Fisher's autobiographical and analytic reflections comment on memories that intersect on the fringes of Hollywood.

The moving image takes on a new dimension in Douglas Gordon's video installation *24 Hour Psycho* (1993). Using Alfred Hitchcock's *Psycho* (1960) as a ready-made visual document, the display and projection decisions Gordon makes recall the work of structural filmmakers. Rather than being projected at the standard sound speed of twenty-four frames per second, Gordon shows *Psycho* silently at two frames per second. This dramatic slowing causes the film to unfold over twenty-four hours, an action that erodes the momentum of narrative cinema. Although slowing down flattens the story line, it paradoxically allows an empirical demonstration of movement to surface. The dramatic effects of editing and framing lose their tension, their access to the cinematic imaginary; it is as if the film is being screened on an analytic projector that has been left on after a film studies seminar. Unlike the structural filmmakers, however, Gordon is not pursuing a critique of the cinema. Rather he renders the film almost as a sequence of photographs under the visible influence of formal entropy.

Anticipating Gordon's work by two decades, a film entitled *One-Eyed Dicks* was continuously projected in the Steichen Galleries of the Museum of Modern Art, New York, in 1970. The presentation, curated by William Burback of the museum's photography department, compiled images shot by automatic cameras triggered during bank robberies. At that time, the standard technology of surveillance captured actions by using a succession of still images—taken, like *24 Hour Psycho*'s projection speed, at the rate of two frames per second (but shown at almost one per second for *One-Eyed Dicks*)—in contrast to the more pervasive presence today of video camera systems in which the movement is continuous. In *One-Eyed Dicks* and *24 Hour Psycho*, the still or slowed-down image resituates the moving image from its expected temporal flow and tames it.

Cinematic appropriation also informs Gordon's *through a looking glass* (1999), for which he sampled a key scene from Martin Scorsese's *Taxi Driver* (1976). In the scene, the protagonist, played by Robert De Niro, confronts himself in the mirror. The installation is comprised of two screens facing each other. On one screen, we see De Niro draw a gun on himself as he looks at his reflection, and

on the other, we see the same footage, only in reverse, as if it is the mirror image. The rhetorical move of doubling and reversal creates an insular circularity that destabilizes the anticipated momentum of narrative film shots.

Where Fisher and Gordon fragment the photographic components of the moving image, William Kentridge builds up, erases, and reworks individual drawn marks to create animations that flow in and out of storytelling and abstraction, the personal and political. To create works such as *Felix in Exile* (1994) and *History of the Main Complaint* (1996), Kentridge composes a group of drawings over time. Each image is an individual scene, which he gradually alters and photographs. Drawings are his stills, or frames, which are projected by video onto the gallery wall. In addition to being graphic records, Kentridge's works are also about disappearances, and about the passage of time, as an added mark covers or transforms another. This formal structure of visual evidence and its erasure echoes Kentridge's subjects, many of which reflect historical atrocities—the Holocaust, apartheid, colonialism—and their personal and psychological effects.

FRAMES AND MIRRORS

In varying ways, the artists discussed so far have called attention to the pace and duration of the moving image and/or emphasized the signifying and formal differences between movement and stillness. A related and equally important theme in the history of the moving image concerns the diverse mechanisms of frame and mirror. At its most basic, the frame is what distinguishes the work of art from everything else around it—setting off the slice or moment of existence that is chosen and transformed by the artist. Framing is perhaps most palpably realized in the various photographic media, whether still or moving; as representations produced by the effects of light, they are always actual imprints, or indexes, of something in the world, however abstract they may appear.[8] Nonetheless, they are representations, not copies or perfect mirror images, of the outside world.

The complexities of this representational dynamic were succinctly addressed by William Anastasi's site-specific photographic installation *Through*, realized in 1967 at the Virginia Dwan Gallery, New York. By placing a photograph on the gallery wall purporting to show what could be seen on the other side if that section of the wall were transparent, the artist referenced the idea of a "window onto the world," a representational concept linked to the history of linear perspective and painting. But Anastasi purposefully negated this framing action through the easily apparent differences between an actual break in the wall and its representation. The photograph in *Through* is two-dimensional, black-and-white, and renders only a moment in time. It could never match the hypothetical break in the wall; it is a blatant fiction, an illusion that intentionally falters in its claims for authenticity. In the film *Frame* (1969), Richard Serra demonstrated a cinematic version of this mismatched mirroring of a thing and its representation. Serra's film shows him comparing a projected image of a window to the real window (which itself becomes removed from its actuality by being filmed and projected). He literally measures the projected image of the window frame against the "actual" window frame and reveals their disparity. As Serra writes:

Perception has its own abstract logic and it is often necessary to fit verbal and mathematical formulation (in this instance, measuring) to things rather than the other way around. The size, scale, and three-dimensional ambiguity of film and photographs is usually accepted as one kind of interpretation of (reality). These media fundamentally contradict the perception of the thing to which they allude. Objective physical measurement of real and physical depth coupled with apparent measurement of film depth points to the contradiction posed on the perception of film or photo. The device of a rule which functions as a stabilizing or compensating system in the film is the subject of its own contradiction. This contradiction is reinforced as a continuous *direction* and *dialogue* between the performer and the cameraman points to the illusion of the film frame."[9]

Framing as a phenomenological delineation of space is addressed in Bruce Nauman's *Spinning Spheres* (1970), a film installation that uses four looped-film projectors to fill the surfaces of the room's four walls with identical footage of a steel ball that spins for three minutes, briefly stops, and then resumes spinning. Maintaining a virtual position, the projections surround the viewer and define the gallery space. The installation embodies the temporal present structured by the Conceptual strategy of the time fragment. In a related work, *Mirror* (1969), by Robert Morris, the artist holds a mirror opposite the filming camera as he choreographs his movements in concert with it, echoing the actions of the cinematic apparatus.

Anastasi, Serra, and Morris each establish a metacommentary on the cinematic/photographic as the frame into which is projected its own limits. (In a shift of perspective, Nauman's *Spinning Spheres* projects the concept of temporal framing onto the gallery walls.) Empirical evidence—showing the interrelated workings of film and photography—becomes the narrative that brings these descriptive systems into existence. Such investigations comment upon Jean-Luc Godard's description of the perfect film as being one

Bruce Nauman, still from *Spinning Spheres*, 1970

that is generated by a camera filming itself in a mirror. As the work of these artists suggests, film is not simply a recording device, but neither can it be dismissed as an exhausted trope designed solely to suggest that the world we know is nothing more than a fictional construct.

Less overtly concerned with a priori formal or perceptual structures, Andy Warhol shaped his frames in relation to his subjects. Nonetheless, in his film *Outer and Inner Space* (1965), his subject, Edie Sedgwick, is both framed and mirrored in the interactions of film and video. This two-screen film projection shows a doubled view of Sedgwick in dialogue with herself in a prerecorded video sequence seen on a monitor placed next to her. The improvisational dialogue (one prerecorded and one generated in reaction to her prerecorded talking) exists in a single character but across time—a doubling mimicked formally in the doubled projection. Through this device, Warhol emphasizes the power of Sedgwick's charismatic language; the tension she builds between her doubled selves is mirrored in the frame of the film and in the

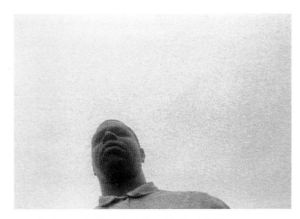

Steve McQueen, still from *Just Above My Head*, 1996

removed yet connected presence of the video monitor.

As an inheritor of Conceptual and structural investigations into the cinematic imaginary, Stan Douglas combines overt fictions with disturbing echoes of reality. Produced in the Babelsberg film studios near Berlin, Douglas's *Der Sandmann* (1994) is a two-projector installation titled after an E. T. A. Hoffmann story from 1817. Mimicking and deconstructing the illusionistic techniques of commercial film and television, the artist constructed elaborate sets. One film shows a state-sponsored subsistence garden as it might have looked in the decades before the fall of the Berlin Wall; the other shows the site as it would later look if transformed by real-estate development. Both sets are filmed through continuous 360-degree shots and projected onto a single screen with half of each image blocked out. The camera pans create a constantly transforming erasure of one moving image by the other. An earlier work by Douglas, *Monodramas* (1991) is a group of thirty- to sixty-second video narratives that were created to be televised between commercials and regular programming. His understanding of the codes of fictional cinema serves to create richly ambiguous scenes, minimelodramas interjected into the unending flow of television. Through these concise pieces filled with dogged and disoriented characters, Douglas addresses issues of point of view, representation, and miscommunication.

Moving-image self-portraits by Steve McQueen and Pipilotti Rist deploy the expressive potential of unconventional viewpoints. In the film *Just Above My Head* (1996), McQueen positions the camera vis-à-vis his performative self. A single projection fills a wall from floor to ceiling. The black-and-white footage shows the top of McQueen's head with the sky filling the majority of the frame. In this combined depiction of author and subject, the rhythm of the artist's movements shaped by the invisible terrain creates a moving image that disorients the viewer. In the video *Atmosphere & Instinct* (1998), Rist shifts the projection onto the floor so that we are looking down on a circle showing the artist calling up to us. Her actions are seen against a verdant background of rich greens and other bright colors, suggesting an update of early cinematic effects and the use of the iris shot to focus attention on a person or gesture. Here the shot becomes a peephole into a seductive yet unobtainable world; with the placement of this projection, Rist compounds the forces of longing and desire. Like the film projections onto floor surfaces by William Lundberg and other film installation artists of the 1970s, Rist's projection pieces are sensitive to the relationships created between the image, its content, and point of view.

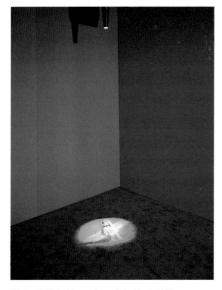

Pipilotti Rist, *Atmosphere & Instinct*, 1998

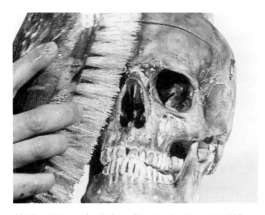

Marina Abramović, still from *Cleaning the Mirror #1*, 1995

Her command of the medium conveys a vibrant immediacy and achieves a reopening of the representation of female sexuality through performative means.

DOCUMENTS AND FICTIONS

The first photographers and filmmakers were quick to realize the evidentiary uses of light- and movement-capturing media. Whether documenting a war or a wedding, photographic and filmic texts were considered "truths" even though they could be extensively manipulated during exposure and processing. By analyzing the formal components of film, structural filmmakers bypassed claims to truth and embraced the expressive potential of constructedness. A number of contemporary moving-image artists have developed a similar approach in relation to subject matter representing perceived violence, loss, and injustice. Marina Abramović's video *Cleaning the Mirror #1* (1995), for instance, reduces gesture—the humanizing power of touch—to haunting repetition, with the artist holding and scrubbing a dirt-covered skeleton during a three-hour performance. Shown simultaneously on five vertically stacked monitors, the skeleton is fragmented sequentially by body part, with the skull filling the topmost monitor and so on down to the feet in the bottommost. This structuring dramatizes the performative nature of the work while also emphasizing the sense of irreparable damage. The foreboding threat of Abramović's actions, as well as their containment by being framed in time and motion, constitute the layered psychological subtexts of her work.

The photographer and video-installation artist Michal Rovner turned to single-channel videotape as a means to construct a fictional documentary expressing her search for the borders, both real and psychological, that comprise the state of Israel. The footage for her first video, *Border* (1996–97), which was shot along the border of Israel and Lebanon, was compiled from three sources: the artist, a professional camera crew, and a military commander. Rovner edited these diverse viewpoints together and added an equally layered soundtrack, creating a complex meditation on the workings of power. The video addresses a range of ambiguities, such as presence and absence, and the impossibility of identifying what is real and who is the enemy. In this poetic transcription of an ever-shifting field, Rovner proposes that the concepts of homeland and identity are as elusive as the contested borders themselves.

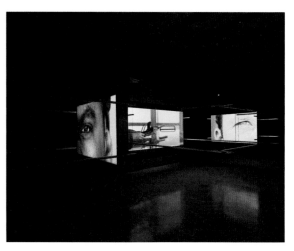

Iñigo Manglano-Ovalle, *Climate*, 2000

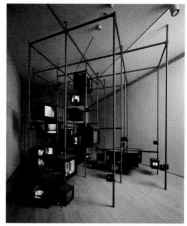

Vito Acconci, still from *Undertone*, 1973

Vito Acconci, *TELE-FURNI-SYSTEM*, 1997

The artists Jane and Louise Wilson (who are twins and work collaboratively) and Iñigo Manglano-Ovalle have utilized the documentary capabilities of the moving image to articulate metaphorical evocations of architecture as the embodiment of power and desire. The Wilsons' *Star City* (2000) is a two-screen video projection that records a training center of the Russian space

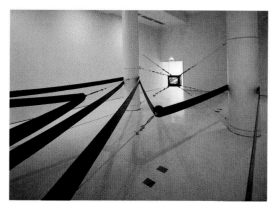

Vito Acconci, *VD Lives/TV Must Die*, 1978

program. Using color videography, the artists describe a spectacular atmosphere in which the utopian-scientific project of state communism has collapsed into a ruin of failed expectations. The camera's circuitous path through the institutional complex represents the fading traces of industrial and scientific power rendered as a sublime and ghostly past.

The enclosed urban environment becomes the text that is decoded in Manglano-Ovalle's three-channel video installation *Climate* (2000). Videotaped on location in Chicago at Mies van der Rohe's 860–880 Lake Shore Drive Apartments (1949–51), it features actors who appear and disappear in that richly encoded monument to Modernism. The projection of the structure's transparent enclosure onto the screens seems to magically suspend them; thus united, the screens and the moving images subtly shift experience, alternately becoming translucent surfaces or glittering mirrors of internal and external anxieties. Through this evocative representation of architecture, Manglano-Ovalle constructs a metaphor for the psychological tensions embedded within any built environment.

INTERACTIONS AND INTERVENTIONS

Rather than seeing the viewer as a passive witness, a number of moving-image artists have sought to physically intervene with their media and, by extension, to encourage (or provoke) viewer participation. The pioneering work of Nam June Paik is key to this thematic development. In the performance piece *Zen for Film*, which was first presented in 1964, Paik recast the cinematic by projecting clear celluloid while he stood and performed in front of the screen. The celluloid bathed Paik in light, splashing his shadow against the screen along with specks of dust that have increased as the film has been reused. His performance of light and shadow is the substitute for

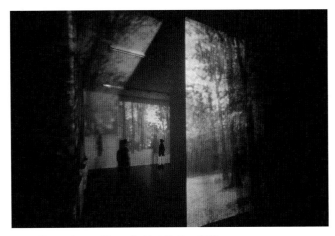

Diana Thater, *Late and Soon, Occident Trotting*, 1993

the absent recorded image, a human/machine interaction that anticipates his engagement with the television set. Unlike Paik's more interactive works, *Zen for Film* suggests viewer engagement by example; in the economy and simplicity of his gesture, he implies that any performing body could theoretically contribute to the blank screen.

The viewer's engagement with the moving image has also been treated in a number of installations and videos by Vito Acconci. His *VD Lives/TV Must Die* (1978) places a functioning monitor into a slingshot, filling the gallery space with the dynamic tension of its threatened release. The monitor plays a video with a provocative image and text that aggressively address the viewer. The video is constructed like Acconci's seminal single-channel pieces such as *Undertone* (1973), which confronts the viewer with an audio component suggesting a psychologically manipulative state of mind. Significantly more accommodating is *TELE-FURNI-SYSTEM* (1997), designed by Acconci and Acconci Studio. Commissioned for the exhibition *Rooms with a View: Environments for Video* presented at the Guggenheim Museum SoHo in 1997, this installation features an elaborate viewing structure, which the viewer/visitor can climb into and sit, stand, or lie down in while watching individual videos.

Diana Thater possesses a sophisticated understanding of the history of film and video art, which she acknowledges and inventively builds upon using signature visual strategies. Her *Late and Soon, Occident Trotting* (1993) treats time as an abstract image that is located within the natural environment. The piece employs four color projectors with one projector facing in one direction and the other three in the opposite direction. Each projector has three lenses that represent different colors. When properly synchronized, the projectors give the illusion of natural color registration. Thater juxtaposes the group of three to the single projector, which in addition to being directionally opposed, is also out of sync in its representation of color. Compared to the other projectors' duplication of the natural spectrum, the single projector serves to deconstruct color, to suggest alternatives. Thater's unusual use of the gallery space takes into account the viewer's movement through it. Her projections comprise an entwined set of perspectives, so that the viewer's experience is one of discovery, of linking together an interdependent network of signifying images capable of enacting a virtual reconfiguration of space.

There is a powerful collective memory of the cinematic—these are the myths that we unconsciously draw upon whenever we see the moving image. Within the exhibition space, the moving image offers a compelling presence through constant change; its "rootedness" is always happening for the first time. Increasingly, artists from around the world are working with film for presentation in theaters and for integration into installations in galleries and public spaces. New cinematic languages are constantly being deployed through a range of media, with the Internet as an increasingly viable platform. Research into the interconnected history of theatrical cinema and the later emergence of installation art enriches our understanding of art making in the twentieth century. In turn, emerging artworks and interpretive processes will doubtless provide critical means for the future.

NOTES

1. The first histories or critical anthologies actually appeared in the 1970s, such as Gregory Battcock, *Idea Art: A Critical Anthology* (New York: Dutton, 1973); and Lucy Lippard, *Six Years: The Dematerialization of the Art Object* (New York: Praeger, 1973). But it was in the 1990s that the historicizing of Conceptualism became a legitimate and even pressing subject for the academy and the museum. See, for instance, Benjamin H. D. Buchloh, "Conceptual Art 1962-1969: From the Aesthetics of Administration to the Critique of Institutions," *October* 55 (winter 1990), pp. 150ff.; Tony Godfrey, *Conceptual Art* (London: Phaidon, 1998); Ann Goldstein and Ann Rorimer, *Reconsidering the Object of Art: 1965–1975* (Los Angeles: Museum of Contemporary Art, 1995); and Luis Camnitzer et al., *Global Conceptualism: Points of Origin, 1950s–1980s* (New York: Queens Museum of Art, 1999).

2. A thorough account of the process of photography's assimilation to the history of painting is provided in Peter Galassi, *Before Photography: Painting and the Invention of Photography* (New York: Museum of Modern Art, 1981). An alternative view that links both the history of painting and the invention of photography to larger societal and intellectual preoccupations of the early nineteenth century can be found in Geoffrey Batchen, *Burning with Desire: The Conception of Photography* (Cambridge, Mass.: MIT Press, 1999).

3. The relationship of the photograph to the film is a complex issue debated most thoroughly in Garrett Stewart, *Between Film and Screen: Modernism's Photo Synthesis* (Chicago: University of Chicago Press, 1999).

4. The issue of artists' videos and installations from the Conceptual and performance art period of the 1970s being a critique of television codes and production practices is examined in David Antin's important essay "Video: Distinctive Features of the Medium," in Susan Delahanty, ed., *Video Art* (Philadelphia: Institute of Contemporary Art, 1975).

5. Image processing is a generic term denoting all types of digital manipulation of the moving image.

6. For an excellent history of this phenomenon in New York, see Julie Ault, ed., *Alternative Art New York, 1965–1985* (Minneapolis: University of Minnesota Press, 2002).

7. Chroma-keying is used to create an overlay effect, usually to insert a different background. The principal subject is photographed against a background having a single color or a relatively narrow range of colors, usually in blue. This allows for the nearly instantaneous switching between multiple video signals, with the end result being a single composite video signal. In *Three Transitions*, Campus painted his face blue in order to switch from one image to another.

8. For a discussion of the index, see Rosalind Krauss, "Notes on the Index," in Krauss, *The Originality of the Avant-Garde and Other Modernist Myths* (Cambridge, Mass.: MIT Press, 1985), pp. 196–219.

9. Richard Serra, statement on *Frame* in *Artforum* 10 (Sept. 1971), p. 64.

ART PHOTOGRAPHY AFTER PHOTOGRAPHY

Nancy Spector

What is the difference between a photographer and an artist who works with photography? Are there specific aesthetic criteria that determine the distinction between these two categorizations? Or is this perceived disparity merely an art-historical construct that has become germane in today's visual culture, which is permeated by mechanically reproducible mediums such as photography, film, video, television, and the Internet. Such a construct allows for the division between the old and the new, or the traditional and the avant-garde. It configures entire museum departments and defines the parameters for certain private collections. It also provides a vocabulary for interpreting a diverse range of works that are, nonetheless, all crafted from the same medium: light reflected on the surface of chemically treated paper to form an impression of the empirical world.

The history of photography within the fine-arts context has been one of absorption and assimilation. Originally considered the mechanical stepchild of painting, photography was devalued initially for its inherent multiplicity and seemingly automated rendering of the world. Not long after its invention in 1839, photography came to pervade every aspect of visual culture, serving as a convenient tool with which to commemorate, document, advertise, and analyze. Photography's position as an art form in its own right, with all the attendant trappings—an art-historical lineage delineated by technical achievements, master practitioners, and recognizable styles—evolved slowly during the first half of the twentieth century through the concerted efforts of individual curators and photographers determined to validate the aesthetic dimensions of the medium and to separate it from its more commercial applications.[1] Through devices like the vintage print and the limited edition, which purportedly secured a work's authenticity and uniqueness, fine-art photography was able to claim the auratic quality typically the province of painting, the most venerated of art forms.[2] Artistic careers were thus born; photographers such as Alfred Stieglitz, Ansel Adams, Paul Strand, Edward Weston, Diane Arbus, and Gary Winogrand were all granted their place within the hallowed halls of the museum and celebrated for the individuality of their authorial visions. Fine-art photography came to be understood as the personal expression of select creative genius, even though it was as mechanistic as its other institutional functions like photojournalism, advertising, or medical imaging.

By the 1960s and 1970s, the ascendancy of fine-art photography had been fully realized with the establishment of a market devoted specifically to the limited-edition (vintage) print, the proliferation of photography departments in major art museums, and the emergence of a publishing industry dedicated to high production-value photography books. Regardless of its visibility and prestige, however, fine-art photography was isolated from the more progressive practices emerging in contemporary art at the time. The 1960s marked a wholesale paradigm shift within visual culture as artists began to challenge the sacrosanct authority of the unique aesthetic object, the institutions that housed or brokered it, and the very language used to articulate it. This moment has been described as the "dematerialization of the object,"[3] when numerous artistic strategies arose to replace the traditions of painting and sculpture. Known variously as Process art, Body art, Earthworks, Post-Minimalism, Performance, and Conceptual art, much of the work created during this period involved performative or temporal activities that were largely ephemeral. Some practices—in particular, linguistically based Conceptual work—directly critiqued the epistemological nature of art, while others reinvented its terms to explore the experiential and the outer limits of the self. What linked these disparate and wide-ranging approaches was photography.

Gordon Matta-Clark, *Conical Intersect*, 1975

The photographic process—with its seemingly neutral, documentary capabilities—became the primary vehicle through which artists depicted their various interactions with the world, their own bodies, or other representational systems.[4] It was not, however, the cloistered and canonized tradition of fine-art photography that served as their source, but rather the veritable avalanche of photographic imagery informing society at large. While the Museum of Modern Art, New York, was staging monographic exhibitions of photographers like Walker Evans (1971), Eugene Atget (1972), Harry Callahan (1976), and William Eggleston (1976), Conceptual artists were turning to photojournalism, the amateur snapshot, and advertising for their visual references.[5] Defined by multiple social and institutional discourses, the photograph was perceived at the time to bridge such discrete categories as high and low art as well as information and personal expression. Photography's inherent reproducibility and potential for mass distribution were embraced as means to subvert the increasingly market-dominated art world. The photograph was thus used as a hybrid medium to create works that privileged art-as-activity over art-as-product. It functioned, for instance, as a recording device for durational events (as in projects by Jan Dibbets and Douglas Huebler); as a visual record of actions sited outside the gallery environment (Daniel Buren, Richard Long, Gordon Matta-Clark, Dennis Oppenheim, Robert Smithson); as a tool to analyze the seriality inherent in architecture and industry (Bernd and Hilla Becher, Dan Graham, Hans Haacke, Ed Ruscha); as a document of the corporeal gesture (Vito Acconci, Jürgen Klauke, Bruce Nauman); as a way to examine the relationship between image, text, and meaning (Robert Barry, Victor Burgin, Joseph Kosuth); as a mirror to the photographic core of our media culture (John Baldessari); as an alternative to the male-dominated realm of painting and sculpture, as a way to explore an embodied feminist experience (Mary Beth Edelson, Valie Export, Hannah Wilke, Ana Mendieta, Annette Messager, Adrian Piper); and as a symbol for collective historical memory (Christian Boltanski).[6]

Since the photograph was considered to be a content carrier rather than an aesthetic object, its own immediate physical presence was, in some cases, deemed entirely unnecessary. In 1966 Dan Graham situated his artwork in the space of a magazine, emulating the look and tone of the photo-essay with his illustrated study of suburban

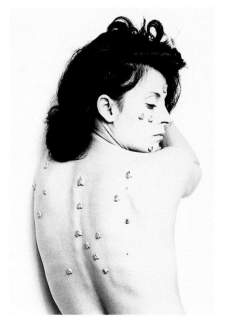

Hannah Wilke, *S.O.S. Starification Object Series*, 1974

Ana Mendieta, *Untitled* (from the *Silueta* series), August 1976

architecture entitled "Homes for America."[7] Like Robert Smithson's 1967 *Artforum* article "Incidents of Mirror-Travel in the Yucatan"—an artwork posing as a hallucinatory travelogue[8]—Graham's project functioned as a parody of photojournalism, while raising doubts about the artistic "autonomy" of his own photographs.[9] In fact, the illustrations for both Graham's and Smithson's articles were taken from Kodachrome color slides;[10] Graham did not begin printing or exhibiting his own images as independent photographs until 1970.

Graham's and Smithson's critical interventions into the framework of print journalism—which, in retrospect, can be understood as parodic performances—presaged the emergence of postmodernist art by nearly a decade. Manifest as a crisis in cultural authority, postmodernism exposed the legitimizing narratives of late-capitalism to be ideological constructs designed to maintain its presumed hegemony. In the visual arts, postmodernist theory was translated into a widespread suspicion of representation, which was revealed to construct ideas about identity and to perpetuate desire. Questions regarding the mechanisms of power inherent to contemporary systems of representation—advertising, television, cinema, print media, fashion, and architecture—emerged as operative aspects of the most provocative art created during the late 1970s to the mid-1980s: To whom is representation addressed and who is excluded from it? In what ways does representation define and perpetuate class structure, sexual difference, and racial difference? What does representation validate and what does it obstruct? And, ultimately, can the mechanisms of representation—like those of ideology, which are seamless, transparent, and always present—be critiqued, dismantled, or transformed?

The medium most suited to stage this critique of representation and its multiple discourses was photography. In fact, interventionist, photo-based practices became the defining aesthetic mode of postmodernist art. Described by Abigail Solomon-Godeau in 1984 as "photography after art photography,"[11] this work adhered principally to two different but overlapping conceptual strategies: appropriation and simulation. In the former category, Sherrie Levine rephotographed existing, well-known art photography and claimed it as her own in the series *After Walker Evans* (1981). While often interpreted as an ironic critique of modernism's cult of the original, this appropriated work also has a strong feminist subtext. By directly seizing the iconic products of modern photographic masters, Levine refused the supremacy of authorship, her own and that of her paternal elders. She staged this challenge within and against a culture that has routinely privileged artistic creativity as a male prerogative. In a similarly critical fashion, Richard Prince culled the image-world of mass advertising to rephotograph emblematic images of American consumer culture—the Marlboro Man, the fashionably-dressed woman, and scantily clad biker "chicks"—to self-consciously reveal the packaging of masculinity and its attributes.

Robert Smithson, *Yucatan Mirror Displacements (1–9)*, 1969 [#7 shown]

Following a related strategy of simulation, Cindy Sherman also repeated or reasserted

33

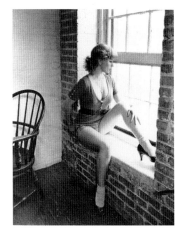

Cindy Sherman, *Untitled Film Still #15*, 1978

vernacular imagery, but this time, by restaging celluloid stereotypes of femininity. Her early photographic reenactments of B-level, Hollywood movie scenes unveil the performative nature of gender construction. Conceived as black-and-white "self-portraits"—each one utilizing a different disguise to depict a heroine at risk, in love, or weary from indifference—these "film stills" initiated Sherman's still-ongoing interrogation of vision and its relationship to sexuality. Formulated by what A. D. Coleman has designated the "directorial mode," Sherman's artfully constructed mise-en-scènes parody the different pictorial venues through which woman is represented in today's image-saturated culture: Hollywood cinema, fashion, society portraiture, pornography, and the like.[12]

The oppositional aspects of postmodernist art were quickly absorbed by the institutions they sought to critique, as is most often the case with any culturally subversive avant-garde practice.[13] Postmodernism easily entered art-historical discourse, and critics promptly acknowledged the appearance of a new "movement," identifying its various tendencies as "neo-geo," "postconceptual," or "simulacral." Its practitioners immediately gained commercial representation—in fact, galleries like International with Monument and Metro Pictures, which opened in New York in 1980, were founded in direct response to, and in tandem with, the emergence of postmodernist practices in the visual arts. Museums in Europe and the United States promptly organized exhibitions that examined the phenomenon. Some of the more noted of these shows included *Image Scavengers: Photography* (1982) at the ICA Philadelphia, *A Fatal Attraction: Art and the Media* (1982) at the Renaissance Society in Chicago, and *Damaged Goods: Desire and the Economy of the Object* (1986) at the New Museum of Contemporary Art in New York. In 1989 the Museum of Contemporary Art in Los Angeles presented *A Forest of Signs: Art in the Crisis of Representation* as a summation of the decade's postmodernist impulses; its accompanying catalogue includes individual texts on the thirty featured artists, three art-historical essays, and an illustrated exhibition history. Given the critical dimensions of postmodernist art and its theoretical sources in poststructuralist, linguistic studies, the art of this decade engendered an unprecedented amount of analytical text. Postmodernism's champions announced its advent and predicted its demise.

In an essay written three years after the publication of her pivotal text "Photography after Art Photography," Abigail Solomon-Godeau lamented the failure of postmodernist art to remain detached from the institutions it evolved to critique.[14] In her mind, the acceptance of such art by the museum signaled its corruption and the individual artist's complicity with the market. Postmodernism, she noted, had become just another style. What did this condemnation mean for the efficacy of the actual artwork and the continued relevance of the artists' careers that she so summarily dismissed? According to Solomon-Godeau and other critics associated with postmodernist theory, fine-art photography was merely an invention of the market/museum axis that determines which art receives

Hellen Van Meene, *Untitled*, 1999

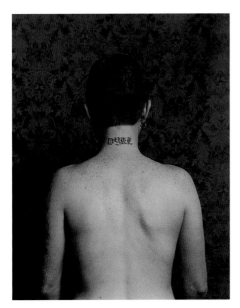

Catherine Opie, *Dyke*, 1993

mainstream attention, and postmodernist photography was ruined by this alliance once it gained acceptability.[15] Such an argument disallows the capacity of such art to stage an institutional critique from within the confines of the museum walls. It rejects the viability of the interventionist strategy so crucial to art of this period and so influential to a younger generation of artists like Felix Gonzalez-Torres, Andrea Fraser, and Fred Wilson, who infiltrate the museum and use it as a vehicle for their own subversions of the system. Solomon-Godeau's critique also allows little room for artists to succeed unless they remain outside of any legitimizing systems.

Much of the best work created during the 1990s attempted to bridge the gap between institutional validation and alternative structures. From Rirkrit Tiravanija's communal Thai meals to Gonzalez-Torres's endlessly replaceable stacks of imprinted paper and piles of edible sweets, artists sought to engage the public through interrelational artworks. The proliferation of photography, film, and video during this decade occurred partly through the need to record the performative aspects of these ephemeral practices, which, in some cases, marked a return to a 1970s aesthetic of "dematerialization." But the current pervasiveness of photo-based activities also seems to be a recuperation of *both* fine-art aesthetics and conceptual strategies. Today's photo-based art boasts an intricate, many-layered genealogy that draws on numerous and often conflicting traditions. It is a polymorphous medium that expands outward to include video, film, and new digital technologies, as well as fresh interpretations of conventional, straight photography. A number of artists, for instance, have responded to the documentary impulse that informed so much fine-art photography. In the realm of portraiture, Rineke Dijkstra's disquieting images of children on the verge of adolescence, Hellen Van Meene's intimate portrayals of young girls, Katy Grannan's depictions of individuals fantasizing their own representations, and Catherine Opie's pictures of butch dikes and transgendered individuals combine the dispassionate, typological studies of August Sander with the aestheticizing visions of Richard Avedon or Robert Mapplethorpe.

Photography's relationship to typological analysis—as evident in Sander's systematic catalogue of German portraits entitled *Citizens of the Twentieth Century* (1918–33), the Bechers' ongoing inventory of industrial relics, or Ruscha's booklet recording every building on Sunset Strip (1966)—is well manifest in photo-based art today. For instance, Olafur Eliasson's photographic grids, each depicting single examples of a natural phenomenon taken from the same vantage point, recall the visual rigor of the Bechers' photographic formations. Candida Höfer, a former student of the Bechers, creates ordered, color photographs of building interiors—with an emphasis on places of learning and classification—that subtly investigate the psychology of public space. Choosing as her subjects libraries, museums, lecture halls, theaters, and waiting rooms, Höfer documents the architecture of society's communal experiences and its compulsion for taxonomic systems. In addition to portraits and landscapes, Thomas Struth documents sites of

tourism—museums, cathedrals, and Buddhist temples—inhabited by their attentive visitors. The fanatically detailed images act as visual analogues to the very process of looking promoted by such famous destinations. Andreas Gursky inventories late-capitalist society and the systems of exchange that organize it. His precisely composed images reproduce the collective mythologies that fuel contemporary culture: travel and leisure (sporting events, clubs, airports, hotel interiors, art galleries), finance (stock exchanges, sites of commerce), material production (factories, production lines), and information (libraries, museums, book pages, data). Yet, despite the traditions he invokes both formally and conceptually, Gursky has no pretense to objectivity. He digitally manipulates his images—combining discrete views of the same subject, deleting extraneous details, enhancing colors—to create a kind of "assisted realism."

The development of new, digital technologies has given artists enormous latitude in the invention of their photographic images. While contrary to some beliefs, photography has never been a purely objective medium, providing an unmediated view of reality. Everything, from vantage point to printing process, makes one picture different from another, even if they are of the exact same subject. Furthermore, the camera can record the most outrageous untruths by manipulating the visible or indulging in total fantasy. The 1990s witnessed an explosion of photographic fiction. Immediate art-historical sources for this phenomenon may be found in Sherman's parade of invented personae or James Casebere's photographs of paper constructions suggesting uninhabited cities from the late 1970s. But it is more the impact of cinema and television today that has given rise to the new narrative photography. Artists now freely manipulate their representations of the empirical world or invent entirely new cosmologies. Some, like Gabriel Orozco, directly intervene in the environment, subtly shifting components of the found world and establishing their quiet presence in it. Others, like

Oliver Boberg, Thomas Demand, or Gregory Crewdson, fabricate entire architectural settings for the camera lens. Working from preexisting, journalistic photographs of banal environments where extraordinary or atrocious things have occurred—Bill Gates's college desk, Jackson Pollock's barn, Jeffrey Dahmer's hallway—Demand builds one-to-one scale models of his subjects. The resulting photographs intimate the historical weight of their settings with an uncanny, uncaptioned silence. In a similar vein, Crewdson once constructed elaborate, small-scale dioramas of generic neighborhood backyards in which the flora and fauna enacted strange rituals: birds built a circle out of eggs; butterflies congregated to form a pyramid, vines turned into braids. These miniature worlds would each render a single photograph. In subsequent work, Crewdson expanded his subject matter to include images of small-town life strangely out of sync with reality—much in the spirit of David Lynch. Shot in and around Lee, Massachusetts, these surreal photographs were constructed with the scale and intricacy of film sets.

Anna Gaskell, *untitled #5 (wonder)*, 1996

Photography and film share the same genetic code, but it is only in recent

years that artists have begun to fully exploit this fact in photographs that depict moments from fantastical tales. Unhampered by photography's intrinsic stillness, Anna Gaskell stages mysterious mise-en-scènes for the camera, each one an evocative passage from a larger narrative. Her photographic fictions circulate around processes of make-believe—from the innocence of children's games to the anguish of mental illness. Built from layers of untruth, they bring into focus the tenuous distinction between reality and the imaginary. Gaskell has also translated her imagery into videos, extending in time the strange fairy tales invoked by her still photography. In her *Soliloquy* series (1998-99), Sam Taylor-Wood reinterprets renowned paintings— Henry Wallis's *The Death of Chatterton* (1865) and Velázquez's *Rokeby Venus* (1650)—in the form of Renaissance altarpieces. The upper, devotional image represents the artist's photographic rendition of a painterly scene: a reclining woman gazes at her reflection in a mirror,

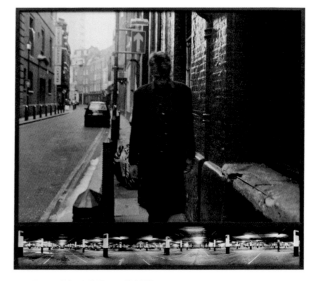

Sam Taylor-Wood, *Soliloquy V*, 1998

a young man swoons across a chaise, a man stripped bare to the waist leads a pack of dogs. The lower zone or predella contains a filmstrip-like sequence of images that reveals the subconscious fantasies of the subject above. Matthew Barney, perhaps *the* paradigmatic storyteller of the 1990s and beyond, creates photographs that distill essential moments from the plots of his epic films. His five-part *Cremaster* project (1994–2002) has engendered a rich body of photographic work that pronounces the significance of pure invention in contemporary art today.

The prevalence of photo-based practices in recent art has yet to be theorized. In many ways, the sheer profusion of photography, in all its polymorphous manifestations—black-and-white prints, Cibachromes, film stills, digital imagery—rejects the kind of critical analysis that determines specific art-historical movements or medium-based categories. Photography has become common parlance today in a way that painting or sculpture never could. Its ubiquity in all forms of visual culture complicates photography's reception as a purely artistic medium, particularly since artists freely draw from, emulate, and/or critique the image world at large. What is clear, however, is that the mistrust of visual representation that informed the most radical and important photo-based art of the 1980s, has subsided, at least for the moment. It remains to be seen where the current exuberance for photography will lead.

An earlier version of this essay appeared in *Imperfect Innocence: The Debra and Dennis Scholl Collection*, exh. cat. (Baltimore: Contemporary Museum, and Palm Beach: Palm Beach Institute of Contemporary Art, 2003), pp. 8–15.

NOTES

1. Christopher Phillips documents the transformation of photography into a highly valued museum art form through a detailed analysis of the evolution of the photography department of the Museum of Modern Art, New York, from 1935 with the arrival of Beaumont Newhall, the museum's first curator of photography, to the early 1980s and the tenure of Peter Galassi. He reveals ways in which the modernist values of authenticity, originality, and medium-specificity were brought to bear, often retrospectively, on the photographic print. See Phillips, "The Judgement Seat of Photography," *October* 22 (fall 1982), pp. 27–63.

2. The conversion of photography, with all its attendant applications in the commercial and scientific realms, into a fine-art form, can be seen as a complete inverse of Walter Benjamin's celebration of the medium precisely for its loss of the "aura," that privileged, quasi-mystical quality associated with singular, irreplaceable art objects. Benjamin saw in photography a liberating potential for shifting the values of bourgeois culture. See Benjamin, "The Work of Art in the Age of Mechanical Reproduction," trans. Harry Zohn, in *Illuminations* (New York: Schocken Books, 1969), pp. 217–51.

3. In 1967 Lucy Lippard and John Chandler wrote, "During the 1960s, the antiintellectual, emotional/intuitive processes of artmaking characteristic of the last two decades have begun to give way to an ultraconceptual art that emphasizes the thinking process almost exclusively. . . . Such a trend appears to be provoking a profound dematerialization of art, especially of art as object, and if it continues to prevail, it may result in the object's becoming wholly obsolete." See Lippard and Chandler, "The Dematerialization of Art," *Art International* 12, no. 2 (Feb. 1968), p. 31.

4. It was also during this period that artists such as Vito Acconci, Peter Campus, Dan Graham, and Bruce Nauman began to utilize film and the more portable technology of video to record their performative activities.

5. This phenomenon of borrowing from popular culture for artistic source material was not unprecedented. The European avant-garde of the 1920s and 1930s, including such artists as John Heartfield and Hannah Höch, developed the photographic montage as a form of political critique. And American artists of the 1960s, such as Robert Rauschenberg and Andy Warhol, transformed their painting practices with photographic techniques, albeit to less politically explicit ends.

6. This listing of artists and the various ways in which photography was utilized during the 1960s and 1970s is by no means complete. For a more detailed analysis of Conceptual photography than this brief essay will allow, see Christopher Phillips, "The Phantom Image: Photography within Postwar European and American Art," in *L'Immagine riflessa* (Prato: Museo Pecci, 1995), pp. 142–52. This listing is indebted to Phillips's outline of photography's varied uses during this period.

7. See Dan Graham, "Homes for America," *Arts Magazine* 41 (Dec. 1966–Jan. 1967), p. 21.

8. See Robert Smithson, "Incidents of Mirror-Travel in the Yucatan," *Artforum* 8, no. 1 (Sept. 1969), pp. 28–33.

9. This point is made by Jeff Wall in his critical investigation of Conceptual photography, "Marks of Indifference: Aspects of Photography in, or as, Conceptual Art," in *Reconsidering the Object of Art: 1965–75* (Los Angeles: Museum of Contemporary Art and Cambridge, Mass.: MIT Press, 1995), pp. 252, 257.

10. Smithson never actually printed or editioned his photographs. When the Guggenheim Museum purchased his *Yucatan Mirror Displacements (1–9)*, 1969, the images used to illustrate his *Artforum* article, it acquired nine color slides.

11. Abigail Solomon-Godeau, "Photography after Art Photography," in Brian Wallis, ed., *Art after Modernism* (New York: New Museum of Contemporary Art, 1984), pp. 75–85. In this important essay, Solomon-Godeau makes the crucial distinction between postmodernist photography and fine-art photography, which "lies in the former's potential for institutional and/or representational critique, analysis, or address, and the latter's deep-seated inability to acknowledge any need even to think about such matters" (p. 77).

12. A. D. Coleman, "The Directorial Mode: Notes Toward a Definition," *Artforum* 15, no. 1 (Sept. 1976), pp. 55–61.

13. For the term "oppositional postmodernism," see Hal Foster, "Postmodernism: A Preface," in Foster, ed., *The Anti-Aesthetic: Essays on Postmodern Culture* (Seattle: Bay Press, 1983), p. xi.

14. See Abigail Solomon-Godeau, "Living with Contradictions: Critical Practices in the Age of Supply-Side Aesthetics," in *The Critical Image: Essays on Contemporary Photography*, ed. Carol Squiers (Seattle: Bay Press, 1990), pp. 59-79.

15. In addition to texts by Christopher Phillips and Solomon-Godeau, see Douglas Crimp, "On the Museum's Ruins," in Hal Foster, ed., *The Anti-Aesthetic*, pp. 43–56.

MARINA ABRAMOVIĆ

b. 1946
Belgrade

Since the beginning of her career in Belgrade during the early 1970s, Marina Abramović has pioneered the use of performance as a visual art form. The body has always been both her subject and medium. Exploring the physical and mental limits of her being, she has withstood pain, exhaustion, and danger in the quest for emotional and spiritual transformation. This particular blend of epic struggle and self-inflicted violence was borne out of the contradictions of her childhood: both parents were high-ranking officials in the government, while her grandmother, with whom she had lived, was a devout Serbian Orthodox. Though personal in origin, the explosive force of Abramović's art spoke to a generation in Yugoslavia undergoing the tightening control of Communist rule.

The tensions between abandonment and control lay at the heart of her series of performances known as *Rhythms* (1973–74). In *Rhythm 5*, Abramović lay down inside the blazing frame of a wooden star. With her oxygen supply depleted by the fire, she lost consciousness and had to be rescued by concerned onlookers. Using her dialogue with an audience as a source of energy, Abramović created ritualistic performance pieces that were cathartic and liberating. In *Rhythm 0*, she invited her audience to do whatever they wanted to her, using any of the seventy-two items she provided: pen, scissors, chains, axe, loaded pistol, and others. This essay in submission was played out to chilling conclusions—the performance ceased when audience members grew too aggressive. Truly ephemeral, Abramović's earliest performances were documented only by crude black-and-white photographs and descriptive texts, which she published as an edition years later, choosing the most iconic images to represent the essence of her actions. Since 1976 she has utilized video to capture the temporal nature of her art. *Cleaning the Mirror #I* (1995) is composed of five stacked monitors playing videos of a haunting performance in which Abramović scrubs a grime-covered human skeleton on her lap. Rich with metaphor, this three-hour action recalls, among other things, Tibetan death rites that prepare disciples to become one with their own mortality.

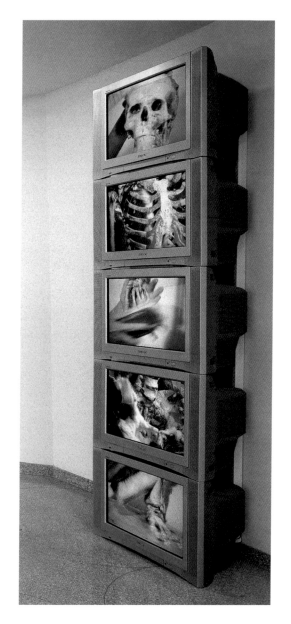

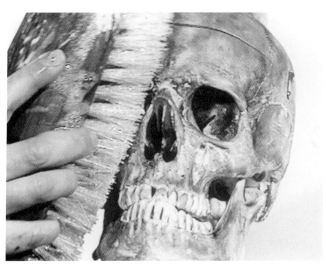

Installation view and detail, *Cleaning the Mirror #1*, 1995.

FRANCIS ALŸS

b. 1959
Antwerp

"Sometimes making something leads to nothing, sometimes making nothing leads to something." The seemingly paradoxical logic of this statement, uttered by the artist himself, informs the work of Francis Alÿs. His works often begin as simple actions performed by himself or commissioned volunteers, which are recorded in photographs, film, and other means of documentation such as postcards. Many of his projects are generated during the artist's "walks," or *paseos*, in which he traverses city streets. In these works, Alÿs proposed witty updates to Baudelaire's figure of the nineteenth-century flaneur. His first walk was *The Collector* (1991–92), in which he strolled through the streets of Mexico City pulling a small metal "dog" by a leash, its magnetic wheels collecting the city's detritus in its wake. In *Paradox of Praxis* (1997), the artist pushed a large block of ice down the streets for hours until it was reduced to a mere puddle. For *The Leak* (1995), he roamed the streets of Ghent with a punctured can of paint, leaving a sort of Jackson Pollock–like breadcrumb trail back to a gallery space, where he finally mounted the empty paint can to the wall.

Alÿs's endeavors often exceed the dimensions of discrete objects. In 2002 a group of some five hundred volunteers armed with shovels formed a line at the end of a massive, 1,600-foot sand dune and began moving the sand about four inches from its original location. This epic project, *When Faith Moves Mountains* (2002), was completed for the third Bienal Iberoamericana de Lima in a desolate landscape just outside the Peruvian capital. The work is neither a traditional sculpture nor an Earthwork, and nothing was added or built in the landscape. That the participants managed to move the dune only a small distance mattered less than the potential for mythmaking in their collective act; what was "made" then was a powerful allegory, a metaphor for human will, and an occasion for a story to be told and potentially passed on endlessly in the oral tradition. For Alÿs, the transitory nature of such an action is the stuff of contemporary myth.

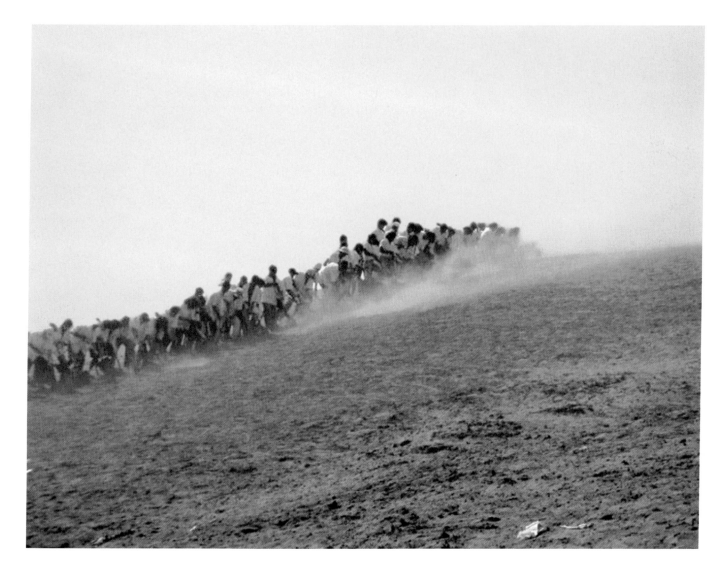

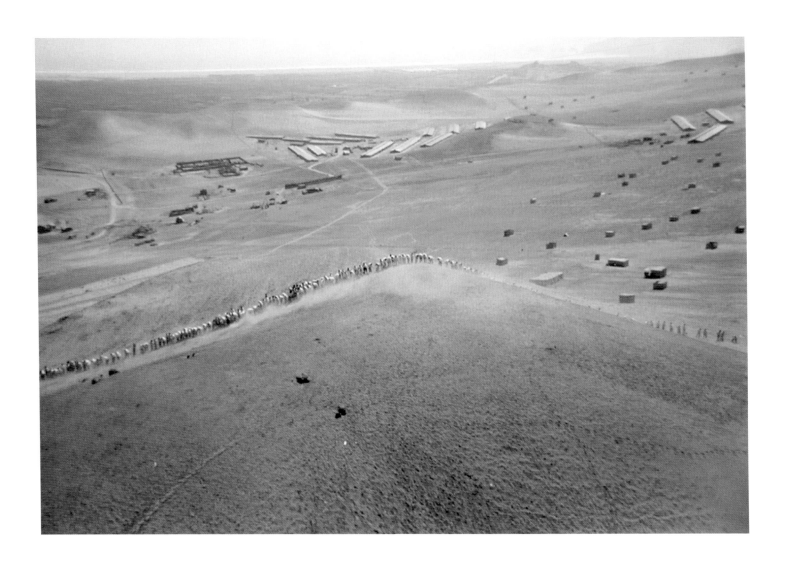

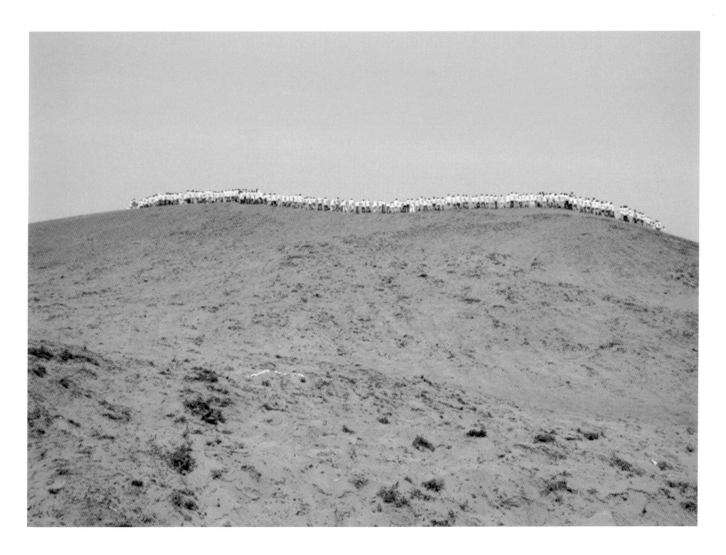

JANINE ANTONI

b. 1964
Freeport, Bahamas

Janine Antoni has crafted her personal aesthetic out of everyday activities and the objects that surround them. In particular she focuses on the rituals of the body, such as eating, sleeping, and bathing, as well as what would once have been called "women's work," such as mopping and weaving. A polyglot when it comes to mediums, Antoni has created sculptures, videos, photographs, and paintings, but the unifying substrate in her work has always been her body and the actions and contexts that encode it. In an early piece entitled *Loving Care* (1992), Antoni crept across a gallery on her hands and knees, dipping her long hair in a bucket of hair dye and painting the floor with it. Her most notorious piece, *Gnaw* (1992), involved carving two large cubes of chocolate and lard with her teeth and casting lipsticks and heart-shaped boxes from the spit-out remnants. For *Lick and Lather* (1993–94), the artist cast self-portrait busts in chocolate and soap, licking the former and washing with the latter until they resembled mere ghosts of her image.

Not all of Antoni's projects have involved such visceral materials and acts. Two photographic works have used her parents as sculptural material. In *Mom and Dad* (1994), Antoni made up each of her parents in the guise of the other, photographing them together in three different permutations with either one or both of them costumed in this way; *Momme* (1995) shows her mother sitting on a sofa, with the artist's foot peeking out of her dress, as if in some regressive fantasy. These pieces epitomize the darkly fantastic humor that pervades much of Antoni's work. She simultaneously sanctifies and satirizes, as when she upended the typical image of the nurturing mother with child in the photographs *Coddle* (1999) and *2038* (2000) by replacing the child with her own leg and a cow, respectively. Antoni's emphasis on her own body imbues her work with an air of autoeroticism or even narcissism but also harkens to the importance of autobiography in much 1970s feminist art. In staging a kind of return to that era, Antoni borrows much of its energy; by infusing that power into the banal rituals of the everyday, she shows just how deeply gendered they still are.

 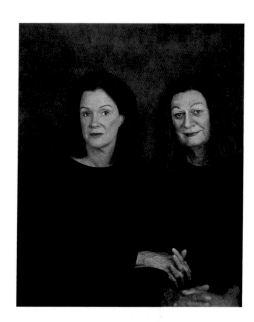

MATTHEW BARNEY

b. 1967
San Francisco

Matthew Barney's *Cremaster* cycle (1994–2002) is a self-enclosed aesthetic system consisting of five feature-length films that explore processes of creation. The cycle unfolds not just cinematically but also through the photographs, drawings, sculptures, and installations the artist produces in conjunction with each episode. Its conceptual departure point is the male cremaster muscle, which controls testicular contractions in response to external stimuli. The project is rife with anatomical allusions to the position of the reproductive organs during the embryonic process of sexual differentiation: *Cremaster 1* (1995) represents the most "ascended" or undifferentiated state, *Cremaster 5* (1997), the most "descended" or differentiated. The cycle repeatedly returns to those moments during early sexual development in which the outcome of the process is still unknown—in Barney's metaphoric universe, these moments represent a condition of pure potentiality.

Cremaster 1, takes place in Boise, Idaho's Bronco Stadium. The film parodies the musical extravaganzas of Busby Berkeley as filtered through the lens of Leni Riefenstahl's Third Reich athletics. Chorus girls form outlines of reproductive organs on a football field, their movements determined from above by a starlet, who inhabits two blimps simultaneously and creates anatomical diagrams by lining up rows of grapes. *Cremaster 2* (1999) alternates between the Columbia Icefield in Canada and the Bonneville Salt Flats in Utah. It is a gothic Western premised loosely on the real-life story of Gary Gilmore, who was executed in Utah for murder. Gilmore's biography is conveyed through a series of fantastic sequences including a séance to signify his conception and a prison rodeo staged in a cast-salt arena to represent his death by firing squad. *Cremaster 3* (2002) is part zombie thriller, part gangster film. As the final installment completed in the series, the film is a distillation of Barney's major themes, filtered through a symbolic matrix involving Freemasonry, Celtic lore, and coded references to the *Cremaster* cycle itself. Set in New York's Chrysler Building, *Cremaster 3* also includes detours to the Guggenheim Museum, to the harness track in Saratoga Springs and to Giant's Causeway in Northern Ireland. *Cremaster 4* (1994) is set on the Isle of Man, where a motorbike race traverses the landscape, a tap-dancing satyr writhes his way through an underwater canal, and three fairies picnic on a grassy knoll. Part vaudeville, part Victorian comedy of manners, and part road movie, this film portrays sheer drive in its struggle to surpass itself. Set in Budapest, *Cremaster 5* is performed as an opera complete with Jacobin pigeons, a lovelorn queen, and her tragic hero. The narrative flows from the Hungarian State Opera house to the Gellért baths, which is inhabited by water sprites frolicking in a pool of pearls. As the cycle's concluding chapter, the film traces the story of final release, a physical transcendence that is misunderstood and mourned as loss.

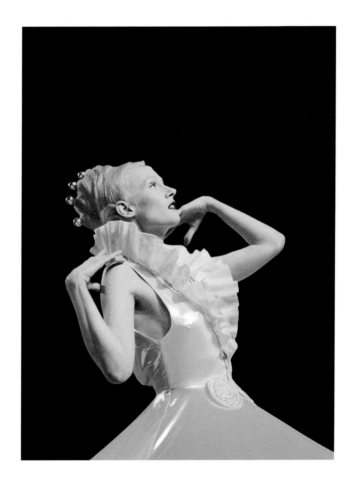

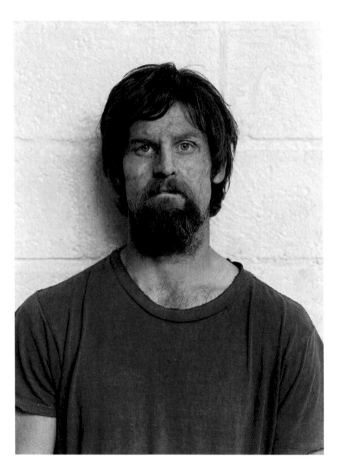
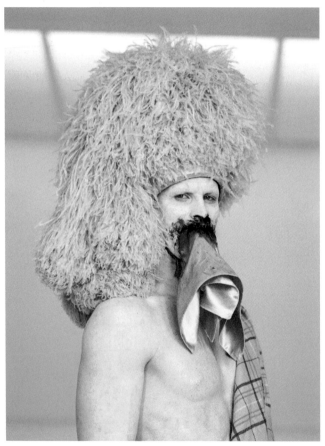

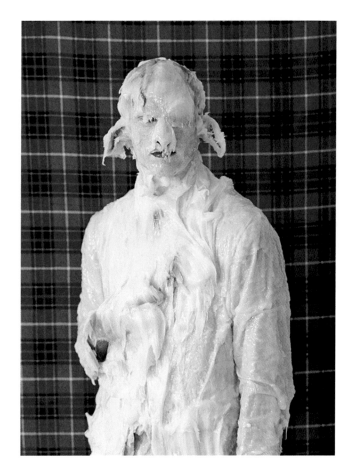 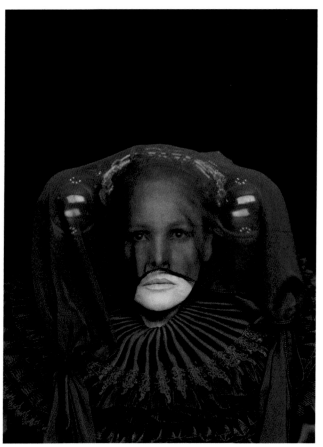

Cremaster Suite, 1994–2002

UTA BARTH

b. 1958
Berlin

Uta Barth's hazy photographs occupy the territory between abstraction and representation. Their lack of focus has become something of the artist's signature, and it often elicits comparisons between her work and that of such early-twentieth-century pictorialists as Gertrude Käsebier and Edward Steichen. In some regards this association is apt, especially when one considers the matte surfaces and heavy wooden backing of some of Barth's photographs, which emphasize their presence as objects. Moreover, as in pictorialist work, light evanescently illuminates many of Barth's scenes and subjects. For the most part, though, the fuzzy glow of her pictures far exceeds that of her predecessors' photographs. Barth renders landscapes and everyday spaces all but illegible by employing an extremely shallow depth of field. In doing so, she ruptures the age-old emphasis in photography on the referent and instead turns her audience toward its own experiences.

As early as her series *Field* and *Ground* (both 1994–97), Barth began moving toward an emphasis on pure surface; often only the occasional detail could clue viewers into what they were seeing. In her more recent series *nowhere near* (1999), she offers a clearly rendered object: the panes of her living-room windows, through which she shoots the surrounding landscape. Yet windows exist not to be seen but to be seen through. In focusing her lens on the glass itself rather than the view behind it, Barth highlights the conceptual underpinnings of all her work: an examination of the act of perception. When she enlarges some photographs to epic proportions and arranges them in diptychs or triptychs, Barth effectively overwhelms viewers with an acute awareness of their own processes of seeing, very often by confounding their understanding of what it is they see. In their banal beauty, her photographs hold a mirror up to the limits of perception itself.

55

OLIVER BOBERG

b. 1965
Herten, Germany

In his photographs of fictive architectural sites, Oliver Boberg poses questions about the medium of photography and the act of viewing. Utilizing his training as a painter, he fashions realistic sculptural versions of banal buildings and public spaces and then contrives careful lighting designs in order to enhance their believability. As with artists James Casebere and Thomas Demand, Boberg's models are created for the sole purpose of being photographed; they are three-dimensional sculptures meticulously designed to function as two-dimensional images. While this work is connected to the architectural photography of Bernd and Hilla Becher, these inheritors of this largely German tradition have increasingly turned their attention to issues of photographic veracity. If a real object in real space can be recorded in such a way as to evoke a completely different subject and place, then the issue raised is that of perception, of the expectations the viewer brings to a given photograph. Boberg's suggestion is that we approach images with models of what we expect to see already in mind, models that photographs merely confirm, models like the ones that the artist constructs.

In a recent work, *Night Sites* (2002), Boberg has turned to film to investigate and subvert the experience of cinematic absorption. Each of the seven 16-mm films that make up this piece is a continuous loop of an "establishing shot" of a rural site in which nothing happens, save the film's ambient sound track. Since these establishing shots do not turn out to be setups for the following shots of a story, as one might have anticipated, the viewer is instead left with the awareness of his or her own inflated expectations about the medium at hand.

Despite his pictures' artificiality, Boberg is able to create a remarkable sense of atmosphere. The absence of people in the drab entranceway to a building depicted in *Passage* (1999) is made ominous by the movement from light to dark, from outside to the edge of inside within the photograph. The uniformity and rigid geometries the artist chooses may reference, and critique, the attempted universality of German postwar architecture. In Boberg's hands these idealized structures are shown at their most hackneyed and seem to fall victim to wear and decay. The decorative plants overgrow their boundaries in *Passage*, and the once-pristine white of the industrial building in *Car Park* (1999) appears sullied and aged.

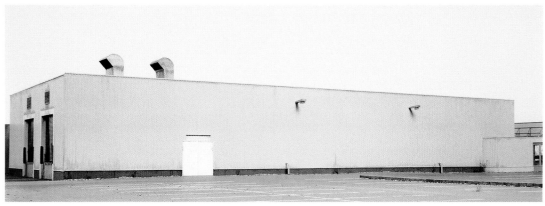

JEFF BURTON

b. 1963
Anaheim, California

Jeff Burton works across conventional photographic hierarchies that characterize fine-art photography as the medium's "highest" form, fashion or commercial photography as a "lower" form, and pornography as "lower" still. A rigorous attention to detail and composition merges with a sense of seduction in his images, which often include a part of—but seldom the whole of—a naked body. A drama seems always ready to unfold or, more accurately, is already going on—it is simply happening outside the frame of the photograph, beyond our sight. The viewer acts as voyeur, taking pleasure either in looking at the sensuous body on display or in contriving the narrative that might surround it. Pointedly, Burton never offers the sexual, or even pornographic, act in his photographs; that is not to say that such acts are not happening, but that the photographer and the viewer are on the sidelines of such doings.

Burton began his career on the sets of erotic films—films that reveal everything in a way that can seem crude or obscene, even if titillating. By turning his camera and attention to the periphery, he captures the actors' oiled bodies at rest, unstaged. In doing so, he creates photographs that are more mysterious, more ambiguous—and therefore markedly more seductive—than the images recorded for the films themselves. Burton relies on dramatic lighting, highly saturated colors, and low or unusual viewpoints—as in *Untitled #124 (reclining nude man)* (2000)—when photographing these fragmented scenes and making them the catalysts for personal memory, desire, and fantasy.

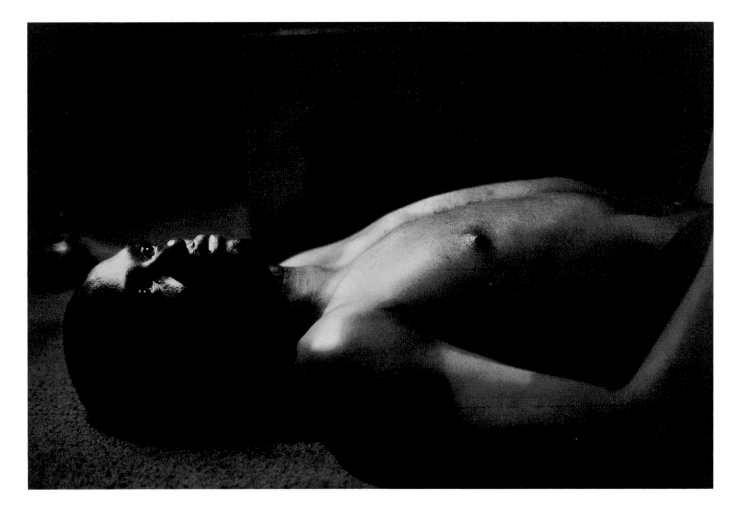

JAMES CASEBERE

b. 1953
Lansing, Michigan

James Casebere photographs the buildings that structure our social fabric, not during on-site visits to architectural structures, but rather from tabletop models he fabricates in his studio. These models, made from such featureless materials as Foamcore, museum board, plaster, and Styrofoam, remain empty of detail and human figures. It is only when Casebere casts highly nuanced light on their bland surfaces and spartan interiors that the models are transformed. Photographed in this way, his images suggest the psychologically charged spaces of the institutions that organize and control society.

During the 1970s Casebere was captivated by the social and cultural impact of film, television, and architecture. In particular, Robert Venturi's articulation of architecture as a system of signs evoked for Casebere the notion that a community is defined by its structures, both those that are highly visible, such as factories and churches, and those tucked out of sight, such as prisons and asylums. By the time he received his MFA from the California Institute of the Arts in 1979, he was staging his photographs to construct realities inspired by contemporary American visual culture. Like David Levinthal, Richard Prince, Cindy Sherman, Laurie Simmons, and others of their generation, Casebere challenged the commonly held perception of photography as a direct corollary to truth and reality.

Casebere is intent on blurring the line between fiction and fact, between myth and reality, in both his architectural models and his photographs of them. For example, in *Asylum* (1994) the space suggests the mechanism of photography itself: the prison cell is the box of the camera and the window acts as the aperture, letting in light. Casebere continually explores the mythologies that surround particular institutions, as well as the broader implications of dominant systems, such as commerce, labor, religion, health, and law. Here, he elicits ideas associated with asylums, ranging from the political to the spiritual; the room evokes a feeling of isolated incarceration as much as it does one of solitary transcendence, revealing the degree to which architecture and place exert their power on human behavior.

Asylum, 1994

PATTY CHANG

b. 1972
San Francisco

Exploring the darker side of femininity and socially constructed notions of desire, Patty Chang often takes a corporeal, visceral approach to Performance, an art form that underlies her work in video and photography. Like female pioneers of Performance art in the 1970s, such as Marina Abramović, Eleanor Antin, and Hannah Wilke, Chang uses her body to address issues of the objectification of women and their representation in art history and popular culture. Chang's work is often inflected with humor and often pushes commercial and popular female stereotypes to their extreme. In the photograph *Melons* (1998), for example, she uses cantaloupes as prosthetic breasts. How consumption and desire are inscribed upon the female body is addressed in Chang's art, but equally so is a woman's own desire of self.

Chang drinks her own image in *Fountain* (1999), the photographic series in which she, like Narcissus in the Greek myth, is transfixed by her own reflection in a pool of water, an act driven by both vanity and necessity. She explores the objectification and exoticization of Asian women in coy works such as *Contortionist* (2000), a photograph in which the artist gazes knowingly at the camera as she appears in the pose of a Chinese acrobat with legs resting on her own shoulders. Chang uses metaphor in works such as *Losing Ground* (2001), a video work that visually alludes to Andrew Wyeth's painting *Christina's World* (1948) and depicts Chang on a suburban lawn that is curiously destabilizing.

Much as Janine Antoni, Sally Mann, and Gillian Wearing have explored the sexuality and conflicts inherent to the parent-child relationship, Chang examines the territory of the primal, parental connection in her work *In Love* (2001). In this dual-channel video, two separate scenes of the artist with a parent are juxtaposed. Chang faces her mother and, in the adjacent frame, appears face to face with her father. Simultaneously both images show the artist's and respective parent's faces pressed together in what at first appears to be a deep kiss. Gradually it becomes evident that the video is running in reverse time, and that they share not a kiss but rather an onion from which they both eat. They bite into it slowly, pausing as they take turns offering it to each other, as if it suggests the proverbial, forbidden fruit. Parent and child swallow before they take additional bites, blinking hard to hold back tears from the onion's sharpness and pungency. However, in the video's reversal of time, the onion is reconstituted and the tears disappear—wholeness is thus regained.

MILES COOLIDGE

b. 1963
Montreal

Miles Coolidge's photographs of suburban and industrial landscapes are impassive portraits of contemporary alienation. His works, among them *Industrial Buildings* and *Police Station, Kids-R-Us, McDonald's* (both 1994) from his *Safetyville* series (1994–95), document banal spaces where the possibility of human existence has nearly been evacuated. At first glance the twenty color prints of *Safetyville* seem to depict views of an anonymous, suburban town in America. Upon closer inspection, however, the details become less plausible and the scenes less convincingly real. Safetyville is, in fact, only a model, a miniature town built at one-third scale in Sacramento, California, and designed to teach children about pedestrian safety. The flatness of Coolidge's images of the site further underscores the distorted logic of the child-sized buildings, which are mere facades like structures on a movie set. In part a commentary on rampant American consumerism, the images draw attention to the corporate logos adorning the buildings. Those brand names, such as McDonald's and Procter and Gamble, become markers of identification and comfort.

In his more recent series, *Mattawa* (2000), addressing a housing development for migrant farm workers in Washington state, Coolidge pushes the social critique of *Safetyville* even further. *Mattawa #9*, one work from this series of fourteen photographs, depicts rows of shipping containers that have been converted into worker dwellings. The narrow form of the containers stand in stark contrast to the mountains and fields that lie beyond their cold, geometric confines. Ironically, the workers are dehumanized as they are forced to inhabit the containers in which the fruits of their labor are transported. In both *Safetyville* and *Mattawa*, signifiers of daily life and human use, such as weathered facades, tattered signs, and cracked pavement, are mingled with an uncanny sense of absence. Employing an unlikely pairing, Coolidge fuses social commentary with a flat, formalist aesthetic.

PROCTER & GAMBLE

SPEED
LIMIT
40

Police Station, Kids-R-Us, McDonald's, and Industrial Buildings, both 1994

GREGORY CREWDSON

b. 1962
Brooklyn

In Gregory Crewdson's photographs, suburban America is besieged by inexplicable, uncanny occurrences. His elaborately staged panoramas often elicit comparisons to the films of Alfred Hitchcock, David Lynch, and Steven Spielberg. Although he eschews the clarity of narrative film, Crewdson engages with his material as a director might, going to great lengths to construct fictional realms, recently employing a crew of up to thirty-five to help realize his cinematic visions.

In Crewdson's work, meaning is kept just out of reach, where it lurks like a repressed trauma. His early *Natural Wonder* series (1992–97) focused on wildlife—birds, worms, and insects—forced to the edges of suburbia. These scenes take on the air of mysterious rituals. In one photograph, several birds have created a circular clearing in the grass and lined it with their speckled eggs, over which they stand guard. In another image, dozens of butterflies converge in a frenzied mass, smothering whatever lies beneath them. These ambiguous activities go entirely unnoticed by people, although a human presence is often suggested in the photographs by placid houses in the background. In his series *Hover* (1996–97), Crewdson turns to the human realm and explores its darker aspects. Abandoning the close-up views of *Natural Wonder* for higher, more expansive camera angles, these black-and-white photographs offer glimpses into private backyard sanctums in which disturbing acts occur: a man kneels over a woman who has collapsed and is inexplicably bound by festive balloons; elsewhere, a man obsessively mows his lawn in ever-larger concentric circles.

Crewdson's most recent series, *Twilight* (1998–2002), returns to those uncanny suburban motifs, staging them in a more elaborate manner. These dark-toned images are illuminated by shafts of light, as if from some outside force making contact with the inhabitants of the pictured world. In *Untitled (pregnant woman/pool)* (1999), a woman stands in a small inflatable swimming pool as celestial beams of light shine prophetically on her pregnant belly. The characters often seem lost in internal reverie, like the family members at dinner confronted by their naked mother coming in from the garden. They share physical space but are emotionally lost to one another. The *Twilight* photographs are self-consciously staged, yet the sense of drama and mystery permeating the scenes compels viewers to overlook this artifice. Like all the artist's work, these images suggest that at the heart of the American dream of property and privacy, emerging where least expected, darkness lurks.

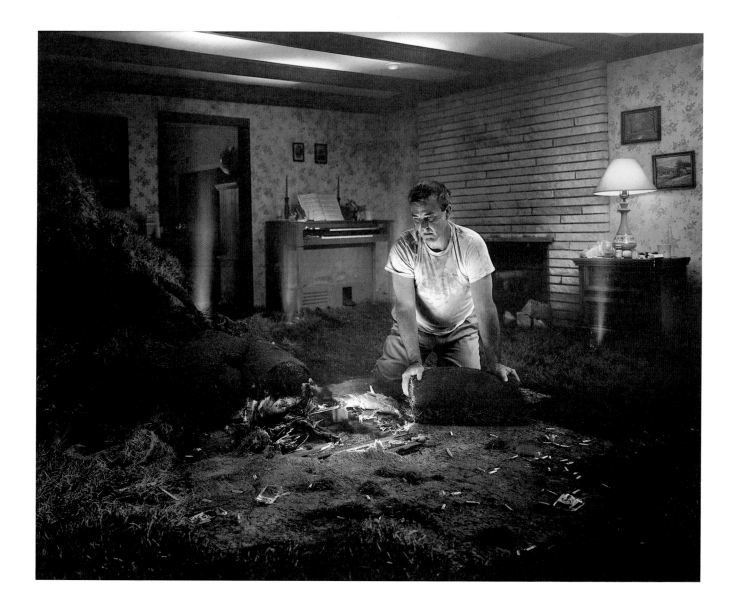

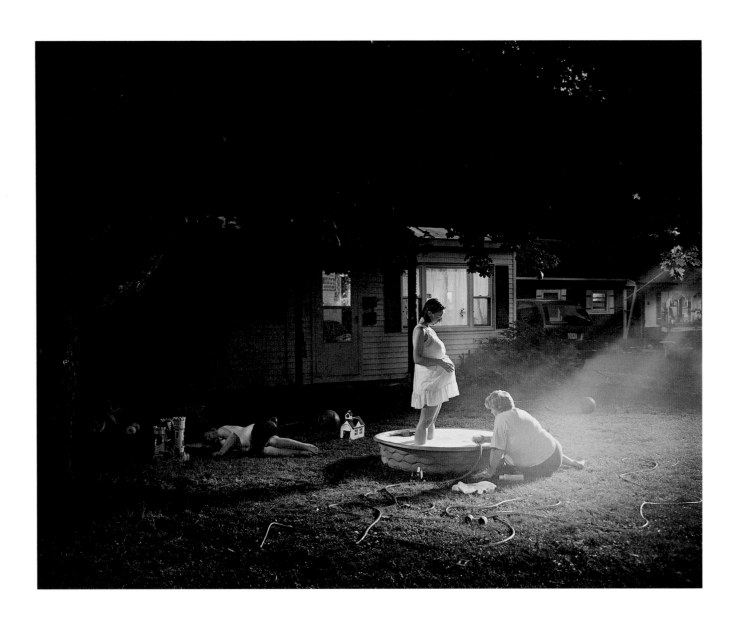

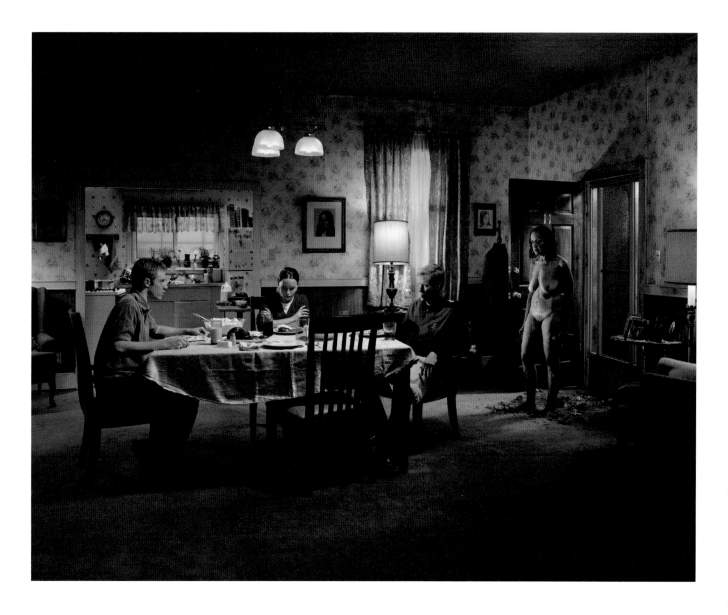

Untitled [pregnant woman/pool], 1999; Untitled [family dinner], 2001–02

71

THOMAS DEMAND

b. 1964
Munich

Using flimsy materials such as paper or cardboard, Thomas Demand constructs life-size models of architectural spaces in which events of historic or popular significance have taken place. He then photographs the models to re-create the image that he originally selected from the Internet or newspaper. His work thus engages formal intersections between photography, sculpture, and architecture while commenting on the power of both space and the photographic image to affect public consciousness saturated by mass media. "I like to imagine the sum of all the media representations of the event as a kind of landscape," he says, "and the media industry as the tour bus company that takes us through these colorful surrounds." Key for Demand is that the original event, with its real context, is utterly absent from his photograph; there is not the slightest trace. It is only the deceived eye of the viewer that might make the association. Implicit here is a critique of the assumption that the photograph is a guarantor of truth.

Representative of mass media's tendencies, many of the stories Demand chooses are violent or linked to grim situations. *Corridor* (1995) depicts the hallway leading to serial killer Jeffrey Dahmer's apartment; *Office* (1996) reconstructs the East Berlin headquarters of the Stasi secret police. These images lack any sort of human presence as well as the horrible, visceral evidence that would have accompanied actual events in such places. Instead, they might be said to speak to Hannah Arendt's "banality of evil," the notion that evil may persist best when perceived as ordinary by its perpetrators. These silent, unexceptional spaces thus take on a sinister edge. They are uncanny—familiar to everyone, yet occlusive of darker forces beneath their cleansed surfaces. In *Archive* (1995), the reconstruction of Nazi propagandist and filmmaker Leni Riefenstahl's personal inventory is strangely lit, the boxes suspiciously generic and unlabeled. Demand has here, as he does in many works, left clues to his image's artificiality. The resolute blankness of the scene is a reminder of our distance from the actual place and events referenced and the photograph's unsettling ability to *replace* memory, to supplant the real, particularly for history that entire societies experience. "Things enter reality through photography," Demand declares. "Tourists don't know they've seen the sights until they can match their experiences to picture postcards."

Archive, 1995

RINEKE DIJKSTRA

b. 1959
Sittard, The Netherlands

Rineke Dijkstra is first and foremost a portraitist. Specifically, she documents individuals caught in transitional states of being: mothers just after giving birth; preadolescent bathers poised on various beaches in the United States and Eastern Europe; club kids just off the dance floor in England and the Netherlands; teenage soldiers in Israel. Formally, her comparative series resemble classical portraiture—frontally posed figures isolated against minimal backgrounds—and in some sense follow in the tradition of August Sander, the early- and mid-twentieth-century chronicler of occupational typologies in Germany. In contrast to Sander who sought to fix and identify social types—the baker, the bricklayer, the peasant—Dijkstra searches for glimmers of individuality among like types—a hair out of place, a bead of sweat on the brow, an uneven stance. The uniformity within each series is disrupted by the sitter's emotional and physical particularities, which often expressly communicate a tension heightened by his or her shifting state.

Although she isolates the bathers in her *Beaches* series (1992–96) and frames them with only sea and sky, Dijkstra reveals much about them by capturing a subtle gesture or expression in these unguarded moments that reside somewhere between the posed and the natural. The end result is a collaboration between sitter and photographer, a record, however partial, of their interaction. In photographing the already awkward young subjects in their bathing suits, Dijkstra sets up a situation marked by exposure and self-consciousness that parallels the uneasy passage between childhood and adulthood. The images represent individuals from various countries and, as a whole, add up to a meditation on adolescent disconcertment. The photograph is the ideal medium for Dijkstra's practice precisely because of its explicit suspension of the movement of time: like Dijkstra's subjects, photographs are always between one moment and another.

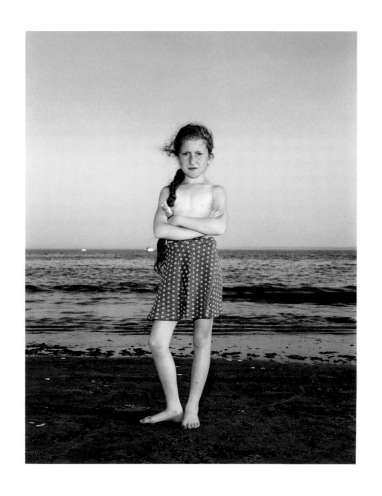

Coney Island, N.Y., USA, July 9, 1993, 1993

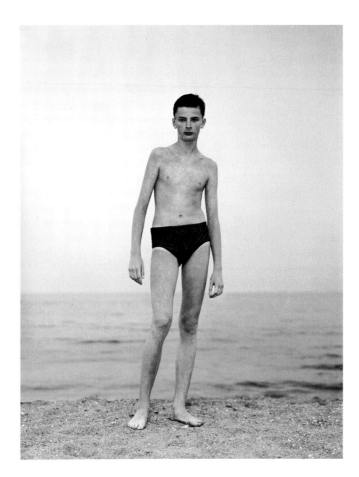
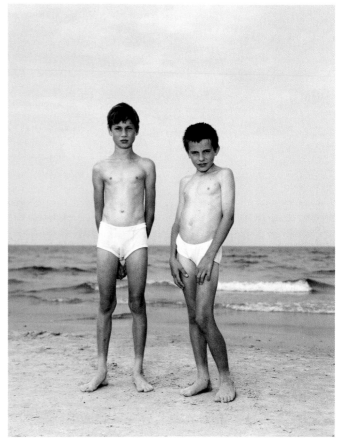

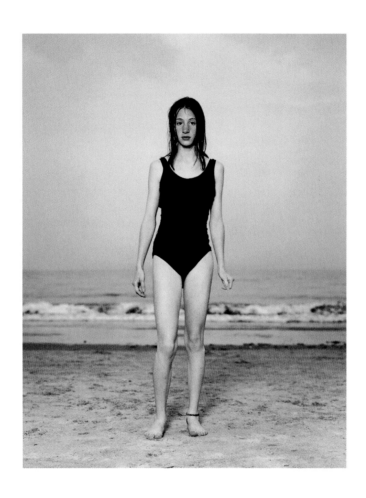

Odessa, Ukraine, August 4, 1993, 1993; Kolobrzeg, Poland, July 27, 1992, 1992; Coney Island, N.Y., USA, June 20, 1993, 1993

TRISHA DONNELLY

b. 1974
San Francisco

On the opening night of her first solo exhibition in New York, at the Casey Kaplan Gallery in 2002, Trisha Donnelly staged a performance, or as she prefers to call it, a "demonstration." Dressed as a Napoleonic courier, she rode into the crowded gallery on a white horse to deliver a message of surrender. "If it need be termed surrender, then let it be so, for he has surrendered in word, not will. He has said, `My fall will be great but it will be useful.' The emperor has fallen and he rests his weight upon your mind and mine and with this I am electric. I am electric." Having uttered this rather rebellious declaration of defeat, Donnelly turned and exited the gallery, leaving her guests to ponder the equally cryptic installation of video, photographs, and drawings comprising her show. Donnelly's is an art of nonsequiturs. The logic that connects her live performances with her objects and installations is entirely her own. She creates privately coded belief systems that communicate through the power of her expressions and gestures.

Whether live or recorded on video, these performances invite the spectator to navigate their elusive narratives by accepting the terms of the artist's own private language. In a recent video projection *Canadian Rain* (2002), Donnelly "created" rain in Canada by repeatedly executing gestures from an entirely invented sign language. Similarly, in an earlier video performance, she described how to find the most beautiful spot on Earth using only her imaginary signing system. In the silent video *untitled (jumping)* (1999), Donnelly reenacts what she contends are the signature gestures of specific rock musicians at the moment they achieve their "performance wall"—the point when they reach physical transcendence through their music. By jumping on an unseen trampoline, she floats in and out of the frame in slow motion, assuming a dreamlike state and re-creating the musicians' adrenaline-induced moments of ecstasy. The identities of the different performers—from Ozzy Osbourne to Joey Ramone—are never revealed.

STAN DOUGLAS

b. 1960
Vancouver, British Columbia

Stan Douglas explores the nexus of the socially and commercially mediated, resulting in video and installation works that examine how cinematic and televisual space constructs meaning in the wider culture. Using such heterogeneous themes and source materials as the history of Spanish exploration, Thomas Alva Edison's films from circa 1900, German postwar history, and Italian horror films of the 1980s, Douglas's work reflects an archival, analytic, and creative process, as he expands the artist's territory from the studio to the research room to the production shoot. His disruption of standard modes of reception—be they in the classroom or in front of the television—challenges viewers to explore how meaning is constructed.

Douglas's *Monodramas* (1991) suggest a larger narrative in which a pregnant moment is used metonymically for a greater meaning that remains unknown to the viewer. Alternating between highly charged verbal or physical exchanges and subtle shifts in landscapes or characters, each of the ten thirty- to sixty-second scenes in *Monodramas* was originally presented on broadcast television in British Columbia—interrupting other programs without any explanatory introduction. In many scenes, expectations are broken and brief disagreements arise, such as an exchange in which one man addresses another, "Hi, Gary," to which the response is "I'm not Gary." Through his use of the familiar length of television advertisements and of what seem to be excerpts, Douglas subverts commercial intent, leaving behind only a sense of an unfocused desire.

Stills from *Monodramas*, 1991

81

OLAFUR ELIASSON

b. 1967
Copenhagen

Where can we draw the line between nature and culture? And how do we as individuals fit into the relationship between the two? Since the early 1990s Olafur Eliasson has been making installations and series of photographs that consistently address such questions. His works consider the problems of representing and perceiving natural phenomena. To make them, he has constructed a waterfall in a museum courtyard, grown edible mushrooms on rotting tree trunks, and cut a hole in a gallery roof, allowing a disk of sunlight to move across the floor. Each process is put in motion through basic mechanisms and simple materials—sunlight, water, ordinary garden hoses—that are plainly visible to spectators. The processes can unfold very slowly, allowing viewers time to contemplate what Eliasson characterizes as a "discrepancy between the experience of seeing and the knowledge or expectation of what we are seeing."

By re-creating natural phenomena within or around artificial sites, Eliasson exposes moments of disjuncture between reality and representation. In this context, his use of photography is apt. As a medium, photography is especially relevant to explorations of the dialectic between nature and artifice, representation and reality. Eliasson considers his photographs as sketches for his installations and does not exhibit the two bodies of work together. Usually arranged in a grid format, these landscape "studies" show natural phenomena, such as rivers, caves, and glaciers, mostly in Iceland. Eliasson intentionally selects points of view that highlight viewers' bodily relations to the pictured scenes, choosing disembodied aerial shots or close-ups that reinforce the artist's own presence. When exhibited as a series, the individual images create a cumulative sense of the terrain and the slow progression of geological activity, such as glaciers melting or continental plates shifting. Eliasson ultimately foregrounds our own presence in the face of these colossal changes, and his re-creations and interventions upon natural phenomena are a means of investigating perception itself.

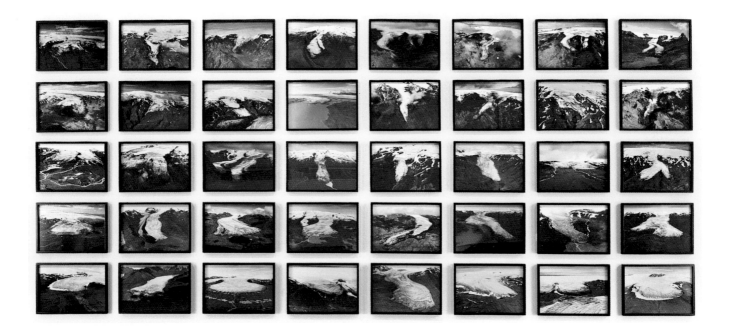

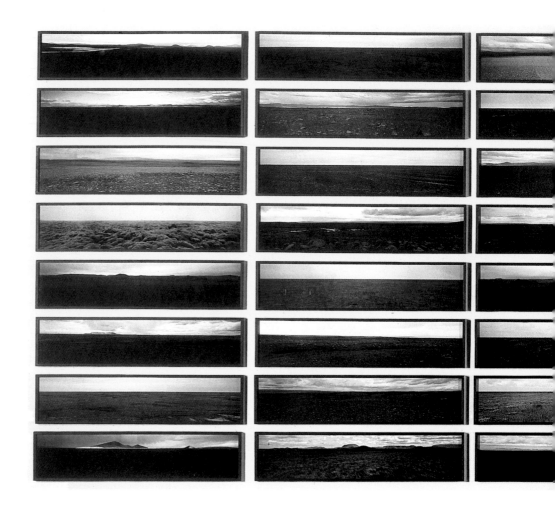

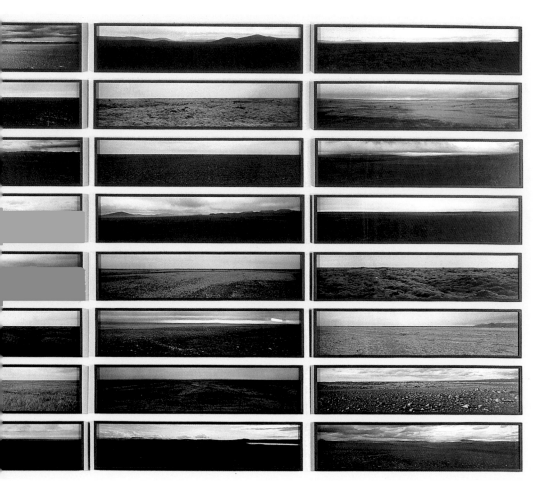

ELGER ESSER

b. 1967
Stuttgart

Like many contemporary German photographers, Elger Esser studied under Bernd and Hilla Becher at the Kunstakademie Düsseldorf. Yet unlike others schooled by the Bechers such as Andreas Gursky, Candida Höfer, or Thomas Struth, Esser attends to the unmanipulated, ephemeral, even romantic landscapes of Europe. Simply put, he photographs beaches, wetlands, riverbeds, and valleys. Such places offer up a low, straight horizon that is likely to be one of the most striking details of the resulting image. His views are often comprised largely of air and water, light and its reflection. In *Ameland Pier X, Netherlands* (2000), for example, the horizon divides the sky from the sea, forming two halves that are almost mirror images of each other, similarly tinted by the pale, luminous tones of an overcast day.

There is a sense of placelessness to these landscapes, despite Esser's lending of location details to the titles. Whether they portray the Seine in Paris, a beach at Beaduc, France, or a narrow strip of the Dutch shore, his photographs pay tribute to the universal lure of a seemingly infinite horizon and ultimate calm in the foreground. The picturesque quality of these views brings to mind everything from old-fashioned scenic-view postcards to nineteenth-century American Luminist paintings. But in the stillness of the landscapes and their muted, dreamlike colors linger evocations of the sublime, recalling the expressive effect of works by such great Romantic landscape painters as Caspar David Friedrich. The large-scale of Esser's prints coupled with the expansive distances and often indistinct horizons he photographs works to envelop the viewer, offering an alluring tension between the landscape originally encountered by the artist and experienced by the viewer.

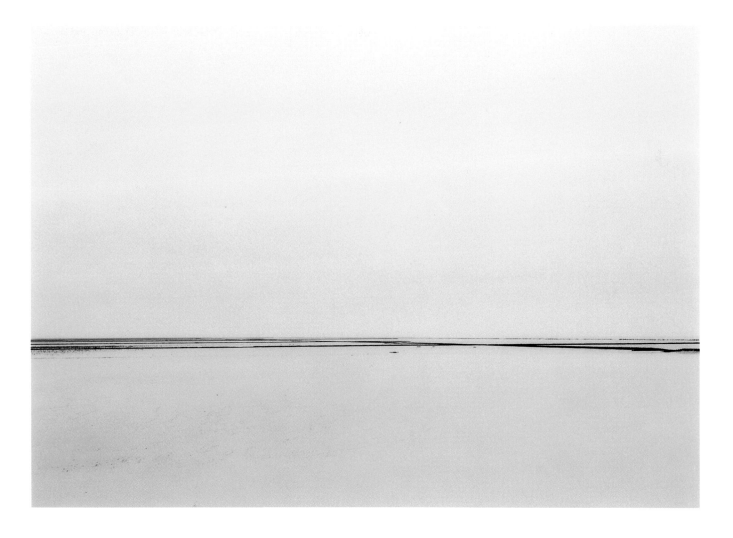

Ameland Pier X, Netherlands, 2000

PETER FISCHLI / DAVID WEISS

b. 1952, Zurich
b. 1946, Zurich

Peter Fischli and David Weiss have been collaborating since 1979 on a body of work that celebrates—with great humor and intelligence—the sheer banality of everyday existence. As contemporary flaneurs, they observe their world with bemused detachment, reveling in the mundane and turning every undertaking into a leisure activity. Their earliest projects lampooned the seriousness of high art: for *Wurstserie* (1979), they playfully photographed curious arrangements of sausages and luncheon meats to emulate the tableaux of genre paintings. The iconic themes of Western culture are parodied in a 1981 ensemble of 250 roughly hewn clay figurines representing such extraordinary events as *Anna O Dreaming the First Dream Interpreted by Freud*; *Marco Polo Showing the Italians Spaghetti, Brought Back from China*; and *For the First Time, Mick Jagger and Brian Jones Going Home Satisfied After Composing "I Can't Get No Satisfaction."* By the end of the 1980s, the duo had expanded their repertoire to embrace an iconography of the incidental, creating deadpan photographs of kitsch tourist attractions and airports around the world. For their contribution to the 1995 Venice Biennale, at which they represented Switzerland, Fischli/Weiss exhibited ninety-six hours of video on twelve monitors that documented what they called "concentrated daydreaming," real-time glimpses into daily life in Zurich: a mountain sunrise, a restaurant chef in his kitchen, sanitation workers, a bicycle race, and so on.

Fischli/Weiss's delight in the ordinary is given perfect form in the flower portraits—dazzlingly colorful, close-up shots of myriad garden plants in bloom or various stages of decay—that make up *Untitled (Flowers)* (1997–98). As in all the previous work in their conceptually driven practice, the flowers undermine conventional distinctions between high and low art—a culturally enforced contrast the artists once derided in a clay sculpture of two dachshunds, one standing on its hind legs, the other on all fours. Fashioned in the spirit of amateur photography in both subject and style, the flower portraits employ the technique of double exposure to achieve dizzying layered effects. The process allowed the artists to exploit their collaborative approach: one would shoot an entire roll of film in a suburban rose garden; the other would rewind it and then shoot the same roll in a park in Zurich. Deliberately decorative, these photographs push the limits of acceptability in Conceptual art. The cumulative effect of 111 different pictures, which can be installed in a room like wallpaper, glimpsed image by image as in a print portfolio, or seen singularly as framed photographs, is one of abundance and kaleidoscopic visual pleasure.

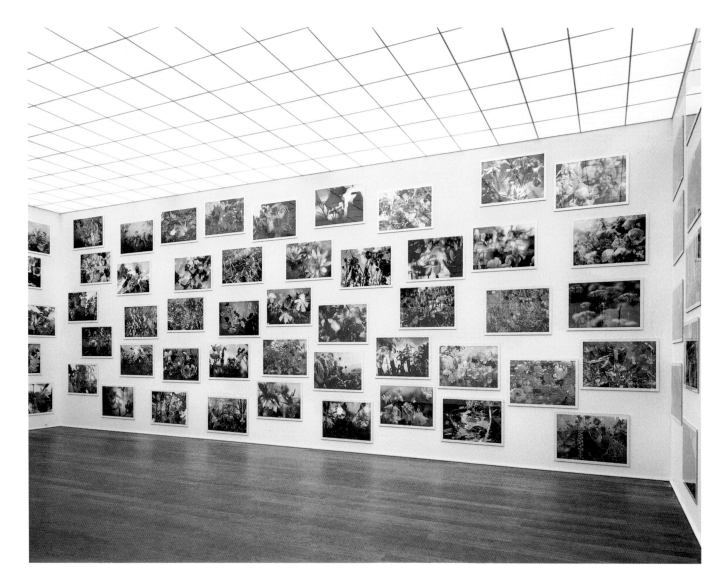

Installation view, *Untitled (Flowers)*, 1997–98

89

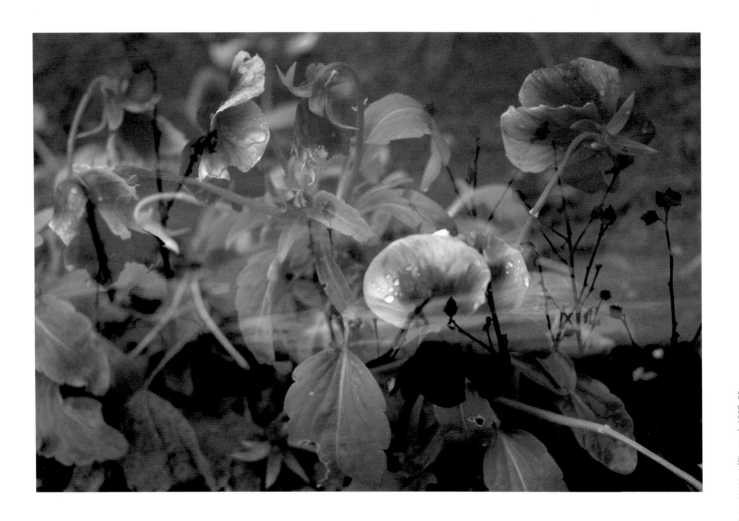

THOMAS FLECHTNER

b. 1961
Winterthur, Switzerland

During the late 1990s, Thomas Flechtner compiled what may be one of the most extensive photographic examinations of snow made to date. His large-scale prints swell with the stuff. Horizon lines, when visible, remain well inside the upper registers of the frames. Many of the pictures edge toward the monochromatic, their whiteness interrupted only by shadows or spare architecture. As a resident of La Sagne, in the Jura region of Switzerland, Flechtner worked from experience: with every winter's snowstorms, roads disappear, residents leave town, and life comes to a standstill. It is in these conditions that the photographer made his work, venturing by skis into the cold and barren landscape.

Flechtner completed four series of snow photographs, in which the drifts increasingly overwhelm signs of life. In *Colder* (1996–2000), Flechtner—who began his career photographing architecture—focused on La Chaux de Fonds, a town near his home. In these night scenes, the buildings' lights seem like bastions of life under siege of the weather, and they cast brilliant colors on the highly reflective whiteness. The hotels and parking decks at high mountain passes in the *Passes* series (1997–2001) are abandoned and partially buried. With the sky indistinguishable from the ground, the structures float in a silvery whiteness that dominates the compositions. In *Walks* (1998–2001), Flechtner used his skis to carve banded patterns into untrammeled fields of snow, capturing his actions with exposures of up to five hours. These systematic interventions into the landscape refigure the image of humanity against the elements in an elegantly formal manner. Finally, *Frozen* (2000) presents icy landscapes so hostile that humanity is altogether absent. This series was photographed in Greenland and Iceland, where Flechtner had traveled in hopes of creating more of his *Walks*; however, violent storms persistently erased his patterns. Turning to the desolate landscape itself, he created stunningly empty visions of what seems like another planet, where the snow exists in a sublime environment of blue and white light.

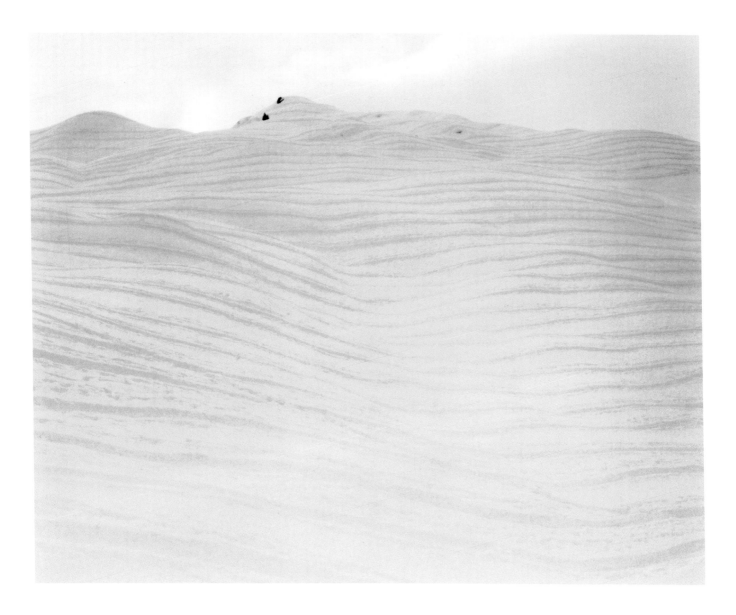

Glasspass (Walks #10), 2001

ANNA GASKELL

b. 1969
Des Moines, Iowa

Anna Gaskell crafts foreboding photographic tableaux of preadolescent girls that reference children's games, literature, and psychology. She is interested in isolating dramatic moments from larger plots such as Lewis Carroll's *Alice in Wonderland*, visible in two series: *wonder* (1996–97) and *override* (1997). In Gaskell's style of "narrative photography," of which Cindy Sherman is a pioneer, the image is carefully planned and staged; the scene presented is "artificial" in that it exists only to be photographed. While this may be similar to the process of filmmaking, there is an important difference. Gaskell's photographs are not tied together by a linear thread; it is as though their events all take place simultaneously, in an ever-present. Each image's "before" and "after" are lost, allowing possible interpretations to multiply. In *untitled #9* of the *wonder* series, a wet bar of soap has been dragged along a wooden floor. In *untitled #17* it appears again, forced into a girl's mouth, with no explanation of how or why. This suspension of time and causality lends Gaskell's images a remarkable ambiguity that she uses to evoke a vivid and dreamlike world.

Gaskell's girls do not represent individuals, but act out the contradictions and desires of a single psyche. While their unity is suggested by their identical clothing, the mysterious and often cruel rituals they act out upon each other may be metaphors for disorientation and mental illness. In *wonder* and *override*, the character collectively evoked is Alice, perhaps lost in the Wonderland of her own mind, unable to determine whether the bizarre things happening to her are real or the result of her imagination. In *wonder*, Alice's instability is invoked even at the level of presentation: the varied sizes of the photographs refer to her own growth spurts and shrinking spells. Gaskell's allusions to Carroll's story, however, are not always so playful. The seven versions of Alice in *override* alternate roles as victim or aggressor. They try to control the changes to Alice's body by literally, physically holding her in place—a potent metaphor for the anxiety and confusion experienced by children on the verge of adolescence. *hide* (1998) derives from a Brothers Grimm tale of a young woman who disguises herself under an animal pelt so that she might escape her own father's proposal of marriage. Gaskell addresses this psychologically loaded subject matter with images of girls wandering in a gothic mansion illuminated by candlelight. Here the psyche in question has been fractured and fraught with terror by a perverse father's look, a voyeuristic gaze.

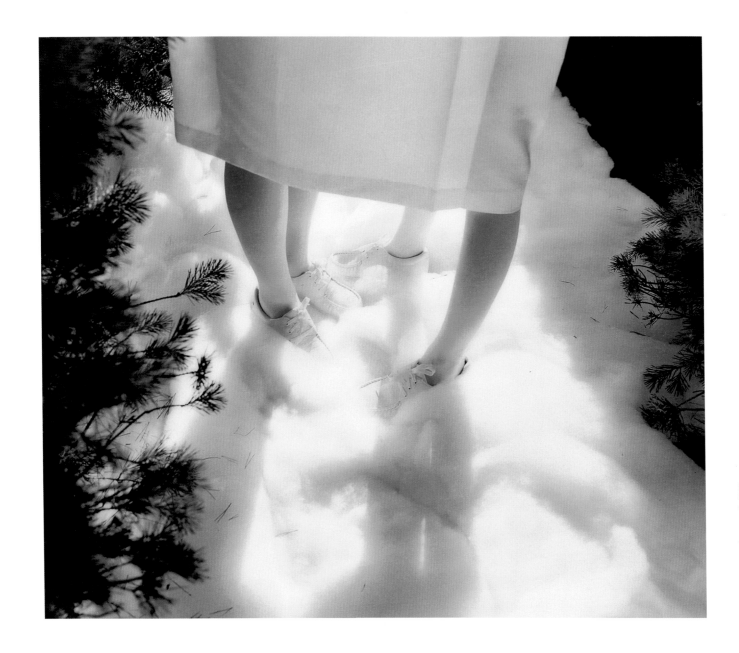

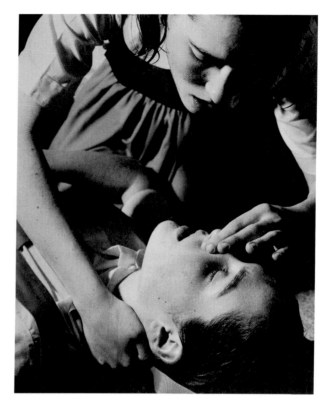

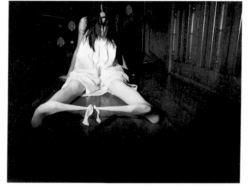

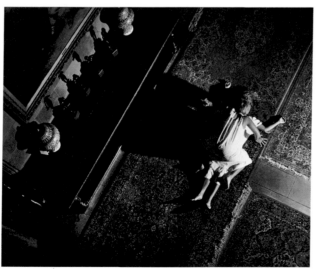

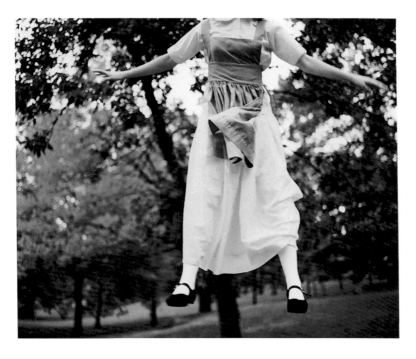
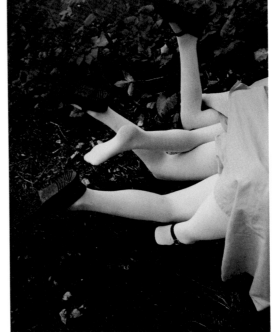
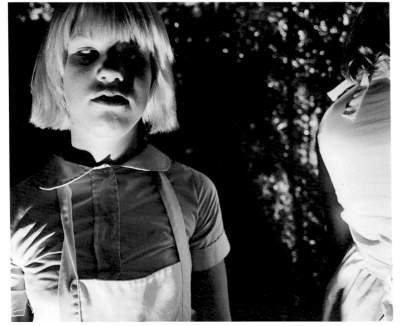
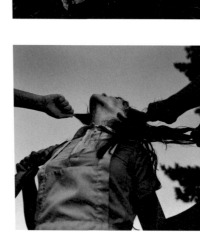

Page 96, clockwise from top left: untitled #35 (hide), 1998; untitled #2 (wonder), 1996; untitled #8 (wonder), 1996; untitled #47 (hide), 1998; page 97, clockwise from top left: untitled #6 (wonder), 1996; untitled #29 (override), 1997; untitled #25 (override), 1997; untitled #26 (override), 1997

NAN GOLDIN

b. 1953
Washington, D. C.

Since the late 1960s, Nan Goldin has worked on an evolving body of work that builds upon the informal, content-driven aesthetic of the snapshot. Like Diane Arbus and Mary Ellen Mark, she works loosely within the documentary tradition; unlike these two, however, Goldin has developed an ongoing first-person account of life among the friends, lovers, and acquaintances who make up what she has called her "re-created family." Goldin's photographs invite the viewer inside the private dramas of people and situations normally considered on the outer reaches of social acceptability—from a scene of drag queens backstage to one of postcoital dejection, from a lackluster moment at a dinner party to a transvestite's toilette.

The emotional states of Goldin's subjects are visually intensified by her focus on interior spaces, lush color, and theatrical lighting. Most striking of all, perhaps, is her photographs' sense of intimacy and informality. Her subjects appear not as victims of a distant, voyeuristic gaze, but as friends grown used to the camera's inevitable presence. For example, *Greer and Robert on the bed, NYC* (1982)—one of several hundred images comprising Goldin's slide show *The Ballad of Sexual Dependency* (1980–86), which documents the gender-bending, substance-abusing, club-going culture of New York's downtown scene—captures the frightening fragility of an uncertain relationship.

Ivy with Marilyn, Boston (1973)—part of a compilation of photographs titled *The Other Side: 1972–1992*, published in 1993—is from an early black-and-white body of work depicting the drag queens with whom Goldin lived and socialized. These photographs of the "third sex" suggest that in the universal struggle between autonomy and dependency, the greatest autonomy may come from disavowing the gender roles that complicate this struggle. Her more recent projects take up different themes, such as pregnancy and motherhood in *From Here to Maternity* (1986–2000) and the struggles of a life lived under the shadow of AIDS in *POSITIVE* (1993–2000). Yet these photographs continue Goldin's investigation into human relations that, like sex, revolve around negotiating simultaneous desires for togetherness and separation, community and independence.

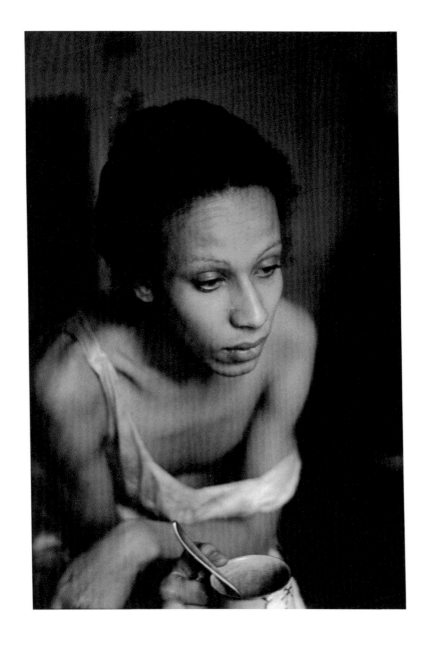

Roommate with teacup. Boston, 1973

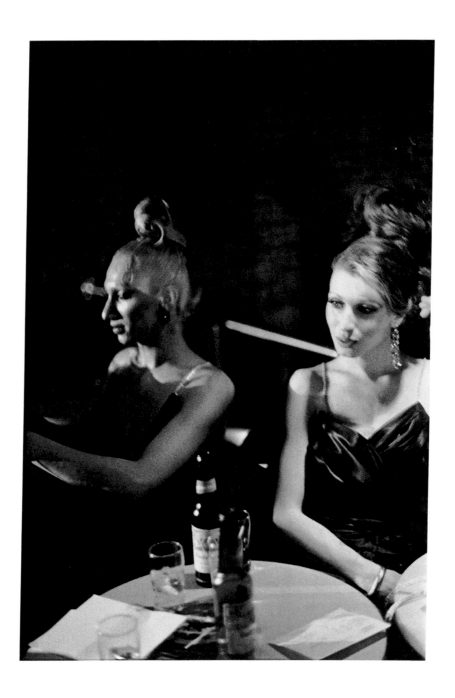

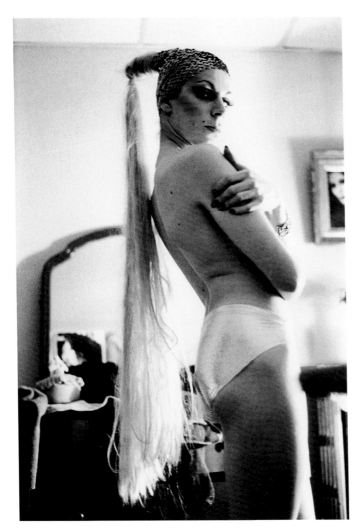

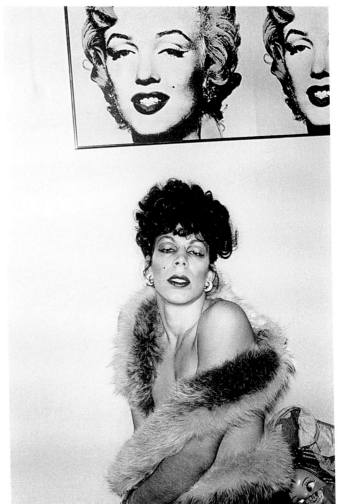

Page 100: *Naomi and Marlene on the balcony, Boston, 1972*; page 101, left to right: *Ivy wearing a fall, Boston, 1973; Ivy with Marilyn, Boston, 1973*

101

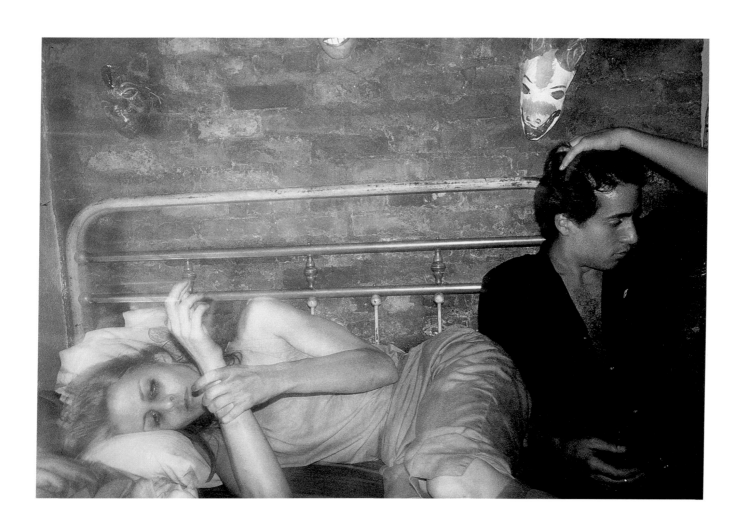

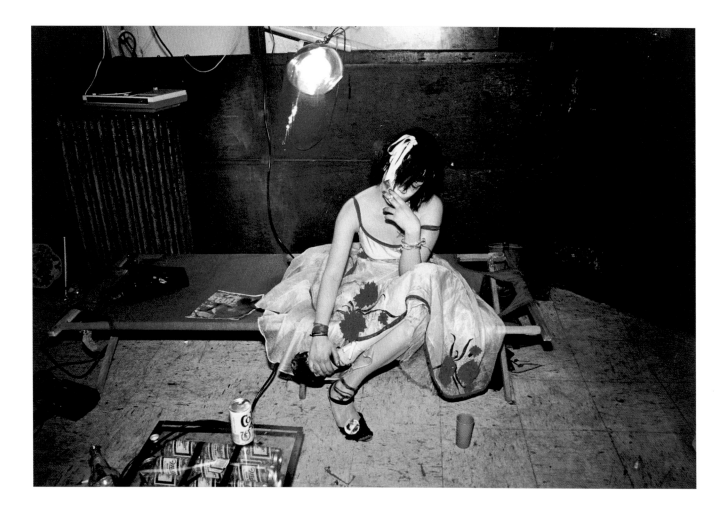

Greer and Robert on the bed, NYC, 1982; Trixie on the cot, NYC, 1979

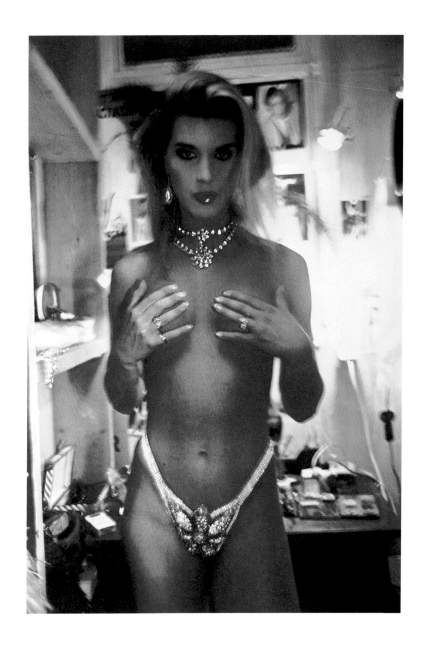

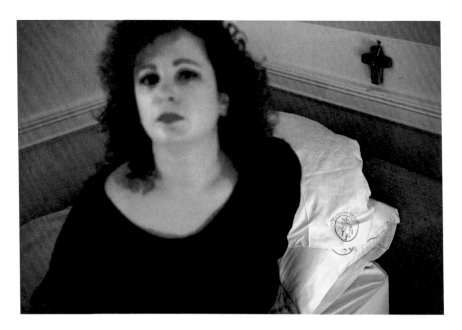

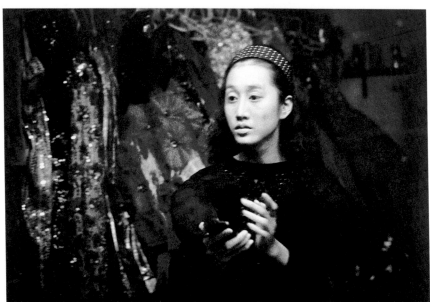

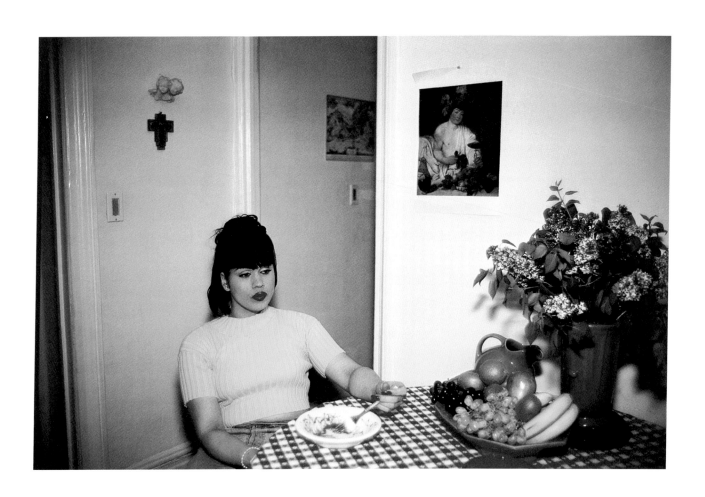

Gina at Bruce's dinner party, NYC, 1991; Vivienne in the green dress, NYC, 1980

DOUGLAS GORDON

b. 1966
Glasgow

The work of Douglas Gordon revolves around a constellation of dualities and dialectics. Mistaken identities, doubles, split personalities, and such opposites as good and evil, and self and other are thematized as inseparable. Gordon's films, video installations, photographs, and texts transform differences into uncanny, nuanced pairs.

Gordon approaches film as ready-made or found object, mining the potential collective memory that exists in cinematic fragments, and in the process, disclosing unseen or overlooked details and associations. His installation *through a looking glass* (1999) features the well-known scene from Martin Scorsese's 1976 film *Taxi Driver* in which Travis Bickle, played by Robert De Niro, asks, "You talkin' to me?" while gazing into a mirror. In Douglas's piece, the scene is projected onto dual screens placed on opposite walls of a gallery space. The original episode from the movie, filmed as a reflection in the mirror, is shown on one wall. The other screen displays the same episode with the image reversed, flipped left to right. The two facing images, which begin in sync, progressively fall out of step, echoing the character's loss of control and his mental breakdown. These discordant projected images seem to respond to one another, thus trapping the viewer in the crossfire. In its almost dizzying play of dualities, *through a looking glass* perfectly articulates the dialectical inversions, doublings, and repetitions that are the central concerns of Gordon's work.

Gordon also uses still photography to capture performative acts, as in *Tattoo (for Reflection)* (1997). In accordance with Gordon's instructions, the writer Oscar van den Boogaard had the word "guilty" tattooed in reverse on the back of his left shoulder; the tattoo can only be read via its reflection in a mirror. Gordon revels in the mixed messages found in the tattoo's various cultural associations, from its use as an identifying mark on prisoners to its current incarnation as a subculture status symbol. In true Gordonian, reflexive fashion—with the word legible on van den Boogaard's back only when reversed—the photograph becomes an index of an index.

Tattoo (for Reflection), 1997

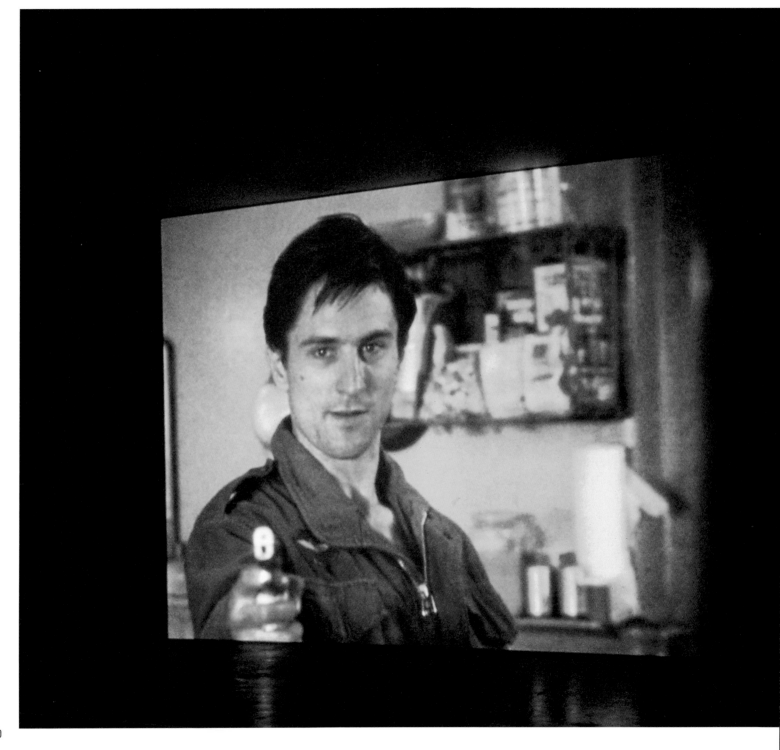

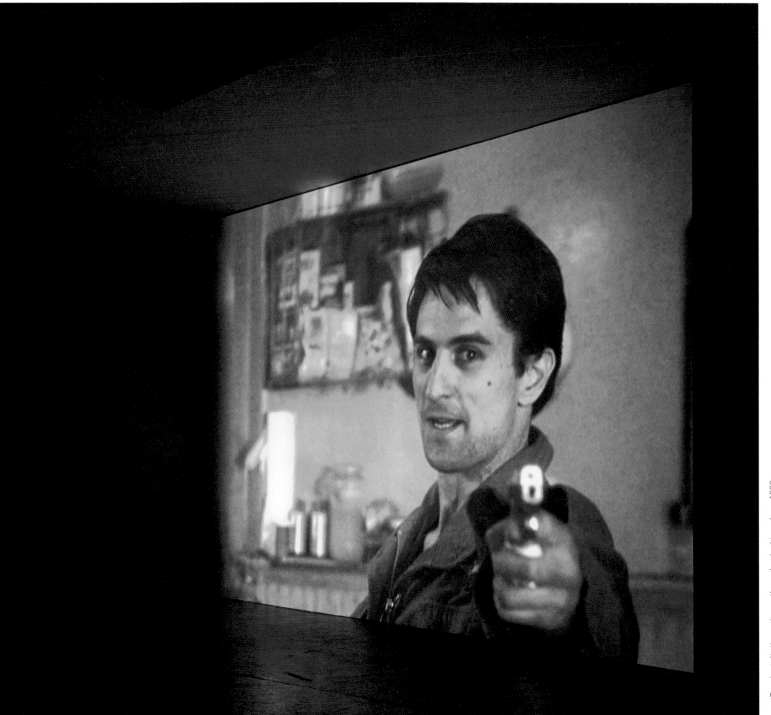

Two installations views, *through a looking glass*, 1999

111

KATY GRANNAN

b. 1969
Arlington, Massachusetts

Katy Grannan relies on documentary photography as a point of reference in order to merge reality and fiction, while capturing the subtleties of her sitters' psychologies. To find subjects for her often unsettling photographs, Grannan has sought ordinary, nonprofessional models. In places such as upstate New York and Wisconsin, she placed a classified ad in local newspapers: "Art models. Artist/photographer (female) seeks people for portraits. No experience necessary. Leave msg." The ad yielded two series of photographs, *Dream America* (2000) and *The Poughkeepsie Journal* (1998–99). Grannan's subjects posed for her in their own nonspecific, suburban American homes, complete with banal, often dingy furnishings and shopping-mall-purchased accessories. After arriving with only a fan, a light, and a camera, Grannan altered these settings by moving furniture and selecting a few "props" from around the house; sometimes people were photographed with their pets. Her process was swift and spontaneous—each portrait was completed within a period of three hours.

Although people of varying ages replied to Grannan's ad, including couples and women who posed with their children, most of the images in *The Poughkeepsie Journal* depict young women in their late teens and early twenties, many photographed at their parents' homes. Often they are clad only in underwear or completely nude, shown in varying degrees of modesty and exposure. Grannan captures their desire to appeal to and entice viewers (including themselves and the photographer) while also eliciting a certain melancholy. As the figures of *The Poughkeepsie Journal* pose uneasily in their bedrooms and living rooms, they are captivatingly present, and indeed, what Grannan captures is the seductiveness of being photographed. These young women seem to be making a poignant effort to achieve a kind of sexiness, glamour, or independence that might transport them, if only momentarily, from the confines of their ordinary lives.

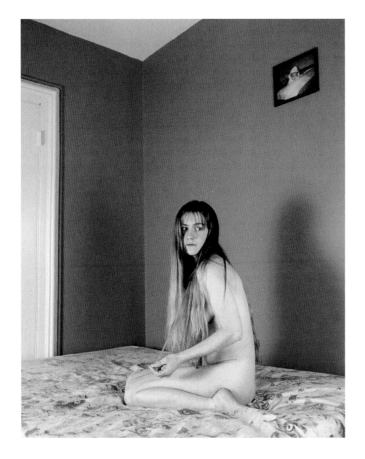
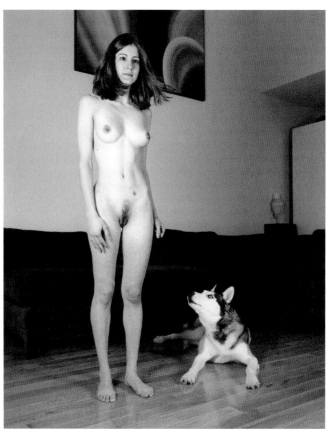

ANDREAS GURSKY

b. 1955
Düsseldorf

Andreas Gursky's photographic vision is obsessively precise. He digitally manipulates his images—combining discrete views of the same situation, deleting extraneous details, enhancing colors—to tease an eccentric geometry out of each of his subjects. He reorders the world according to his own visual logic, accumulating myriad details to present a sense of harmonic coherence. In *Library* (1999), Gursky converts the Stockholm public library into a perfect hemisphere of color-coded books by removing the library's floor, which, in reality, includes an escalator that would have interfered with the symmetry of the image. This tendency to pick and choose elements from reality places Gursky's project somewhere between photographic documentation (what the camera *records*) and painting (what the artist *extracts*). His work evolved out of the tradition of German documentary photography that runs from August Sander's typologies of workers through Bernd and Hilla Becher's comparative records of outmoded architectural structures. Gursky studied under the Bechers at the Kunstakademie Düsseldorf alongside future photographers Candida Höfer and Thomas Ruff, but he has since left the pretense of objectivity behind.

The elimination of certain details frees Gursky's images from being bound to their locations while it strengthens their formal affinities with each other. Large in scale and brilliantly lit, his color photographs emulate the physicality of oil on canvas. His pictures may be described as modern-day versions of classical history painting in that they reproduce the collective mythologies that fuel contemporary culture: travel and leisure (sporting events, clubs, airports, hotel interiors, art galleries), finance (stock exchanges, sites of commerce), material production (factories, production lines), and information (libraries, book pages, data). Amid the massive and overwhelming networks that define the postmodern condition, however, the individual is lost. People in Gursky's images are dwarfed either by the enormous, frenetic crowds in which they subsist, or by the monumentality of architectural or natural settings. Fully integrated into their given system, people become just another of that system's formal elements. In *Singapore Stock Exchange* (1997), the image is digitally altered so that the traders all wear the same red, yellow, or blue jacket—an aestheticization of competitive activity itself. Gursky's ambivalence toward the superstructures of contemporary life oscillates between the startling beauty of his images and their profound loneliness; ultimately, it registers as fascination.

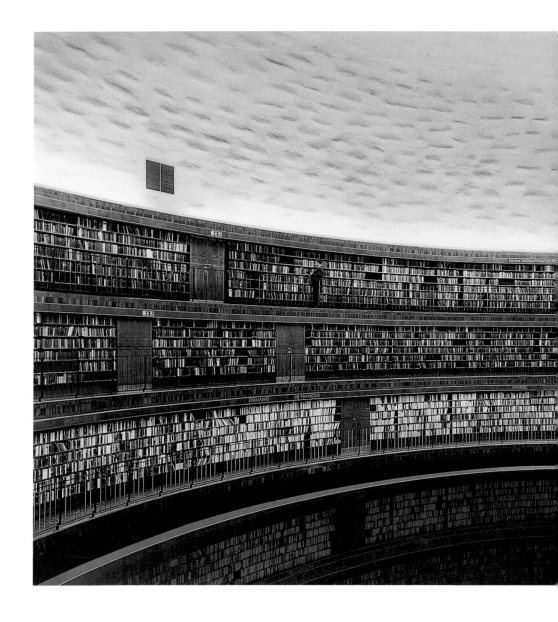

ANN HAMILTON

b. 1956
Lima, Ohio

Ann Hamilton is best known for large-scale installations laden with richly sedimented layers of meaning. These mesmerizing and often inscrutable works, which are frequently placed outside traditional museum spaces, deploy unconventional materials as a way to elicit sensory responses and to obliquely reference historical and cultural meanings derived from the artist's studies of a particular site. Her repertoire of materials has included several tons of horsehair, thousands of honey-coated pennies, beetle-infested turkey carcasses, and hundreds of pounds of work uniforms. Typically, a lone individual intently engaged in a repetitive task—burning words from a book, wringing his or her hands in honey, or unraveling a length of fabric—inhabits her environments, lending the intimacy of human touch.

Hamilton thus translates intellectual and social constructs into corporeal impulses, building up a collage of metaphors that speak to the conditions of lived experience as well as to the history of a particular place. With their allusions to experience, memory, and desire, her installations mine the intersection between the individual body and the social body. By emphasizing material presence and appealing to the senses, they suggest that knowledge is gained both corporeally and intellectually. This notion is also conveyed by the works' scale, which transforms the traditional relationship between viewer and object by literally bringing the viewer into the physical space of the artwork.

Hamilton's work foregrounds sensory experience and evokes memories that are rooted in the body, operating in a seemingly prelinguistic or entirely nonverbal realm. Her videos—originally components of larger installations—convey visually what is experienced haptically. In each piece, an ordinary somatic function—speaking; hearing—which is nonetheless rooted in the intellect, is compromised and overwhelmed by a purely tactile sensation. Water runs down a neck in *untitled (dissections . . . they said it was an experiment)* (1988/1993), deluges an ear in *untitled (the capacity of absorption)* (1988/1993), and floods a mouth in *untitled (linings)* (1990/1993), while in *untitled (aleph)* (1992/1993), rocks fill a mouth that struggles to create speech. The only video that incorporates sound, *untitled (aleph)* takes its name from the shape the mouth forms in the transition between silence and speech. The visceral quality of Hamilton's installations is captured in concentrated form in these videos, which transfix the viewer with their intimate explorations of bodily experience.

118

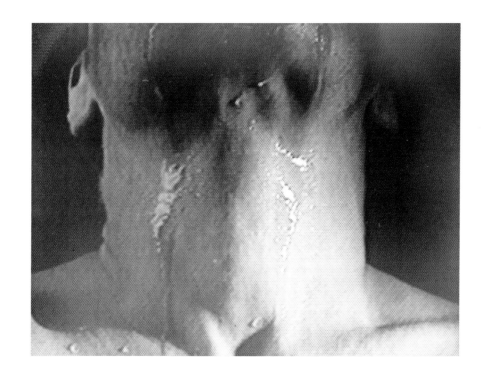

Still from untitled (dissections . . . they said it was an experiment), 1988/1993

Stills from *untitled (linings)*, 1990/1993; *untitled (the capapcity of absorption)*, 1988/1993; *untitled (aleph)*, 1992/1993

ANTHONY HERNANDEZ

b. 1947
Los Angeles

Clearly, *Pictures for Rome* (1998–99) are not the same as pictures *of* Rome: Anthony Hernandez's photographs make no reference to any of the many iconic landmarks of that ancient city. In fact, they make no reference to any city in particular, but focus instead on the discarded monuments of a generic consumerist metropolis, its modern ruins. In Hernandez's photographs, the troubling architectural skeletons, debris of abandoned buildings, and languishing unfinished projects of modern society are considered as urban relics. Whether chronicling an aborted commercial building or never-completed hospital, an empty housing complex or deserted classroom, His images document the ghosts of urban renewal—the failed projects and material disasters that are the less glamorous side of urban development.

This social emphasis resonates with his earlier project *Landscapes for the Homeless*, a series made largely in his hometown of Los Angeles, where he photographed "homes" tucked under freeways or in the corners of abandoned lots. People are not to be found, but signs of their presence imbue every scene. The same is true of *Pictures for Rome*; for example, in *Rome #1* graffiti marks two cobalt blue doors, and in *Rome #25* the outlines of posters that once decorated the walls haunt the now-vacant room. This focus on the formal and poetic qualities of interiors sometimes results in photographs that are visually disorienting; for example, in *Rome #17* what appears to be a series of receding rectangular concrete structures ending in ball-like objects suspended before a luminous glow is actually a view up an elevator shaft in an unfinished building. Hernandez's emphasis on a structure's formal allure invites us to enter the spaces in the photographs and imagine these unstable settings of abandon and dispossession. These modern-day Roman ruins are perhaps as enchanting as those of ancient Rome, but they are also disconcerting depictions of decay in our modern era of unprecedented material destruction and waste.

Top: *Rome #17, 1999*; bottom: *Rome #25, 1999*

123

CANDIDA HÖFER

b. 1944
Eberswalde, Germany

Candida Höfer began taking color photographs of interiors of public buildings, such as offices, banks, and waiting rooms, in 1979 while studying at the Kunstakademie Düsseldorf. Over the ensuing years, she has perfected her strategies for eliciting psychological undertones from her architectural subjects. In her stately photographs Höfer adopts a stance somewhere between detachment and direct involvement. While she does not aim for pure objectivity, as evidenced by her often slightly oblique camera angles, she remains at a certain distance, subtly observing and recording what she sees.

Although Höfer's pictures rarely include people, vestiges of human activity are often evoked or replaced by inanimate surrogates, like a line of empty chairs or a cluster of tables. She frequently photographs archival spaces where information is collected, dispersed, or displayed, such as museums and libraries. Her systematic portrayal of these locations creates another kind of archive. Seen together, Höfer's works address society's abiding need for classification and uniformity. In *Deichmanske Bibliothek Oslo II* (2000), a few figures inhabit the vast library, which is structured by a seemingly endless succession of books, a series of monumental columns, and the receding grid of the ceiling. The rigid geometry of the scene is not imposed through any kind of digital manipulation. Höfer's defining compositional choice is her point of view (in this case, as if floating from above), surveying the orderly arrangement of systems of knowledge. In reality one moves quickly through these ordinary rooms, unaware of their extraordinary geometry, but in her photographs it is given sustained attention.

PIERRE HUYGHE

b. 1962
Paris

Pierre Huyghe questions the very definitions of time, memory, and engagement in his numerous artistic endeavors, be they installations, photographs, site-specific works, or community projects. Often using film as his primary source material, he dislocates it from the cinematic space of the movie theater, and in his installations refashions it to extend the narrative space of the film through formal and conceptual strategies. Huyghe, for example, has restaged Alfred Hitchcock's *Rear Window* (1954) and inserted into Wim Wenders's *The American Friend* (1977) a scene only implied in the original editing. In *The Third Memory* (1999) he juxtaposes Hollywood's fictionalized *Dog Day Afternoon* (Sidney Lumet, 1975) with an account of the true event of the bank robbery it was based on as related by the burglar himself. Huyghe's work implies that in our media-saturated culture psychological and cinematic projections blur, and events in lived experience inextricably merge with televisual experience to produce a kind of "third memory."

Expansive terrains in which memories, scenes, and their significance can be inserted, Huyghe's projects allow for infinite points of entry and mutations of meaning. *One Million Kingdoms* (2001) is the most recent in a series of animated films in which a Japanese *anime* character, the brooding young girl AnnLee, is inserted into various dramas. Here she is dropped into a lunar landscape that is mapped out and developed in correspondence with the rises and falls of the narrator's voice—tinny, at times labored—digitally derived from a recording of Neil Armstrong. The stories of the first moon landing, in 1969, and of Jules Verne's 1864 novel *Journey to the Center of the Earth* have been conflated here in a conspiracy theory of the faked and the fantastic. Armstrong's first words, "It's a lie," prompt AnnLee, as she moves from place to place on a constantly fluctuating terrain, in which mountains, craters, ridges, and outcroppings rise and fall according to the intonations of the narrator's voice. His words blur the fictional and factual, using language that derives from distinct genres and centuries—Verne's work of fiction and Armstrong's and Buzz Aldrin's presumably true transmissions of their experience during the landing of *Apollo 11*'s lunar module. Thus the landscape of AnnLee is a shifting terrain determined by utterances, which chart both the real and the imaginary.

WILLIAM KENTRIDGE

b. 1955
Johannesburg

In 1989 Johannesburg-based artist William Kentridge began creating his series of hand-drawn films that focus on apartheid- and postapartheid-era South Africa through the lens of two fictive white characters, the pensively reflective Felix Teitlebaum and the aggressive industrialist Soho Eckstein, who can be seen as alter egos. Kentridge's animated films are composed from his charcoal and pastel drawings, which he vigorously reworks, leaving traces of erasure, redrawing, and often highly visible pentimenti. Two key works in this series are *Felix in Exile* (1994) and *History of the Main Complaint* (1996). Made just before the African National Congress's landmark election to power, *Felix in Exile* is a richly nuanced exploration of the landscape as witness, wherein memories of the devastatingly violent rule of apartheid and the struggle against it are rendered visible to Felix through the gaze of Nandi, a black South African woman who surveys the land. Kentridge created *History of the Main Complaint* around the time the Truth and Reconciliation Commission began meeting to publicly examine apartheid-era human-rights abuses and other crimes in an effort to unearth truth and move beyond the wrongs of the past. In the film, X rays and CAT scans probe beneath the surface of a comatose Soho, revealing violent acts committed against black South Africans. It is only through Soho's acknowledgment of his responsibility that he can be roused back into consciousness.

Kentridge is also renowned for his theater-based work, including his collaborations with the Handspring Puppet Company, in which complex multimedia performances combine puppets, animation, projection, and live action. In his performance-based pieces as well as his video sculptures and hand-drawn films, Kentridge's inclusion of both the hand of the puppeteer, as well as traces and erasures of his drawings allude to a multilayered and complex notion of history and narrative crafting, in which it is revealed how much the actor is acted upon and how notions of agency are called into question.

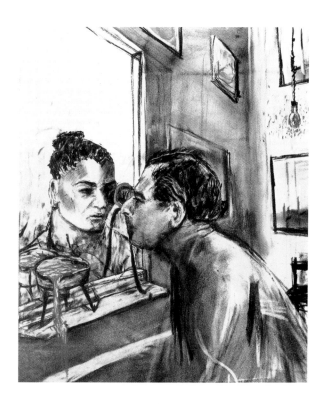

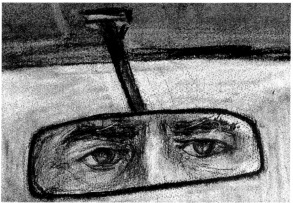

GLENN LIGON

b. 1960
Bronx, New York

In his most well-known body of work, made in the early 1990s, Glenn Ligon painted door-sized canvases white and then stenciled across and down them black text appropriated from such influential authors as James Baldwin, Ralph Ellison, and Zora Neale Hurston. These phrases, such as "How it feels to be colored me"—not an emphatic statement, but an endlessly open question—are repeated until the stenciling blurs into illegibility. This and the removal of the text from its original literary context wonderfully complicate both language and meaning. Foregrounding race and sexuality, Ligon's work is primarily concerned with the construction of black identity as it is articulated through words and images.

In 1986, Robert Mapplethorpe published *The Black Book*, a selection of his many idealized and homoerotic nude photographs of black men. The book incited a range of responses, from appreciative identification to moral outrage, from distant ambivalence to personal embarrassment. Ligon, too, responded to the book, scrawling his reactions to each image on the pages of his copy. Realizing that he wanted to sort out the effect these images of black masculinity had on him as well as on others, he conceived of *Notes on the Margin of the Black Book* (1991–93). Maintaining Mapplethorpe's original order, Ligon installed framed pages from *The Black Book* along the wall in two rows, inserting between them small framed typed texts by diverse sources, including philosophers, activists, curators, historians, and religious evangelists. These seventy-odd texts, some written specifically about Mapplethorpe's images, others not, suggest a variety of interpretations while also foregrounding the various fears and fantasies projected onto these black male nudes, as the quote from Baldwin makes clear: "What one's imagination makes of other people is dictated, of course, by the laws of one's own personality and it is one of the ironies of black-white relations that, by means of what the white man imagines the black man to be, the black man is enabled to know who the white man is." In *Notes*, as in all of Ligon's work, sex, race, and desire cannot be disentangled, and questions are raised about the complex nature of the self and its relation to culture.

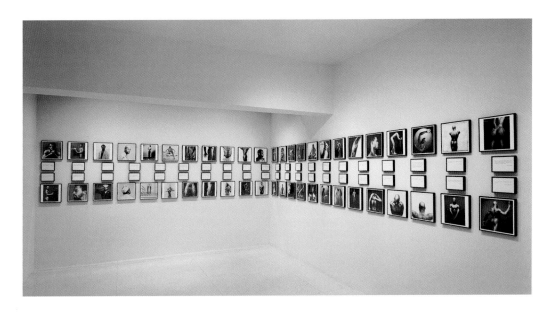

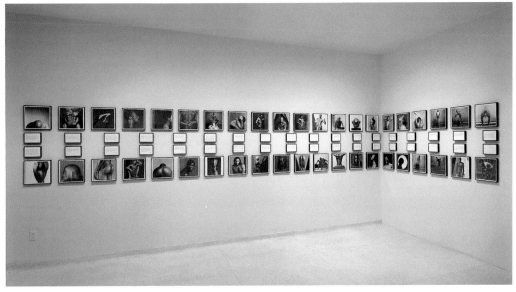

IÑIGO MANGLANO-OVALLE

b. 1961
Madrid

Iñigo Manglano-Ovalle has created a diverse body of work that comprises installation-based practices, photography, sculpture, and community-based projects. Filtering his subject matter through the lens of modernity, he explores a broad range of issues—such as representation and identity, new technologies, and structures of power—and simultaneously reexamines modernist theories and strategies. Manglano-Ovalle mines the often detached, cool logic of modernism and abstract formalism in order to reach a more expansive and inclusive treatment of social and individual realities. Seemingly neutral and clinical realms of science, such as climatology and genomic mapping, are problematized and engaged as form and content in his work. The assumptions of those fields and their implications in creating or reifying social hierarchies slowly and subtly emerge in the artist's ambitious projects.

The video installation *Climate* (2000) has a tripartite structure—in both narrative and form—and reflects Manglano-Ovalle's interest in exploring simultaneity. The piece also demonstrates his insistence on drawing viewers in to engage directly, and thus be implicated in, the space of the installation rather than simply interacting as contemplative onlookers. The three separate videos in *Climate* were filmed in Ludwig Mies van der Rohe's sleekly modernist Lake Shore Drive Apartments (1949–51) in Chicago, and examine the assumptions of International Style architecture within the framework of today's increasingly globalized society. In this work, surveillance technology, assault weapons, and people waiting suggest a chilling world without boundaries in which nature has been dominated by a sterile, detached precision.

The DNA portraits by Manglano-Ovalle engage the formalist arguments of modernist art critic Clement Greenberg and the aesthetics of the post-painterly abstraction he championed. Manglano-Ovalle's seemingly abstract color print *Glenn, Dario, and Tyrone* (from *The Garden of Delights* [1998]), is in fact a photograph of three individuals' DNA samples. For the series, the artist asked sixteen individuals to take part, each selecting two others with whom he or she would like to be represented in a triptych portrait. With this introduction of self-determination, Manglano-Ovalle allowed his participants to create and define their own network of relationships and make choices about the representation of "family."

Manglano-Ovalle's engagement with issues of typology, genealogy, and racial makeup extend beyond the recent issues that DNA technologies have raised, taking in part his inspiration from Hieronymus Bosch's painting *The Garden of Earthly Delights* (1505–10), and the fantastic grotesqueries that emerged from Bosch's imaginary mixed couplings. Manglano-Ovalle was also interested in these issues as they are represented in Spanish colonial *casta* (caste) paintings. A taxonomy of the racial mixing of Spaniards, Indians, and Africans, the *casta* paintings were meant to impose a hierarchy of race and class in a rapidly hybridizing New World. Manglano-Ovalle problematizes issues of representation, objectification, and social control in his contemporary portraits.

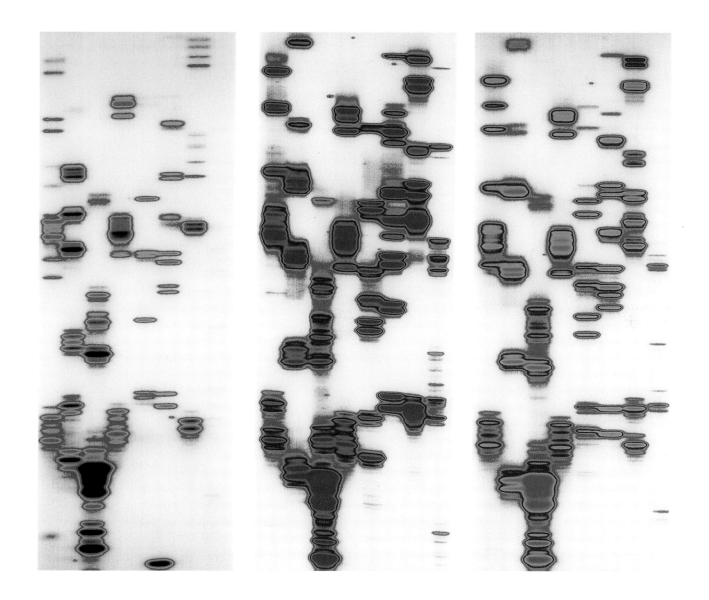

Glenn, Dario, and Tyrone (from The Garden of Delights), 1998

133

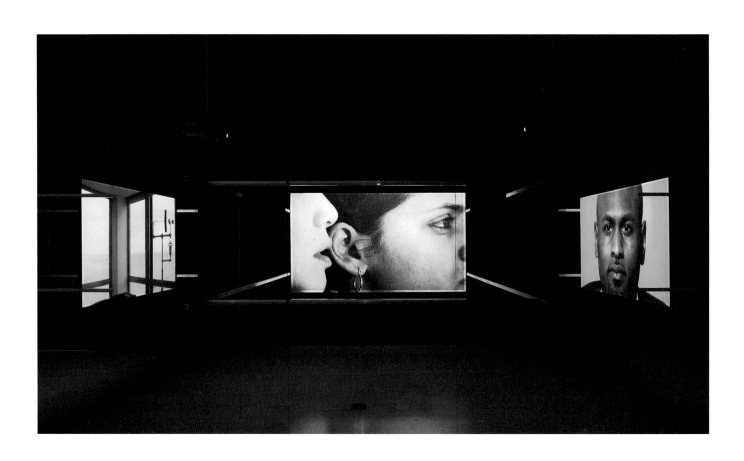

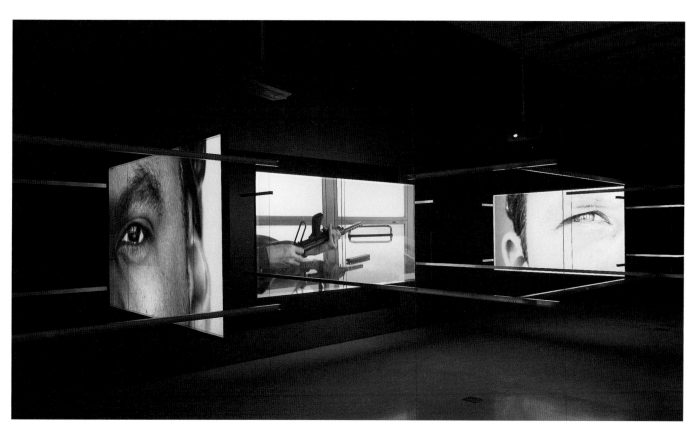

ANNETTE MESSAGER

b. 1943
Berck, France

Annette Messager embarked on her artistic career amid the tumultuous climate surrounding the May 1968 student uprisings in Paris. It was in this atmosphere of radicalism that she discovered that art could be found in the streets and in the tasks of everyday life, rather than solely within the cloistered realm of the museum. Some of her early pieces—such as *Boarders at Rest* (1971–72), in which she clothed dozens of embalmed sparrows in tiny hand-knit sweaters, and *My Collection of Proverbs* (1974), a selection of mostly misogynistic phrases about women hastily embroidered on unhemmed squares of cloth—use modest materials and techniques commonly associated with domesticity and often devalued as "women's work." Her nostalgia-laden gestures belie the subversive messages of social concern in her art, in which the conflict between nature and civilization and the lack of sexual equality in society are recurrent themes.

My Vows, a series begun in 1988, hovers between photography and sculpture. The works consist of numerous small black-and-white photographs of the human anatomy, often clustered in dense groupings, each print hung tenuously from the wall by a single, simple string. The body parts depicted in the photographs—from a calloused toe to an ankle to the close-up image of a breast—belong to men and women of all ages and types. Together the photographs form an inclusive representation of humanity that is equally old and young, masculine and feminine, sensual and base, and often simultaneously humorous and poignant. Ultimately, they reflect an understanding of humanity that is not categorized by physical difference. *My Vows* may also be understood in relation to Messager's Catholic heritage; the work resembles the assembled votive offerings left at pilgrimage sites by the faithful, which often include accumulations of handwritten notes or miniatures of ailing limbs for which cures are being sought. The work's solemn reference is characteristic of the tension between lyricism and gravity that often informs Messager's art.

My Vows, 1990

MARIKO MORI

b. 1967
Tokyo

Mariko Mori's photographs, videos, and installations draw on imagery from Japanese pop culture and Eastern religion, all infused with a dose of cybernetic hybridity culled from science fiction fantasies. Mori, a former model, is the creator, star, and artistic director of these elaborate, futuristic scenes. In her early performative works like *Play With Me*, *Tea Ceremony*, and *Subway* (all 1994), in which she rides the Tokyo subway wearing a headset and shiny silver minidress, Mori appears as a robotic pixie who ostentatiously inserts herself into everyday Japanese society. In the 1996 video *Miko no Inori*, a silver-eyed, blonde cyborg (Mori) caresses a shining glass sphere, which is hollow and beautiful, like fashion itself. Her characters parody cultural standards of femininity, presenting it as a form of automatism and inseparable from consumerism. But a deep ambiguity runs through Mori's critique, suggesting that perhaps her personae have been sent as ideal fulfillments of these systems' machinations.

In more recent works, Mori has turned away from such investigations of the feminine toward something more mystical. Rather than appearing as a cartoonish robot girl on the streets of Tokyo, the artist now imagines herself as a floating bodhisattva or a goddess hovering above a lotus flower, flanked by doll-like aliens. Large-scale photographs like *Burning Desire* and *Mirror of Water* (both 1996–98), *Entropy of Love* (1996), and *Pureland* (1997) are reinterpretations of ancient Eastern religious beliefs and mysticisms for the computer age. In these images, Mori the pop star ascends to the level of deity, leading viewers to a state of techno-nirvana. Her recent installation projects, *Dream Temple* (1999) and *Wave UFO* (2002), bring to life the imaginary realms depicted in her photographs. Each consists of an elaborate structure—a Buddhist temple in one, a tear-shaped spacecraft in the other—that viewers enter and in which they view projected video images. These works act as hybrid temple vessels that deliver her audience into a beatific alternate realm. Mori's utopian dreamscapes offer a hallucinatory vision of the future, blurring distinctions between technology and mysticism—the dual poles of society's salvation.

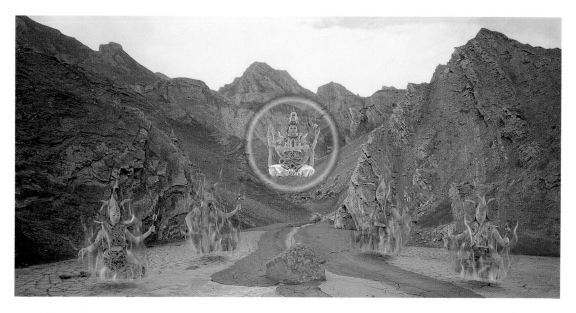

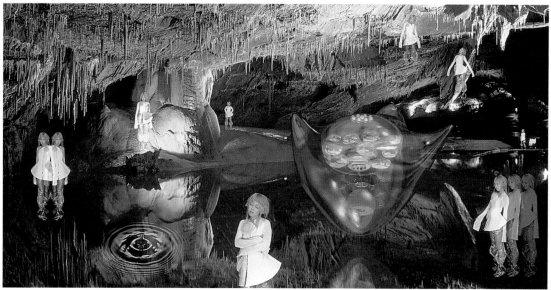

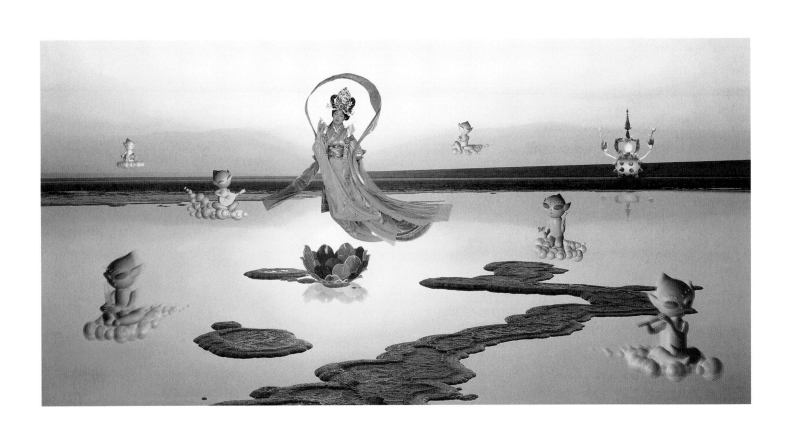

Pureland, 1997; Entropy of Love, 1996

SHIRIN NESHAT

b. 1957
Qazvin, Iran

An Iranian-born artist who has lived in the United States since 1974, Shirin Neshat portrays the emotional space of exile in her photographs and films. She questions the role of women in Islamic society, recognizing the tensions between a collective cultural identity and one driven by individual concerns. Neshat uses the chador, the head-to-toe covering that is mandatory for women in Iran, as an icon for repression and female identity. *Passage* (2001) was commissioned by composer Philip Glass, whose orchestration rhythmically underscores the ritualized movements of the funerary preparations and procession that are the film's subjects. While earlier works such as *Turbulence* (1998) and *Rapture* (1999) address gender roles and the proscribed interaction between the sexes in Iranian culture, *Passage* stems from more philosophical and universal roots. Inspired in part by the countless funerals broadcast on television news programs during the Israeli-Palestinian conflict, Neshat was struck by the haunting images of groups of men carrying corpses; these evoked memories of the many funerals she witnessed in Iran during its war with Iraq. Filmed in Morocco, *Passage*'s panoramic shots of the vast landscape provide an epic backdrop for the two throngs preparing the funeral: men carry a shrouded corpse across sand dunes, and chador-covered women dig a grave with their hands as a young girl plays with stones nearby. Eventually, the actions of the men and women move from the ritual to the elemental as repetitive movements give rise to dust, sticks, stones, and fire, which form a metaphoric circle of life, death, and the hope of renewal.

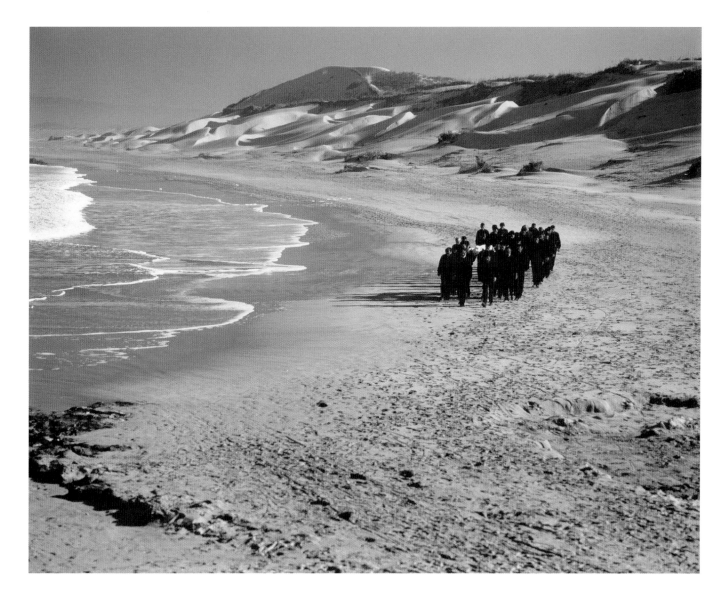

RIKA NOGUCHI

b. 1971
Tokyo

Rika Noguchi has photographed varied locations, from New York, Miami, and Amsterdam to Mount Fuji and elsewhere in her native Japan, primarily creating a series of seascapes, verdant or industrial landscapes, as well as views of construction and urban sites. With their straightforward formal structure and seemingly ordinary subject matter, her pictures are deceptively simple. When considered as a whole, Noguchi's oeuvre is a sustained consideration of the intersection of the man-made and the natural. Her series *Dreaming of Babylon* (1998–2000) is part of that meditation and also of her larger narrative concerning human existence in the physical world. Some of the images include a human figure, as in the lone individual walking down a dusty road in *Dreaming of Babylon 12*. Even when the views are devoid of people, a human presence is suggested through its absence or through traces of the man-made, such as the small structure nestled amid the trees in *Dreaming of Babylon 15*.

The atmospheric light in Noguchi's images is reminiscent of the illumination in nineteenth-century-landscape paintings, many of which are imbued with spiritual connotations. Her work particularly recalls that of early-nineteenth-century German Romantic painter Caspar David Friedrich, who often portrayed a single figure against the ocean or a vista from a high cliff to suggest a force greater than mere humanity. In Noguchi's work such associations are most fully articulated in her series *A Prime* (1998–99), which comprises sunrise views taken from Mount Fuji, a sacred symbol of Japanese national identity. Her meticulously composed images are not digitally manipulated, like so much work of her contemporaries. Rather, she searches for what she calls "a moment of truth" that conveys universal resonance.

Dreaming of Babylon 12, 1999–2000; Dreaming of Babylon 16, 1999–2000; Dreaming of Babylon 15, 1999–2000

CATHERINE OPIE

b. 1961
Sandusky, Ohio

Catherine Opie counts such documentary photographers as Eugene Atget, August Sander, Berenice Abbott, Walker Evans, Lewis Hine, and Dorothea Lange among her greatest historical influences. In fact, she described herself in a 1994 *Los Angeles Times* article as a "kind of twisted social documentary photographer." Long before earning her MFA at the California Institute of the Arts in 1988, she found that photography was perfectly suited to her drive to describe the world and people around her—a drive that unifies all her projects to date, whether focused on gender and sexual identities, notions of community, or the myth of the American dream.

Opie's first well-known series, *Being and Having* (1991), consists of headshots of Opie's female friends sporting false facial hair to suggest the fluidity and complexity of gender. She followed this in the mid-1990s with the *Portraits* series, in which she photographed transgender women and men, drag queens, and leather dykes with great solemnity and formality, thereby using historical norms of studio portraiture to upend heterosexual norms of identity and sexuality. Although for many viewers these subjects represent the exotic "other," Opie's photographs visually resist such simplistic voyeurism through their controlled composition, regal poses, and lush studio backdrops.

Throughout her career, Opie has photographed the landscape around her with the same dignity and elegance, capturing the arc of a deserted strip of freeway or the commonplace stretch of a mini-mall in Los Angeles. Each photograph retains the trace of a human presence, suggesting that the space need only be repopulated to serve its purpose, to ward off decay. In 1998, Opie traveled cross-country in her motor home for two months in order to photograph lesbian couples. This series, called *Domestic*—of which *Melissa & Lake, Durham, North Carolina* is an example—presents these couples involved in everyday, household activities: relaxing in their backyard, hanging out in their kitchen, playing with their children. There is no sensationalism here. Much like the formal studio portraits before them, these intimate photographs speak both to Opie's identification with her subjects and to the overwhelming absence of such images in mainstream representations.

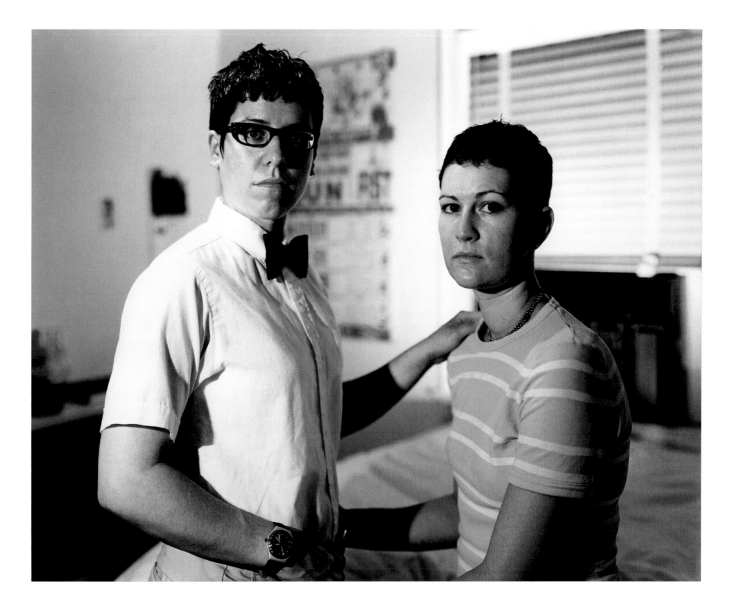

Melissa & Lake, Durham, North Carolina, 1998

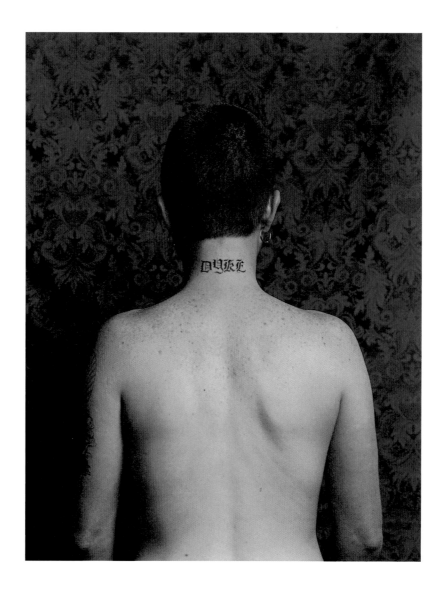

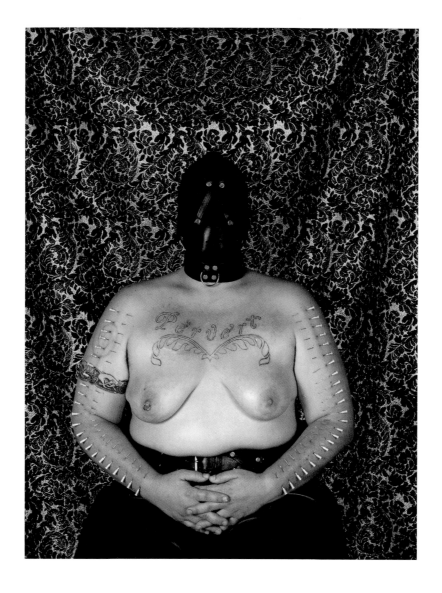

Dyke, 1993; Self-Portrait/Pervert, 1994

GABRIEL OROZCO

b. 1962
Jalapa, Mexico

Gabriel Orozco's multimedia works are philosophical investigations of form, medium, and installation. In his own exhibitions, he often employs sculpture, drawing, photography, installation, and video and recycles older work into sometimes new mediums and contexts. The readymade is central to Orozco's process. He frequently manipulates what he discovers by arranging found materials (a deflated soccer ball, cans of cat food, simple planks of wood) and photographing his constructions. Sometimes he transforms the ordinary just by suggesting a form in a seemingly banal image, as in *Pulpo* (*Octopus*, 1991), which bestows meaning on a tangle of pipes. Here the readymade is not so much a thing found as a dynamic and poetic interaction between artist and object.

Orozco plays photography and sculpture off against one another to create compelling hybrids in the service of his interest in the "lightening of mass." This involves streamlining or hollowing out objects that at first appear heavy and cumbersome, as in the sculpture *La DS* (1993, pronounced like *la déesse*, French for goddess), a trisected Citröen automobile seamlessly reassembled without the middle section. In *Dos Parejas* (*Two Couples*, 1990), heavy industrial objects are playfully anthropomorphized by their title as their sculptural mass is negated through photographic reproduction. In *Photogravity* (1999), Orozco mounted large versions of his old photographs on spindly legs to produce a sort of two-dimensional sculpture. He uses one medium to expose another's limits: photography can strip sculpture of its mass, but it always lacks the real thing that it pictures.

Orozco's photographs document chance encounters with sites and objects in his native Mexico and other locations around the world, including Brazil, Germany, Iceland, India, and New York. "I'm looking for different kinds of contexts . . . I want to make something in a very clean, white space. Then I want to get outside . . . I grew up in museums, but I also grew up in the streets." Acutely attentive to the various receptions his work engenders in different locations, he seeks to make his viewers aware of their own cultural boundedness. His work ultimately promotes "deterritorialization," within which a multiplicity of viewpoints is recognized and none can take precedence. *Pelota en agua* (*Ball on Water*, 1994) first appears to be a photograph of a cloud-streaked sky, but turns out to be a reflection captured in a puddle, evidenced by a half-submerged ball. This conflation of sky and earth, lofty and lowly, is emblematic of Orozco's attempt to bridge the distance between oppositional themes and sites.

Pelota en agua (Ball on Water), 1994

153

Parachute in Iceland (Eastl, 1996; Nike Town, 1998

Mi oficina II (My Office II), 1992; Pulpo (Octopus), 1991

Comedor Blanco (White Dining Room), 1998; *Comedor en Tepoztlán (Dining Room in Tepoztlán),* 1995

JOHN PILSON

b. 1968
New York City

John Pilson's video and photography work explores corporate space, linking the ordered logic of the grid and line of modernism and Minimalism to the rigid grids and lines of the cityscape and the office. In his sparsely populated scenes, anonymous work spaces appear largely devoid of employees to animate them, which underscores the cold, impersonal nature of the corporate environment. What is ubiquitous is the cubicle; with its false walls and false nods toward privacy and permanence, the disposable architecture seemingly conveys a not-so-subtle message to its potentially disposable occupants. Like filmmakers Charlie Chaplin and Jacques Tati, Pilson conveys an absurdist sense of modern working life, but updates his predecessors' themes with a contemporary sense of alienation from one's white-collar labor.

In the multi-channel video installation *À la claire fontaine* (2000), a young girl achieves fleeting moments of self-expression against the backdrop of a cold, empty, and distant modernist landscape. Pressed up against the glass of a high-rise office, she exhales onto the window and then draws with her finger into the fog, singing to herself "À la claire fontaine," a French song about loss and longing. On a different channel we see this girl perched in a potted tree, looking down onto the cityscape from the height of the towering office building. However, the notion of scale is rendered as absurd as the attempt to naturalize such spaces with the introduction of living plants, uprooted from their natural context.

In yet another channel a frustrated desire for real relationships and rapports turns into an aggressive yet illogical confrontation, as a worker in an office mailroom is pelted with rubber balls. On another monitor we watch blurred legs running rapidly back and forth against a bare office wall. The urgent repetition suggests a yearning for purpose, as meaningful action in these workplace settings seems elusive.

Equally, the workplace's standard indicators fail to convey real meaning. In another scene from *À la claire fontaine* an electronic stock index runs a seemingly indecipherable code of signs and numbers over a densely jumbled yet empty trading floor. Another shot is fixed on two phones on a credenza; we wait expectantly for them to ring, but they never do. Frustrated expectations for communication abound; the tools are there, but the meanings and messages are lacking. In Pilson's corporate scenes, the work environments are at once spare, slick, and unkempt. Although files, boxes, and storage systems abound, there seems to be little of substance to fill them. Ironically, the spaces in which workers find themselves spending greater and greater percentages of their lives retain nary a trace of their inhabitants.

Stills from *À la claire fontaine*, 2000

161

PIPILOTTI RIST

b. 1962
Rheintal, Switzerland

Since the late 1980s, Pipilotti Rist has produced both large-scale, multi-channel video projections and more intimate video pieces. The hypnotic, often enchanting worlds she creates are inflected by haunting sound tracks and erratic pacing and feature emblematic female subjects who appear at once coquettish and rebellious. A young woman in a little black dress creates a frenzied spectacle in an early work, *I'm Not the Girl Who Misses Much* (1986). In *Ever is Over All* (1997), a modern-day fable, a woman strolls down the street, swinging a large flower that strikes parked cars and, to her delight, shatters their windows. In *Sip My Ocean* (1996), the onset of disillusionment in love darkens an aquatic, utopian world. The video is projected in duplicate as mirrored reflections on two adjoining walls, with the corner between them an immobile seam around which psychedelic configurations radiate and swirl. A bikini-clad woman is seen intermittently frolicking underwater, her obvious pleasure and sense of self-containment is transmitted to the viewer as part of a mesmerizing narrative about longing, desire, and dreams of fulfillment. Choreographed to a sound track of the artist alternatively crooning and hysterically shrieking Chris Isaak's song "Wicked Game," *Sip My Ocean* disturbs as much as it seduces, leaving one to wonder if there might be trouble in this aquatic paradise. Desire, after all, always demands an "other," one who may or may not yield to the embrace.

To make strange the viewing experience, Rist often installs her projections in awkward or unusual spaces—squeezing imagery between doors or the folds of a curtain, for instance, or projecting onto floors. In the kaleidoscopic *Atmosphere & Instinct* (1998), a childlike woman, clad in a Raggedy Ann–style dress and wig, is seen from a bird's-eye view and appears through the leafy treetops. Moving in and out of sight, past suburban homes, swimming pools, and lawn chairs, she looks up and waves her arms with the desire to be seen or perhaps to fly away; the work takes on a melancholic tone when that desire promises to be unfulfilled.

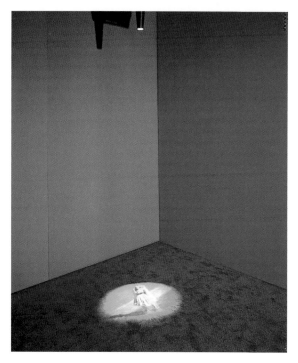

Installation view and still from *Atmosphere & Instinct*, 1998

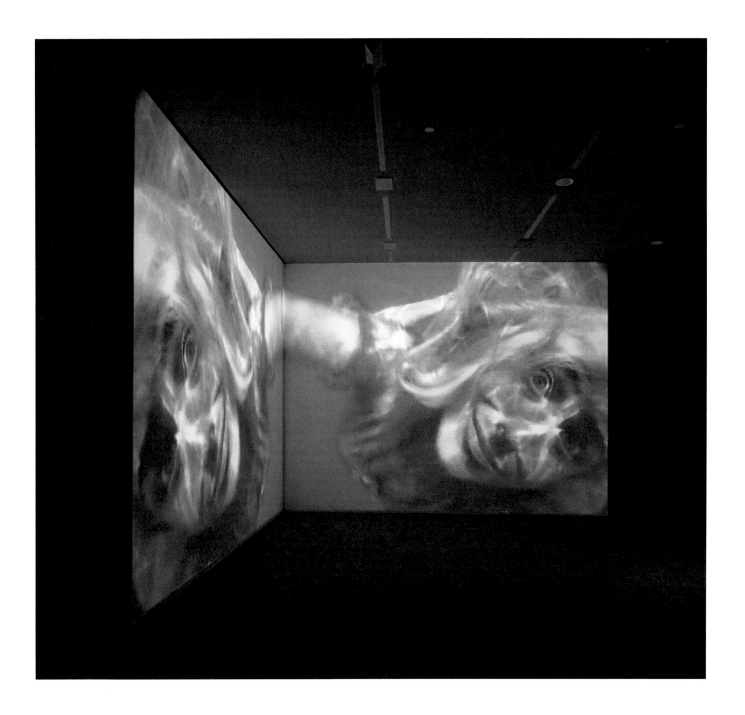

Installation views, *Sip My Ocean*, 1996

MICHAL ROVNER

b. 1957
Tel Aviv

Michal Rovner's photographic and video work reflects a geographically untethered sensibility that perhaps results from the artist's practice of dividing her time between Israel and New York. Using subject matter ranging from farmhouses in the Israeli countryside to broadcast images of the Gulf War, she reworks source material in a manner that recalls both the pictorialism of Edward Steichen and the digitized and manipulated imagery of more recent artists working with new photographic technologies. In Rovner's work, figuration and figure-ground relationships are destabilized, as she pushes the boundaries of representational art. Expanding the notion of a photograph as an index of the real, she seeks to create images that extend beyond the physical and temporal specificity of what is registered by the camera's lens. She instead searches for a more universal sense of truth while exploring notions of selfhood and autonomy. For Rovner it is critical that her point of departure be rooted in the empirical reality before the camera. She brings her own reflections and inflections to the image, reworking it in her studio until it functions as a document of a process—her own response to the initial subject matter and her creative activity—as opposed to a single moment in time.

For the series *One-Person Game Against Nature I* (1992), Rovner photographed a group of figures floating in the Red Sea in the dim light of dusk. Shooting from a high angle to eliminate the horizon line, she made two sets of images: one with a Polaroid SX-70 camera, the other with a video camera. Rovner then digitally manipulated the images and altered the color during the processing, so that the bodies would appear to hover in amorphous states. Details and context are thus eliminated from the resulting work, and the haunting, resonant imagery that emerges is suggestive of spiritual and metaphoric states. The series also takes as a conceptual conceit ideas from game theory, in which individuals engaged in a competitive situation—economic, political, military, or otherwise—determine an optimal strategy based on the assumed goals, actions, and reactions of the other participants. Here nature itself, or perhaps the human condition, is the challenger.

A more recent work, *China* (1995), is a suite of four highly evocative, blurred photographic images tinted a deep crimson, suggesting the merest hint of back- and foreground. The middle ground is occupied by a line formation of figures slowly marching forward. While Rovner visited China in 1995 and gave the suite a geographic title, these images nonetheless suggests a more ambiguous, almost cosmological setting, one of struggle as the figures press on in their journey, their blurred movements barely captured.

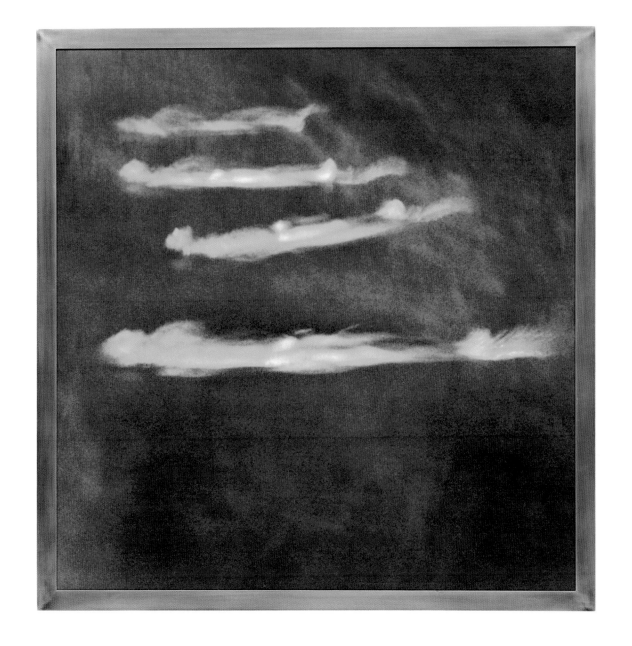

THOMAS RUFF

b. 1958
Zell am Harmersbach, Germany

With each series of photographs, Thomas Ruff tests the limits of the photographic medium. Not content with formulating a "signature" look, he has consistently introduced new styles and methods. His early *Interiors* series (1979–83) consists of straightforward representations of the domestic spaces of his West German youth. Like the work of his colleague Thomas Struth, Ruff's series exhibits the influence of their instructors at the Kunstakademie Düsseldorf, Bernd and Hilla Becher, by depicting banal scenes with a cool detachment. For Ruff, however, this aloofness often extends to his working methods. The photographs in his *Stars* series (1989–92) were reprinted from scientific negatives bought by Ruff from an observatory, and his *Newspaper Pictures* (1990–91), were rephotographed from newspapers but without captions. Ruff also freely manipulates his photographs with digital techniques. In *Houses* (1987–91), he digitally excised details that obstructed his formal vision; his *Posters* (1996–present) are politically propagandistic collages assembled digitally; and his recent *Nudes* (1999–present) are manipulated pornographic images downloaded from the Internet.

Perhaps Ruff's two series *Portraits* (1981–present) and *Other Portraits* (1994–95) best convey his varied artistic motives. Traditionally, portrait photography attempts to reveal the psychology of the depicted subjects through the strategic use of lighting, color, and setting, or by focusing on particular physical details. Both of Ruff's portrait series undermine this revelatory goal, in very different ways. In *Portraits*, sitters are placed before a neutral background, facing the camera without expression, bathed in an even light. This method elicits comparisons to passport photos, the mood of which these works share, except that Ruff enlarges these images to upward of two meters in height. While sharing the scale of these pictures, the images in *Other Portraits* adopt an opposite representational strategy: the subjects' likenesses are clearly altered, their facial features combined employing the same technology used by law enforcement for creating composite image of suspects. While the monumental physical presence and objective rendering of the faces in *Portraits* overshadow the individual personalities of those portrayed, but in *Other Portraits* such techniques of exaggeration are altogether absent. In the later series, as in his oeuvre as a whole, Ruff posits photographic objectivity only to expose it as fiction.

Portrait (M. Roeserl, 1999

ANRI SALA

b. 1974
Triana, Albania

In Anri Sala's films, personal stories are intertwined with larger political and social narratives. Many of the artist's works make reference to his family while referring to past and present conditions in Albania, where he grew up. For *Intervista—Finding the Words* (1998), Sala, with the help of a lipreader, re-created the lost audio portion of a filmed interview his mother had given in the late 1970s as a member of the Communist Youth Party in Albania. In Sala's film mother and son are seen viewing the original tape together. As his mother is confronted with the past and her words, she wonders with astonishment at how she could so earnestly spout party rhetoric. Although the film depicts a moment of nostalgic reassessment more than culpability or disavowal, it makes a powerful comment on the lines between fact and fiction, and the intermingling of family and country.

Although many of Sala's works address personal histories—his own and those of others—their themes of trauma, loss, and recovery are universal. Using tropes of both documentary and fictional filmmaking, *Nocturnes* (1999) approaches these themes in an uneasy exploration of insomnia and personal isolation. The film offers a brief but telling glimpse into the lives and psyches of two men Sala met while studying art in Turcoing, France: Jacques, who collects and obsessively cares for thousands of fish, and Denis, who copes with disturbing memories of his service as a United Nations peacekeeper in Bosnia by playing violent video games.

The film cuts between shots of Turcoing's streets at night and the two men as they describe their nighttime activities. With his face dimly lit by the artificial glow of purplish aquarium lights, Jacques speaks of his fish population as if it were a metaphor for the darker side of human society. When you introduce a new fish into a tank, he explains, you must do it gently and slowly, so the others won't kill the newcomer. As Denis describes his terrifying wartime experiences, we never see his face, only his hands. After killing people, "You can't live normally," he says. At the controls of his Sony PlayStation, Denis immerses himself in a still violent but fictional activity that fills hour after sleepless hour. As the film progresses, Jacques's and Denis's stories, and thus their identities, become less distinct from one another. These young men, outsiders both, derive a sense of power and purpose by controlling artificial situations, but their lives remain touched by anxiety and loneliness.

And the snipers' shots go
ping-ting-ting-ting.

Stills from *Nocturnes*, 1999

JÖRG SASSE

b. 1962
Düsseldorf

Jörg Sasse begins with other people's photographs and ends with altered images so autonomous that their photographic source stands in question. He digitally manipulates found photographs, often snapshots and amateurish landscapes, by changing the scale, eliminating details, blurring focus, and adding color. His process is akin to painting in that he extrapolates his own images from reality instead of relying solely on the camera's record. With the most popular and private sort of photographs, he strives to discern an objective form embedded in each, something glimpsed by the camera and *not* the individual. Sasse's titles, which are numbers selected randomly by a computer, reinforce this sense of a mechanical consciousness in his work.

Sasse studied at the Kunstakademie Düsseldorf with Bernd and Hilla Becher, and his inclusion of industrial structures in his work recalls their interest in juxtaposing such forms. Departing from the Bechers, however, Sasse neither repeatedly analyzes one structure nor records any verifiable "reality." In *2637* (2000), parallel planks of scaffolding, which appear to recede naturally in one-point perspective, seem on closer inspection to physically intersect, creating the sense of an impossibly claustrophobic space. This shallow vanishing point disallows entry into the pictorial space, an index of the flatness of the photograph itself. In other works, the artist references the tension between surface and depth, as well as fiction and reality, by slightly blurring the image, making it impossible to discern whether it is coming into or out of focus. This recalls the work of Gerhard Richter, whose paintings employ the vocabulary of photography, and for whom the blur is a reminder of his image's artifice. In Sasse's work, such devices are more difficult to read. The rapidly spinning carnival ride glimpsed over the edge of a wall in *8246* (2000) was static when photographed. Thus its current state is doubly an image of longing: we are barred from the ride's excitement by the bleak industrial building in the foreground and the fact that this intimation of splendor did not exist for the camera.

SIMON STARLING

b. 1967
Epsom, Surrey, England

Simon Starling's work playfully explores the intimate relationships between craft, material, and technique. His investigations into and reflections on modern manufacturing and traditional crafts reveal countless nuanced contradictions in the production of a single object as well as a fascination with process. His works, which are part utopian vision, part critical commentary on mass production, are often achieved through elaborate, performative projects.

While Starling is mostly a creator of scenarios and objects, he has documented his constructions with photographs to indicate the stages of their making and various component parts. In *HOME-MADE EAMES (FORMERS, JIGS & MOLDS)* (2002), Starling undertook the transformation of a historically significant cultural object, here an Eames-designed fiberglass chair, into handmade copies. The object is reinvigorated as its very history is teased out. Four photographs show the molds and the tools used in replicating the original chair. The Eames's classic DSS chair, designed in 1948, was the first industrially manufactured plastic chair. Its mass production reflected the utopian vision of modernism, which imagined a world in which everyone could enjoy the benefits of classic, clean, utilitarian design. Today, vintage Eames chairs are collectors' items, available only to those with disposable income and discerning taste. Starling's inventive at-home attempt at replication underscores the contradictions inherent to modernism's legacy. Further, in crudely replicating this now iconic chair, he inverts traditions, resuscitating the past and pushing the established boundaries between art and life.

THOMAS STRUTH

b. 1954
Geldern, Germany

Moving freely from one genre to another, intermingling them in exhibitions and publications, Thomas Struth always brings an intense level of visual exactitude to the images he creates. While the subject matter varies—from a mist-laden view of a Japanese temple and a close-up of a sunflower to a pensive family portrait and a picture of the Louvre crowded with visitors—the fundamental theme of his practice does not change. Struth's photography contemplates the science of observation. Eschewing narrative devices and intentional psychological allusions, the work augments vision itself by bringing into focus details too numerous for the eye to capture in an instant. A Struth image does not freeze time in the conventional sense of documentary photography; instead it slows time down just enough to capture the myriad visual nuances that one can only experience through sustained examination.

Struth's early black-and-white cityscapes—images of barren urban streets photographed from one central perspective—elicit comparisons to Bernd and Hilla Becher's typological studies of industrial structures. Struth had studied with the couple at the Kunstakademie Düsseldorf during the 1970s and shared their systematic, objective approach to subject matter. But it was another of his professors at the academy, Gerhard Richter, who made a lasting impression on the young artist's work. Richter's conceptual engagement with the photographic and his practice of working in simultaneous series is evident in Struth's own ongoing series of landscapes, street scenes, flowers, portraits, museum interiors, and places of worship. Recently, Struth photographed the painter and his family in their residence in Cologne. The monochromatic composition of *The Richter Family I, Cologne* (2002), is carefully organized—gender divides spaces and vice versa—but splayed hands and penetrating gazes suggest of tensions just below the surface.

Struth's photographs of historic churches and temples, which function today as both religious sites and tourist destinations, always include people. Like his museum interiors, images of places such as San Zaccaria in Venice and the Buddhist monastery Todai-Ji in Nara portray visitors in various stages of absorption. In *Milan Cathedral (Interior)* (1999) these visitors turn away from the camera to survey their environment, observe the Renaissance paintings, study their guidebooks, or pray. Shot at an oblique angle and lit with the utmost clarity, this dynamic composition captures both the complexity of the cathedral's celebrated architecture and the many separate vignettes being enacted by the individuals present at the moment the photograph was taken.

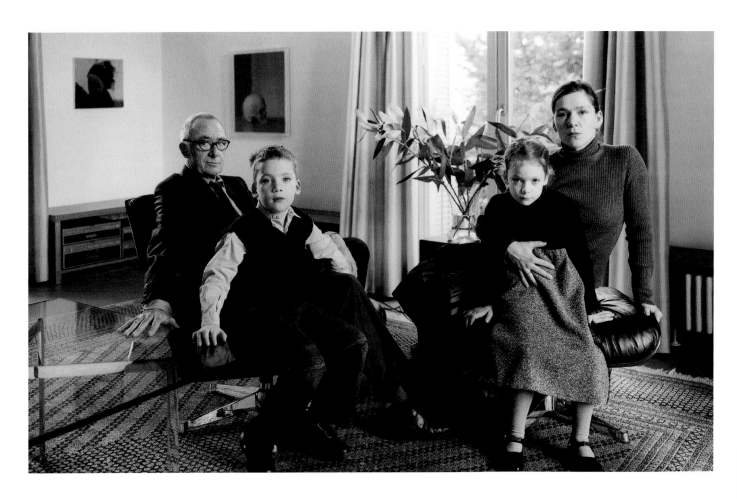

The Richter Family I, Cologne, 2002

Milan Cathedral (Interior), 1998

181

SAM TAYLOR-WOOD

b. 1967
London

Sam Taylor-Wood's photographs and film installations depict human dramas and isolated emotional instances, such as a quarreling couple and tense social gatherings—people in solitary, awkward, or vulnerable moments. These psychologically charged narratives are often presented on a grand scale, in room-encompassing video projections or 360-degree photographic panoramas accompanied by sound tracks. In her *Soliloquy* series (1998–99), Taylor-Wood's cinematic sensibility is coupled with references to the history of painting. The photographs are structured like Renaissance altarpieces and predellas (iconographically related panels attached along altarpiece bases): a large-format portrait is paired with a panoramic image below. Captured in a personal moment of self-reflection, asleep, or daydreaming, the subjects are often depicted in poses borrowed from well-known paintings. In *Soliloquy I* (1998), for example, the languid pose of the sleeping man recalls that of the dying poet in Henry Wallis's *The Death of Chatterton* (1865), and in *Soliloquy III* (1998), the reclining nude recalls Velázquez's *Rokeby Venus* (1650).

Typically, the people portrayed in Taylor-Wood's works are self-absorbed and seemingly detached from their own environment. The title of this series is derived from the name of the theatrical monologue during which an actor disrupts the narrative to directly address the audience with some commentary on the story. That state of deliberate disengagement is implied by the dual images comprising each work: the larger photo represents the conscious state of the subject, while the filmic tableau below provides a register of his or her subconscious fantasies. Sometimes the characters reappear in this imaginary world—the nude from *Soliloquy III* sits at the back of the loft space, dressed in red, observing at a distance the erotic activities that occur before her. In *Soliloquy II* (1998), the shirtless male figure, who, in the large image, is surrounded by dogs (in a pose reminiscent of a Thomas Gainsborough hunting portrait), appears seated with a dog in the corner of the bathhouse setting of the "predella." Reality invades fantasy when a dog's tail or the sleeping figure's hand crosses from the top image into the panel below, scale unchanged—a grotesque intrusion into the imaginary realm.

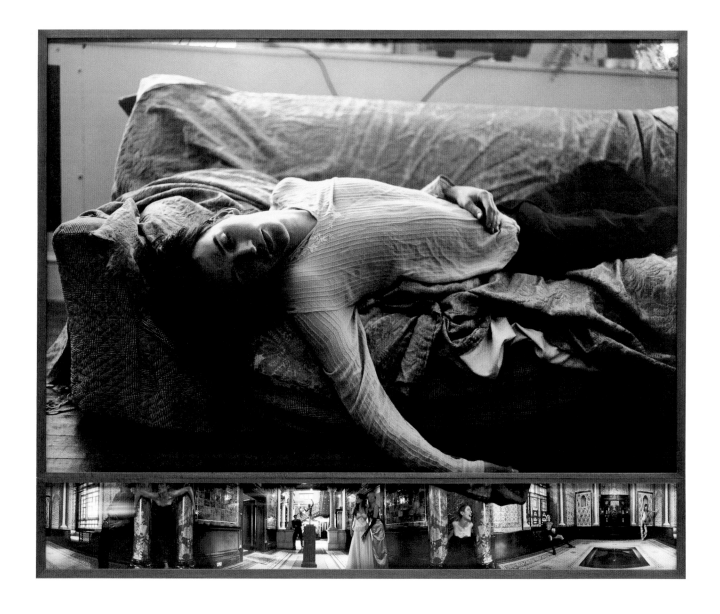

Soliloquy I, 1998

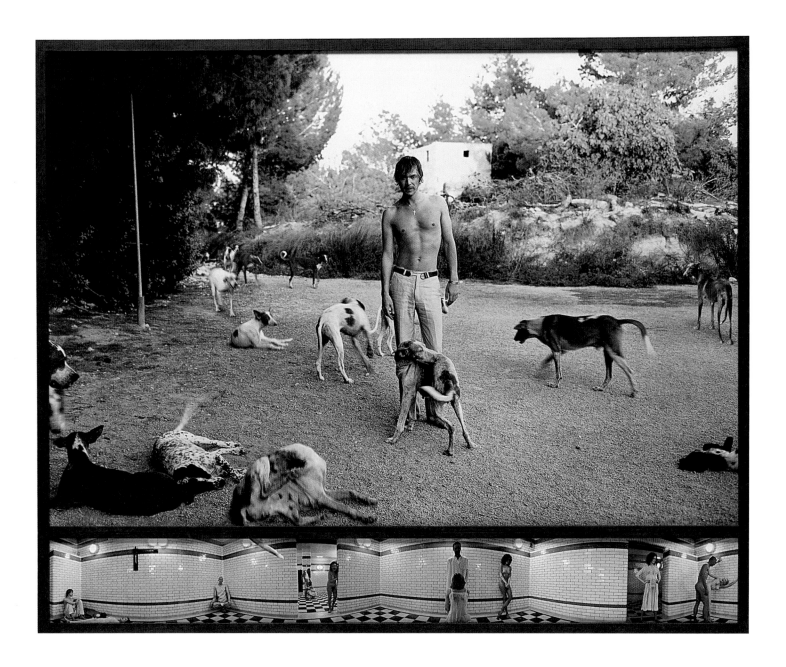

184

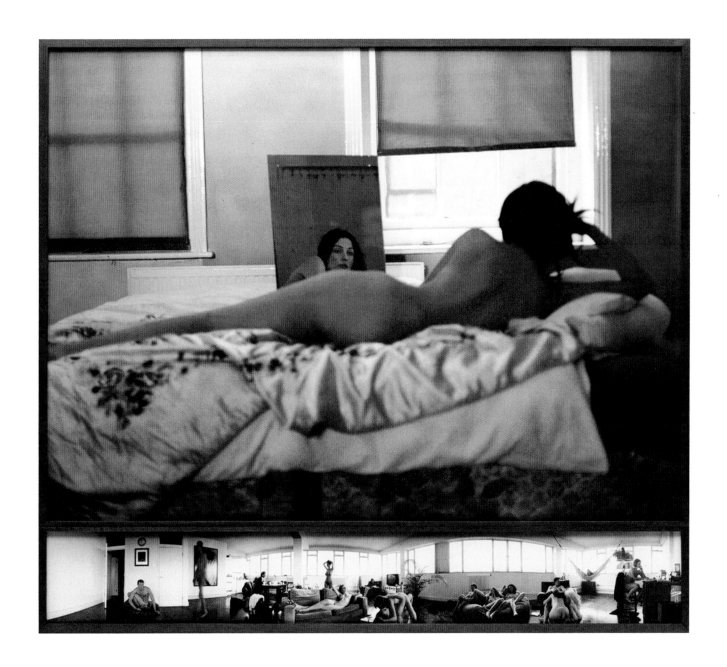

Soliloquy II, 1998; Soliloquy III, 1998

185

DIANA THATER

b. 1962
San Francisco

Diana Thater's installations are hybrids of video, sculpture, and architecture that map cinematic surface onto three-dimensional space. She scales her video projections to the architecture of particular sites and frequently couples them with other videos screened on televisions that are placed sculpturally in the space of the gallery, often on the floor. Her work can be seen as a continuation of first-generation video artists such as Dan Graham and Bruce Nauman, who considered in their work the viewer's movement through space and time and video's potential as an antirepresentational medium. In Thater's case, the viewer's position remains central, but representation and narrative inform her videos, which are often of animals and nature.

In the first of the eight separate installations that compose *The best animals are the flat animals—the best space is the deep space* (1998), a video monitor sits on the floor in front of a freestanding wall, itself in front of a real wall of the gallery. The monitor, serving as a "foreground," displays text, while footage of a zebra performing tricks is projected onto the "mid-ground" of the freestanding wall and close-ups of the zebra's stripes are projected onto the gallery wall in the "background." The piece is a playful examination of the limitations of representation. Each element attempts, and fails, to account for a real animal: a detail (the stripes) stands in for the whole, culture (the trained zebra) for nature, language for material reality. The monitor and walls, when viewed frontally, would seem to mimic a unified pictorial space; yet when viewed from the side, the disparate elements of the installation are pronounced, and the freestanding wall accentuates the flatness and immateriality of the zebra's projected image. Thater's inspiration for this piece was the sequence in Lewis Carroll's *Alice in Wonderland* in which Alice encounters three-dimensional animals that morph into two-dimensional playing cards.

Much of Thater's work engages with how the natural world is often experienced by people: flattened by the camera and at a great spatial and temporal remove. *Late and Soon, Occident Trotting* (1993, titled after Eadweard Muybridge's nineteenth-century photographs of a horse in motion) explores the landscape as one experiences it in the body and as a memory. Here, a projector is set out of register so that the image is broken into the three primary colors of video: red, blue, and green. Three additional projectors, each with only one lens of either red, blue, or green, are installed in an attempt to reconstruct the same image that has been broken down by the single projector. The imagery plays forward and then backward, further disorienting the viewer. Thater's interest is not in the stationary observer who reconstructs the horse's movement from the isolated frozen moments, but rather in the viewer who moves through a landscape in which nothing is stationary.

WOLFGANG TILLMANS

b. 1968
Remscheid, Germany

Wolfgang Tillmans's photographs of friends, dance raves, clubs, and night life have appeared regularly in London's *i-D* magazine and other publications since 1989. Though his work has had a tremendous impact on the studied casualness of much recent fashion photography, Tillmans is not a "fashion photographer." If anything he is a portraitist who often photographs his friends—who appear alternately tough, vulnerable, loving, ferocious, gay, and straight—in intimate situations. Though these probing images reflect his own subjective experiences, they also operate on a more general level, recording a specific dimension of our contemporary culture. Tillmans establishes a collaborative process with his models, whom he calls "accomplices." Thus the informal look of the works belies their choreographed construction. Landscape and still-life images also play a crucial role in his oeuvre, in which half-eaten fruit, sewer rats, crumpled clothing, or urban skylines are photographed with the same dignity and attention to beauty as his human subjects. Traditional subject genres are questioned; crumpled clothing might suggest a figure or landscape, while city scenes seen from the air resemble a still life of objects.

For Tillmans, the images are only half the work; the installation or layout constitutes its completion. He affixes his prints directly to the wall with pins or tape, juxtaposing old and new images of varying sizes and mediums. He eschews standard darkroom procedures, blurring the lines between color and black and white (printing black-and-white images on color paper, for instance). Color photographs are placed next to inkjet prints and next to postcards and magazine clippings of his own images, contesting conventional hierarchies of scale and subject matter while drawing focus to the materiality of the photographic medium—all within a carefully composed environment that seems to disdain permanency.

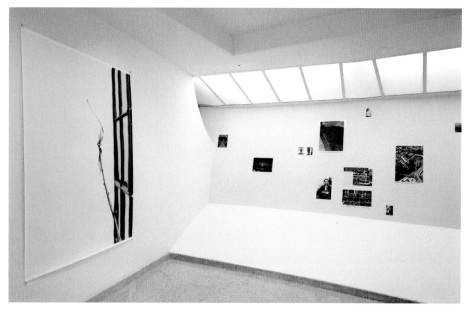

Guggenheim/New York Installation 1991–2000, 2002

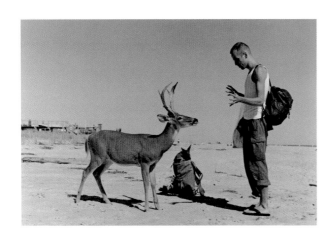

Page 190: *Deer Hirsch*, 1995; *indian corn & pomegranate*, 1994; *rat, disappearing*, 1995; page 191: *Andy on Baker Street*, 1993; *grey jeans over stair post*, 1991; *police helicopter*, 1995

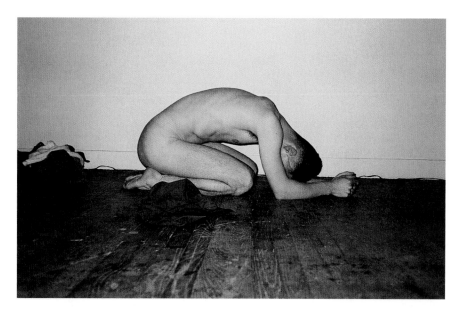

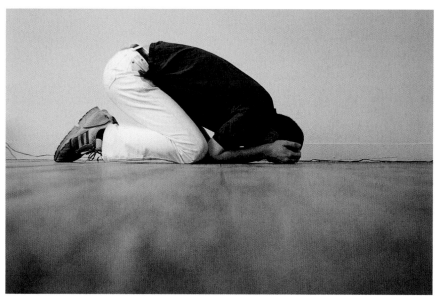

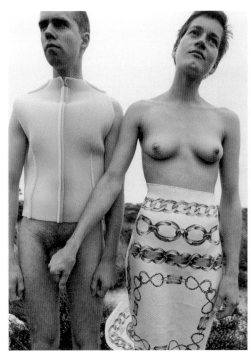

Page 194: *Lutz & Alex holding cock*, 1992; *outside Planet, view*, 1992; *Hallenbad, Detail*, 1995; page 195: *Irm Hermann*, 2000

KARA WALKER

b. 1969
Stockton, California

Insurrection! (Our Tools Were Rudimentary, Yet We Pressed On) (2000) presents a panorama of grisly scenes. A plantation master propositions a naked slave behind a tree. A woman with a baby on her head manages to escape a lynching. A group surrounds and tortures a victim with such "rudimentary tools" as ladles and frying pans, which may deliver a final blow. Other silhouettes and shadowy forms as well as theatrical, atmospheric colors fill what space remains on the wall.

The work is exemplary of the ways in which Kara Walker's art continually records and challenges—in graphically sexual and raucously violent tableaux—the traumatic, even repressed, history of slavery in the United States. She aims to find a voice for the ways in which history holds sway over present-day race relations, however intimate, unofficial, colloquial, or lewd the voice's utterances may be. Walker is best known for her antiquated-style silhouettes of an imagined antebellum South, with all its requisite "masters," "belles," "mammies," and "sambos." Her use of silhouette as a medium draws attention to the reductive nature of stereotypes, in which the complexities of individual identities and situations are distorted, even caricatured, in order to be easily understood. Walker derives her imagery in part from the tradition of the minstrel show, which she redeploys to subversive ends. Historically performed by white actors in blackface, the minstrel theater parodied the lives of African Americans and allowed whites to vicariously break their own cultural taboos by portraying unbridled sexuality and puerile behavior. In her work, Walker inverts the roles of these characters. Her stylized figures enact the violence that attends oppression as they embody scenes of bestiality, castration, murder, and cannibalism.

Walker's earlier silhouettes were composed against white backgrounds, but more recently—as with *Insurrection!*—color infuses the scenes, spilling forth from light projectors to flood the gallery walls and even its floors. This new technique makes the fantastical scenes all the more vivid, literally as well as metaphorically. In order to engage with the work fully, the viewer must at some point along the panorama stand between the projector and the cutouts on the wall. When his or her shadow joins those already playing across the wall, the proposition is clear: this is a work that, while it may be the fanciful "narrative of a negress," involves the hearts and minds of all people, depending on the role and the light in which they cast themselves.

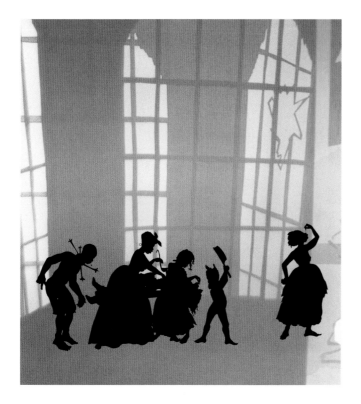

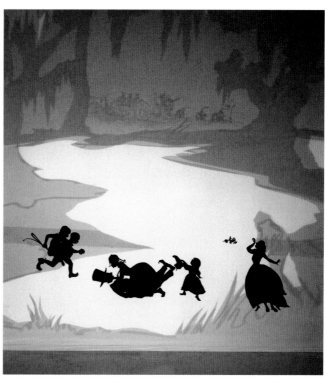

Details of *Insurrection! (Our Tools Were Rudimentary, Yet We Pressed On)*, 2000

197

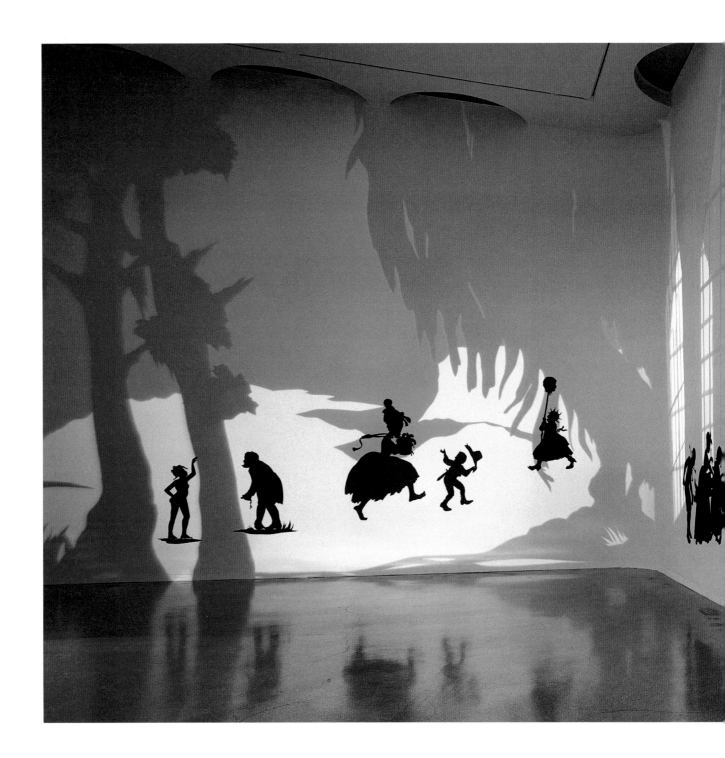

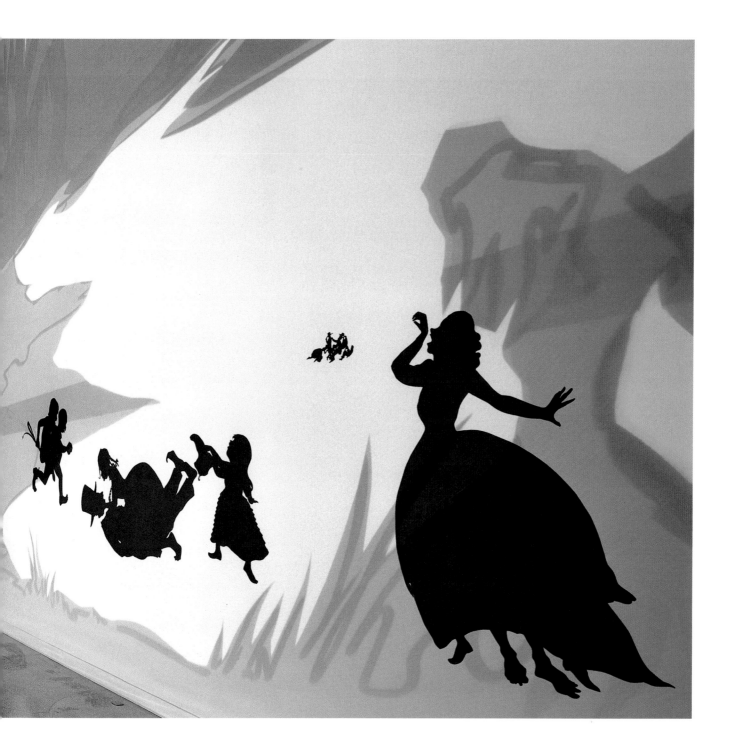

Installation view, *Insurrection! (Our Tools Were Rudimentary, Yet We Pressed On)*, 2000

JANE AND LOUISE WILSON

b. 1967
Newcastle upon Tyne, England

Twins who have collaborated since the early 1990s, Jane and Louise Wilson use film to examine sites of authority and secrecy, which evoke highly charged associations. They are concerned as much with the psychological impact of architecture as with its physical aspects. To film *Stasi City* (1997), they gained access to the former East German secret police headquarters in Berlin. *Gamma* (1997) was made at Greenham Common, a decommissioned American military base in Berkshire, England, where nuclear weapons were stored. In these films, which are shown as large-scale projections, the camera pans across eerie, abandoned offices, equipment, bunkers, and even empty missile silos. Occasionally, the Wilsons themselves appear as trespassers in these previously forbidden territories. Each film is comprised of two, three, or four different projections and are shown on multiple screens that face each other in a darkened gallery, completely absorbing the viewer in their locations' unsettling sense of claustrophobic emptiness.

In *Star City* (2000), the Wilsons venture into another chapter of the Cold War: the space race between the Soviet Union and the United States. Though referenced obliquely, this history is unmistakably present in the piece, which was filmed at a cosmonaut training facility outside of Moscow. We see space capsules, derelict launchpads, control rooms, and rows of neatly stacked space suits and helmets, all accompanied by a sound track of clanging machinery, roaring fans, and a constant ambient drone. Projected onto four screens, the scenes shift subtly in pace and orientation, from close-up to distant shots and from vertical to horizontal. (Such contrasts are typical in the Wilsons' formal repertoire.) The underlying narrative is a tale of utopian idealism, science, and Communism gone awry, yielding only unfulfilled expectations and a program that languishes in economic disarray.

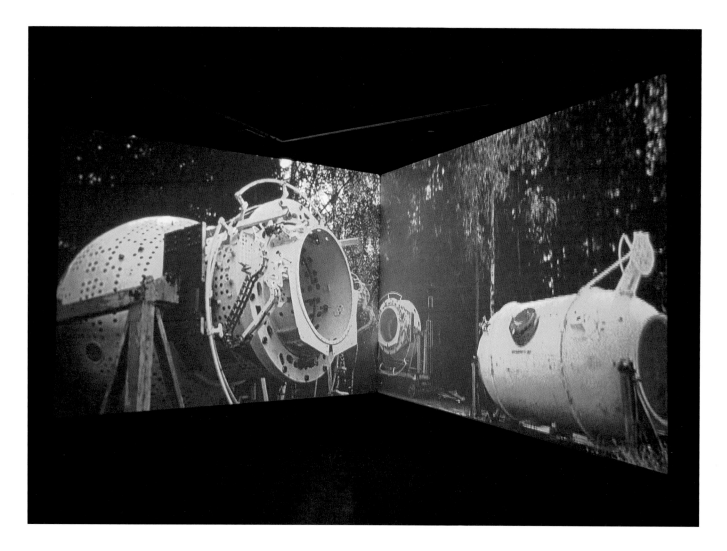

ILLUSTRATIONS AND WORKS IN THE EXHIBITION

PICTURING MOVEMENT, PAST AND PRESENT:

MICHAEL SNOW
Frames from *Wavelength*, 1966–67
16-mm color film with sound, 00:45:00

HOLLIS FRAMPTON
Still from *Nostalgia*, 1971
16-mm black and white film with sound, 00:36:00

PETER CAMPUS
Still from *Three Transitions*, 1973
Color video with sound, 00:04:53

JOHN BALDESSARI
Still from *Ed Henderson Reconstructs Movie Scenarios*, 1973
Black-and-white video with sound, 00:24:04

MORGAN FISHER
Still from *Standard Gauge*, 1984
16-mm color film with sound, 00:35:00

DOUGLAS GORDON
through a looking glass, 1999
Two-channel video installation with sound, Edition 3/3; dimensions vary with installation
Solomon R. Guggenheim Museum, New York, Purchased with funds contributed by the International Director's Council and Executive Committee Members: Edythe Broad, Henry Buhl, Elaine Terner Cooper, Gail May Engelberg, Linda Fischbach, Ronnie Heyman, Dakis Joannou, Cindy Johnson, Barbara Lane, Linda Macklowe, Peter Norton, Willem Peppler, Denise Rich, Simonetta Seragnoli, David Teiger, Ginny Williams, Elliot K. Wolk. 99.5304

BRUCE NAUMAN
Still from *Spinning Spheres*, 1970
16-mm color film (transferred to four Super-8-mm film loops), silent, projected continuously
Solomon R. Guggenheim Museum, New York, Panza Collection. 91.3830

STEVE MCQUEEN
Still from *Just Above My Head*, 1996
16-mm black-and-white film/video transfer, 00:98:00, Edition 1/3
Solomon R. Guggenheim Museum, New York, Gift, The Bohen Foundation. 99.5257

PIPILOTTI RIST
Atmosphere & Instinct, 1998
Video installation with sound, 00:02:15, Edition 2/3, dimensions vary with installation
Solomon R. Guggenheim Museum, New York, Partial and promised gift, The Bohen Foundation. 2001.237

MARINA ABRAMOVIĆ
Still from *Cleaning the Mirror #1*, 1995
Five-channel video installation with stacked monitors, with sound, Edition 2/3; approx. 112 x 24 1/2 x 19 inches (284.5 x 62.2 x 48.3 cm)
Solomon R. Guggenheim Museum, New York, Purchased with funds contributed by the International Director's Council and Executive Committee Members: Edythe Broad, Elaine Terner Cooper, Linda Fischbach, Ronnie Heyman, J. Tomilson Hill, Dakis Joannou, Barbara Lane, Peter Norton, Willem Peppler, Alain-Dominique Perrin, David Teiger, Ginny Williams, Elliot K. Wolk. 98.4626

IÑIGO MANGLANO-OVALLE
Climate, 2000
Three-channel video installation with sound, 00:23:35, Edition 1/3; dimensions vary with installation
Solomon R. Guggenheim Museum, New York, Partial and promised gift, The Bohen Foundation. 2001.190

VITO ACCONCI
VD Lives/TV Must Die, 1978
Installation with rubber, cable, bowling balls, videotape, and monitors; dimensions vary with installation
Solomon R. Guggenheim Museum, New York, Gift, The Bohen Foundation. 99.5256

VITO ACCONCI
Still from *Undertone*, 1973
Black-and-white video with sound, 00:34:12

VITO ACCONCI
TELE-FURNI-SYSTEM, 1997
Multichannel video installation with monitors, speakers, and steel and pipe armature; dimensions, videos, and number of components vary with installation
Solomon R. Guggenheim Museum, New York, Purchased with funds contributed by the International Director's Council and Executive Committee Members: Eli Broad, Elaine Terner Cooper, Ronnie Heyman, J. Tomilson Hill, Dakis Joannou, Barbara Lane, Robert Mnuchin, Peter Norton, Thomas Walther, Ginny Williams. 97.4567

DIANA THATER
Late and Soon, Occident Trotting, 1993
Video installation, silent, 00:30:00, Edition 1/1, 1 A.P; dimensions vary with installation
Solomon R. Guggenheim Museum, New York, Partial and promised gift, The Bohen Foundation. 2001.288

ART PHOTOGRAPHY AFTER PHOTOGRAPHY:

GORDON MATTA-CLARK
Conical Intersect, 1975
Cibachrome print, mounted on mat board
40 1/8 x 30 inches (101.7 x 70.4 cm)
Solomon R. Guggenheim Museum, New York, Purchased with funds contributed by the International Director's Council and Executive Committee Members: Edythe Broad, Elaine Terner Cooper, Linda Fischbach, Ronnie Heyman, J. Tomilson Hill, Dakis Joannou, Cindy Johnson, Barbara Lane, Linda Macklowe, Brian McIver, Peter Norton, Willem Peppler, Alain-Dominique Perrin, Rachel Rudin, David Teiger, Ginny Williams, Elliot K. Wolk. 98.5229

HANNAH WILKE
S.O.S. Starification Object Series, 1974
Black and white photograph, A.P. 1/2
40 x 27 inches (101.6 x 68.6 cm)

Solomon R. Guggenheim Museum, New York,
Purchased with funds contributed by the
Photography Committee and The Judith Rothschild
Foundation. 2001.32.2

ANA MENDIETA
Untitled (from the *Silueta* series), August 1976
Color photograph, unique
9 5/8 x 6 5/8 inches (24.4 x 16.8 cm)
Solomon R. Guggenheim Museum, New York,
Purchased with funds contributed by the
Photography Committee. 98.5236

ROBERT SMITHSON
Yucatan Mirror Displacements (1-9), 1969 [#7
shown]
1 of 9 chromogenic-development slides
Solomon R. Guggenheim Museum, New York,
Purchased with funds contributed by the
Photography Committee and with funds
contributed by the International Director's Council
and Executive Committee Members: Edythe Broad,
Henry Buhl, Elaine Terner Cooper, Linda
Fischbach, Ronnie Heyman, Dakis Joannou, Cindy
Johnson, Barbara Lane, Linda Macklowe, Brian
McIver, Peter Norton, Willem Peppler, Denise Rich,
Rachel Rudin, David Teiger, Ginny Williams, Elliot
K. Wolk. 99.5269

CINDY SHERMAN
Untitled Film Still #15, 1978
Gelatin-silver print, Edition 2/10
9 3/8 x 7 7/16 inches (23.8 x 18.9 cm)
Solomon R. Guggenheim Museum, New York,
Purchased with funds contributed by the
International Director's Council and Executive
Committee Members: Eli Broad, Elaine Terner
Cooper, Ronnie Heyman, J. Tomilson Hill, Dakis
Joannou, Barbara Lane, Robert Mnuchin, Peter
Norton, Thomas Walther, Ginny Williams. 97.4573

HELLEN VAN MEENE
Untitled, 1999
C-print, Edition 8/10
15 1/4 x 15 1/4 inches (38.7 x 38.7 cm)
Solomon R. Guggenheim Museum, New York,
Purchased with funds contributed by the
Photography Committee. 2001.78

CATHERINE OPIE
Dyke, 1993
Chromogenic print, A.P.1/2, Edition of 8
40 x 30 inches (101.6 x 76.2 cm)
Solomon R. Guggenheim Museum, New York,
Purchased with funds contributed by the
Photography Committee. 2003.69

ANNA GASKELL
untitled #5 (wonder), 1996
C-print, laminated and mounted on board, A.P. 2/2,
Edition of 5
48 1/16 x 40 1/4 inches (122.1 x 102.2 cm)
Solomon R. Guggenheim Museum, New York,
Purchased with funds contributed by the Young
Collectors Council. 97.4580

SAM TAYLOR-WOOD
Soliloquy V, 1998
2 C-prints, Edition 4/6
88 x 101 x 2 inches (223.5 x 256.5 x 5.1 cm)
Solomon R. Guggenheim Museum, New York,
Partial and promised gift, David Teiger.
2000.106

CATALOGUE ILLUSTRATION

MATTHEW BARNEY
CREMASTER Suite, 1994–2002
5 C-prints in self-lubricating plastic frames (shown
unframed), Edition of 10, 2 A.P.
44 x 34 x 1 1/2 inches (112 x 86 x 3.2 cm) each

MARINA ABRAMOVIĆ
Cleaning the Mirror #1, 1995
Five-channel video installation with stacked
monitors, with sound, Edition 2/3; approx. 112 x 24
1/2 x 19 inches (284.5 x 62.2 x 48.3 cm)
Solomon R. Guggenheim Museum, New York
Purchased with funds contributed by the
International Director's Council and Executive
Committee Members: Edythe Broad, Elaine Terner
Cooper, Linda Fischbach, Ronnie Heyman, J.
Tomilson Hill, Dakis Joannou, Barbara Lane, Peter
Norton, Willem Peppler, Alain-Dominique Perrin,
David Teiger, Ginny Williams, Elliot K. Wolk.
98.4626

FRANCIS ALŸS
When Faith Moves Mountains, 2002
Three-channel video installation with sound,
originally filmed in 16-mm, 00:34:00, Edition 1/4;
overall dimensions vary with installation
Solomon R. Guggenheim Museum, New York
Purchased with funds contributed by the
International Director's Council and Executive
Committee Members: Ruth Baum, Edythe Broad,
Elaine Terner Cooper, Dimitris Daskalopoulos,
Harry David, Gail May Engelberg, Shirley Fiterman,
Nicki Harris, Dakis Joannou, Linda Macklowe,
Peter Norton, Willem Peppler, Tonino Perna,
Elizabeth Richebourg Rea, Simonetta Seragnoli,
David Teiger, Elliot K. Wolk. 2002.59

JANINE ANTONI
Mom and Dad, 1994
Three color photographs, Edition 6/6
24 x 19 7/8 inches (61 x 50.5 cm) each
Solomon R. Guggenheim Museum, New York
Purchased with funds contributed by the
International Director's Council. 96.4515

MATTHEW BARNEY
CREMASTER 4, 1994
35-mm film (color digital video transferred to film
with Dolby SR sound), 00:42:16
Courtesy Barbara Gladstone Gallery

MATTHEW BARNEY
CREMASTER 1, 1995
35-mm film (color digital video transferred to film
with Dolby SR sound), 00:40:30, Edition 10/10
Solomon R. Guggenheim Museum, New York
Purchased with funds contributed by the
International Director's Council. 96.4516

MATTHEW BARNEY
CREMASTER 5, 1997
35-mm film (color digital video transferred to film
with Dolby SR sound), 00:54:30, Edition 5/10
Solomon R. Guggenheim Museum, New York
Purchased with funds contributed by the
International Director's Council and Executive
Committee Members: Eli Broad, Elaine Terner
Cooper, Ronnie Heyman, J. Tomilson Hill, Dakis
Joannou, Barbara Lane, Robert Mnuchin, Peter
Norton, Thomas Walther, Ginny Williams. 97.4570

MATTHEW BARNEY
CREMASTER 2, 1999
35-mm film (color digital video transferred to film
with Dolby SR sound), 1:19:00, Edition 8/10
Solomon R. Guggenheim Museum, New York
Purchased with funds contributed by the
International Director's Council and Executive
Committee Members: Edythe Broad, Henry Buhl,
Elaine Terner Cooper, Gail May Engelberg, Linda
Fischbach, Ronnie Heyman, Dakis Joannou, Cindy
Johnson, Barbara Lane, Linda Macklowe, Peter
Norton, Willem Peppler, Denise Rich, Simonetta
Seragnoli, David Teiger, Ginny Williams, Elliot K.
Wolk. 99.5303

MATTHEW BARNEY
CREMASTER 3, 2002
35-mm film (color digital video transferred to film
with Dolby Digital sound), 3:01:59, Edition 8/10
Solomon R. Guggenheim Museum, New York
Purchased with funds contributed by the
International Director's Council and Executive
Committee Members: Edythe Broad, Elaine Terner
Cooper, Dimitris Daskalopoulos, Harry David, Gail
May Engelberg, Nicki Harris, Ronnie Heyman,
Dakis Joannou, Barbara Lane, Sondra Mack, Linda
Macklowe, Peter Norton, Willem Peppler, Tonino

Perna, Elizabeth Richebourg Rea, Simonetta
Seragnoli, David Teiger, Elliot K. Wolk. 2002.33

UTA BARTH
Field #23, 1998
Acrylic lacquer on canvas, Edition 3/3
90 1/4 x 132 inches (228.6 x 335.28 cm)
Solomon R. Guggenheim Museum, New York
Purchased with funds contributed by the
Photography Committee. 98.4629

OLIVER BOBERG
Car Park, 1999
Cibachrome print, mounted on Sintra, Edition 4/5
30 1/16 x 69 11/16 inches (76.4 x 177 cm)
Solomon R. Guggenheim Museum, New York
Purchased with funds contributed by the Young
Collectors Council. 99.5309

OLIVER BOBERG
Passage, 1999
Cibachrome print, mounted on Sintra, Edition 4/5
29 1/16 x 39 1/16 inches (73.8 x 99.2 cm)
Solomon R. Guggenheim Museum, New York
Purchased with funds contributed by the Young
Collectors Council. 99.5308

JEFF BURTON
Untitled # 124 (reclining nude man), 2000
Cibachrome print, laminated and mounted on
aluminum, Edition 1/5
39 3/4 x 59 3/4 x 13/16 inches
(101.0 x 151.8 x 2.1 cm)
Solomon R. Guggenheim Museum, New York
Gift, The Betlach Family Foundation. 2001.44

JAMES CASEBERE
Asylum, 1994
Cibachrome print, laminated and mounted on
Plexiglas, Edition 5/5
47 1/2 x 59 1/2 inches (120.6 x 151.2 cm)
Solomon R. Guggenheim Museum, New York
Gift, Lois and Richard Plehn. 97.4550

PATTY CHANG
In Love, 2001
Two-channel video installation, 00:03:28, Edition
2/5; dimensions vary with installation

Solomon R. Guggenheim Museum, New York
Gift, Janet Karatz Dreisen. 2002.24

MILES COOLIDGE
Industrial Buildings, 1994
Cibachrome print, laminated to Plexiglas,
Edition 1/5
30 x 39 inches (76.2 x 99.1 cm)
Solomon R. Guggenheim Museum, New York
Purchased with funds contributed by the
Photography Committee. 98.4637

MILES COOLIDGE
Police Station, Kids-R-Us, McDonald's, 1994
Cibachrome print, laminated to Plexiglas,
Edition 1/5
30 x 39 inches (76.2 x 99.1 cm)
Solomon R. Guggenheim Museum, New York
Purchased with funds contributed by the
Photography Committee. 98.4638

MILES COOLIDGE
Mattawa #9, 2000
C-print, mounted to Plexiglas, Edition 1/7
57 5/8 x 49 7/8 inches (146.4 x 126.7 cm)
Solomon R. Guggenheim Museum, New York
Purchased with funds contributed by the
Photography Committee. 2000.124

GREGORY CREWDSON
Untitled (pregnant woman/pool), 1999
Laser direct C-print, Edition 4/10
50 x 60 inches (127 x 152.4 cm)
Solomon R. Guggenheim Museum, New York
Purchased with funds contributed by the
Photography Committee. 2000.70

GREGORY CREWDSON
Untitled (sod man), 1999
Laser direct C-print, Edition 8/10
50 x 60 inches (127 x 152.4 cm)
Solomon R. Guggenheim Museum, New York
Purchased with funds contributed by the Young
Collectors Council. 2000.92

GREGORY CREWDSON
Untitled (family dinner), 2001–02
Digital C-print, A.P. 2/3, Edition of 10

50 x 60 inches (121.9 x 152.4 cm)
Solomon R. Guggenheim Museum, New York
Purchased with funds contributed by the
Photography Committee. 2002.30

THOMAS DEMAND
Archive, 1995
Cibachrome print, mounted on Sintra
and laminated to Plexiglas, Edition 4/5
72 3/8 x 93 11/16 inches (183.8 x 238 cm)
Solomon R. Guggenheim Museum, New York
Purchased with funds contributed by the Young
Collectors Council. 97.4576

RINEKE DIJKSTRA
Kolobrzeg, Poland, July 23, 1992, 1992
C-print, Edition 3/6
62 5/8 x 50 1/2 inches (159.1 x 128.cm)
Collection Nina and Frank Moore

RINEKE DIJKSTRA
Kolobrzeg, Poland, July 27, 1992, 1992
C-print, Edition 6/6
60 1/4 x 50 3/4 inches (153 x 128.9 cm)
Solomon R. Guggenheim Museum, New York
Purchased with funds contributed by the
Photography Committee. 98.5233

RINEKE DIJKSTRA
Coney Island, N.Y., USA, June 20, 1993, 1993
C-print, Edition 6/6
60 1/4 x 50 3/4 inches (153 x 128.9 cm)
Solomon R. Guggenheim Museum, New York
Purchased with funds contributed by the
Photography Committee. 98.5232

RINEKE DIJKSTRA
Coney Island, N.Y., USA, July 9, 1993, 1993
C-print, Edition 3/6
62 5/8 x 50 1/2 inches (159.1 x 128.3 cm)
Solomon R. Guggenheim Museum, New York
Purchased with funds contributed by the Harriet
Ames Charitable Trust. 2000.110

RINEKE DIJKSTRA
Odessa, Ukraine, August 4, 1993, 1993
C-print, A.P. 2/2, Edition of 6
62 5/8 x 50 1/2 inches (159.1 x 128.3 cm)

Solomon R. Guggenheim Museum, New York
Fractional Gift, Nina and Frank Moore. 99.5266

RINEKE DIJKSTRA
Dubrovnik, Croatia, July 13, 1996, 1996
C-print, Edition 3/6
62 5/8 x 50 1/2 inches (159.1 x 128.cm)
Collection Nina and Frank Moore

TRISHA DONNELLY
untitled (jumping), 1999
Video installation, silent, 00:04:30, A.P. 1/1, Edition
of 3; approx. 11 x 8 1/2 inches (27.9 x 21.6 cm)
Solomon R. Guggenheim Museum, New York
Gift, Pamela and Arthur Sanders, and Jennifer and
David Stockman. 2002.26

STAN DOUGLAS
Monodramas, 1991
Ten videos, with sound, 30 to 60 seconds each,
Edition 5/5
Solomon R. Guggenheim Museum, New York
Purchased with funds contributed by the
International Director's Council. 96.4508.11

OLAFUR ELIASSON
The glacier series, 1999
42 C-prints, Edition 4/6
12 1/4 x 18 5/8 inches (31.1 x 47.3 cm) each;
92 7/8 x 154 3/4 inches (235.9 x 393.1 cm) overall
Solomon R. Guggenheim Museum, New York
Purchased with funds contributed by the
Photography Committee. 2000.69

OLAFUR ELIASSON
The horizon series, 2002
40 C-prints, Edition 6/6
8 7/8 x 41 1/8 inches (22.5 x 104.5 cm) each; 87
15/16 x 218 7/8 inches (223.4 x 555.9 cm) overall
Solomon R. Guggenheim Museum, New York
Purchased with funds contributed by the
International Director's Council and Executive
Committee members: Ruth Baum, Edythe Broad,
Elaine Terner Cooper, Dimitris Daskalopoulos,
Harry David, Gail May Engelberg, Shirley Fiterman,
Nicki Harris, Dakis Joannou, Linda Macklowe,
Peter Norton, Tonino Perna, Elizabeth Richebourg

Rea, Mortimer Sackler, Jr., Simonetta Seragnoli, David Teiger, Elliot K. Wolk. 2003.63

ELGER ESSER
Ameland Pier X, Netherlands, 2000
C-print, laminated to Plexiglas, Edition 1/7
71 1/4 x 92 1/4 inches (182 x 235 cm)
Solomon R. Guggenheim Museum, New York
Purchased with funds contributed by the
Photography Committee. 2001.75

PETER FISCHLI AND DAVID WEISS
Untitled (Flowers), 1997–98
Selection from portfolio of 111 inkjet prints,
Edition 3/9
29 1/8 x 42 1/3 inches (74 x 107.4 cm) each
Solomon R. Guggenheim Museum, New York
Purchased with funds contributed by the
International Director's Council and Executive
Committee Members: Edythe Broad, Henry Buhl,
Elaine Terner Cooper, Linda Fischbach, Ronnie
Heyman, Dakis Joannou, Cindy Johnson, Barbara
Lane, Linda Macklowe, Brian McIver, Peter Norton,
Willem Peppler, Denise Rich, Rachel Rudin, David
Teiger, Ginny Williams, Elliot K. Wolk. 99.5267

THOMAS FLECHTNER
Glaspass (Walks #10), 2001
C-print, mounted on aluminum, Edition 3/3
86 5/8 x 70 3/4 inches (220 x 179.7 cm)
Solomon R. Guggenheim Museum, New York
Purchased with funds contributed by the Young
Collectors Council. 2003.60

ANNA GASKELL
untitled #2 (wonder), 1996
C-print, laminated and mounted on Sintra, A.P. 2/2,
Edition of 5
47 5/8 x 39 5/8 inches (120.8 x 100.6 cm)
Solomon R. Guggenheim Museum, New York
Purchased with funds contributed by the Young
Collectors Council. 97.4577

ANNA GASKELL
untitled #3 (wonder), 1996
C-print, laminated and mounted on Sintra, A.P. 2/2,
Edition of 5
58 11/16 x 47 7/8 inches (149.1 x 121.8 cm)

Solomon R. Guggenheim Museum, New York
Purchased with funds contributed by the Young
Collectors Council. 97.4578

ANNA GASKELL
untitled #5 (wonder), 1996
C-print, laminated and mounted on Sintra, A.P. 2/2,
Edition of 5
48 1/16 x 40 1/4 inches (122.1 x 102.2 cm)
Solomon R. Guggenheim Museum, New York
Purchased with funds contributed by the Young
Collectors Council. 97.4580

ANNA GASKELL
untitled #6 (wonder), 1996
C-print, laminated and mounted on Sintra, A.P. 2/2,
Edition of 5
19 x 23 1/4 inches (48.3 x 59 cm)
Solomon R. Guggenheim Museum, New York
Purchased with funds contributed by the Young
Collectors Council. 97.4581

ANNA GASKELL
untitled #7 (wonder), 1996
C-print, laminated and mounted on Sintra, A.P. 2/2,
Edition of 5
8 1/4 x 6 7/8 inches (21 x 17.4 cm)
Solomon R. Guggenheim Museum, New York
Purchased with funds contributed by the Young
Collectors Council. 97.4582

ANNA GASKELL
untitled #8 (wonder), 1996
C-print, laminated and mounted on Sintra, A.P. 2/2,
Edition of 5
29 x 35 1/4 inches (73.6 x 89.5 cm)
Solomon R. Guggenheim Museum, New York
Purchased with funds contributed by the Young
Collectors Council. 97.4583

ANNA GASKELL
untitled #19 (wonder), 1996
C-print, laminated and mounted on Sintra, A.P. 2/2,
Edition of 5
39 3/4 x 48 3/8 inches (101 x 123 cm)
Solomon R. Guggenheim Museum, New York
Purchased with funds contributed by the Young
Collectors Council. 97.4594

ANNA GASKELL
untitled # 21 (override), 1997
C-print, laminated and mounted on Sintra,
Edition 5/5
56 3/4 x 68 3/4 inches (144 x 174.5 cm)
Solomon R. Guggenheim Museum, New York
Gift, Dakis Joannou. 98.4645

ANNA GASKELL
untitled #24 (override), 1997
C-print, laminated and mounted on Sintra,
Edition 5/5
47 7/8 x 39 3/4 inches (121.5 x 100.8 cm)
Solomon R. Guggenheim Museum, New York
Gift, Dakis Joannou. 98.4648

ANNA GASKELL
untitled #25 (override), 1997
C-print, laminated and mounted on Sintra,
Edition 5/5
19 7/8 x 15 1/2 inches (49.5 x 39.7 cm)
Solomon R. Guggenheim Museum, New York
Gift, Dakis Joannou. 98.4649

ANNA GASKELL
untitled #26 (override), 1997
C-print, laminated and mounted on Sintra,
Edition 5/5
19 3/8 x 23 5/8 inches (49.2 x 60 cm)
Solomon R. Guggenheim Museum, New York
Gift, Dakis Joannou. 98.4650

ANNA GASKELL
untitled #27 (override), 1997
C-print, laminated and mounted on Sintra,
Edition 5/5
49 3/16 x 60 3/16 inches (124.9 x 152.9 cm)
Solomon R. Guggenheim Museum, New York
Gift, Dakis Joannou. 98.4651

ANNA GASKELL
untitled #29 (override), 1997
C-print, laminated and mounted on Sintra,
Edition 5/5
7 1/2 x 9 1/4 inches (19.1 x 23.5 cm)
Solomon R. Guggenheim Museum, New York
Gift, Dakis Joannou. 98.4653

ANNA GASKELL
untitled #31 (hide), 1998
C-print, laminated and mounted on aluminum,
A.P. 2/2, Edition of 3
65 7/8 x 56 inches (167.3 x 142.2 cm)
Solomon R. Guggenheim Museum, New York
Purchased with funds contributed by the
Photography Committee. 2000.74

ANNA GASKELL
untitled #35 (hide), 1998
C-print, laminated and mounted on aluminum,
A.P. 2/2, Edition of 3
36 7/8 x 48 7/8 inches (93.7 x 124.1 cm)
Solomon R. Guggenheim Museum, New York
Purchased with funds contributed by the
Photography Committee. 2000.78

ANNA GASKELL
untitled #36 (hide), 1998
C-print, laminated and mounted on aluminum,
A.P. 2/2, Edition of 3
38 7/8 x 48 7/8 inches (98.7 x 124.1 cm)
Solomon R. Guggenheim Museum, New York
Purchased with funds contributed by the
Photography Committee. 2000.79

ANNA GASKELL
untitled #37 (hide), 1998
C-print, laminated and mounted on aluminum,
A.P. 2/2, Edition of 3
38 7/8 x 48 7/8 inches (98.7 x 124.1 cm)
Solomon R. Guggenheim Museum, New York
Purchased with funds contributed by the
Photography Committee. 2000.80

ANNA GASKELL
untitled #41 (hide), 1998
C-print, laminated and mounted on aluminum,
A.P. 2/2, Edition of 3
18 15/16 x 23 1/4 inches (48.1 x 59.1 cm)
Solomon R. Guggenheim Museum, New York
Purchased with funds contributed by the
Photography Committee. 2000.84

ANNA GASKELL
untitled #47 (hide), 1998
C-print, laminated and mounted on aluminum,

A.P. 2/2, Edition of 3
29 1/16 x 36 inches (73.8 x 91.4 cm)
Solomon R. Guggenheim Museum, New York
Purchased with funds contributed by the
Photography Committee. 2000.90

ANNA GASKELL
untitled #60 (by proxy), 1999
C-print, A.P. 1/2, Edition of 3
60 x 70 inches (152.4 x 177.8 cm)
Solomon R. Guggenheim Museum, New York
Purchased with funds contributed by the Young
Collectors Council. 2000.91

NAN GOLDIN
Naomi and Marlene on the balcony, Boston, 1972
Gelatin-silver print, Edition 2/18
19 3/4 x 16 inches (50.2 x 40.6 cm)
Purchased with funds contributed by the
International Director's Council and Executive
Committee Members: Ruth Baum, Edythe Broad,
Elaine Terner Cooper, Dimitris Daskalopoulos,
Harry David, Gail May Engelberg, Shirley Fiterman,
Nicki Harris, Dakis Joannou, Linda Macklowe,
Peter Norton, Willem Peppler, Tonino Perna,
Elizabeth Richebourg Rea, Simonetta Seragnoli,
David Teiger, and Elliot K. Wolk, with additional
funds contributed by the Photography Committee.
2002.68

NAN GOLDIN
Ivy with Marilyn, Boston, 1973
Gelatin-silver print, Edition 11/18
19 7/8 x 15 7/8 inches (50.5 x 40.3 cm)
Solomon R. Guggenheim Museum, New York
Purchased with funds contributed by the
International Director's Council and Executive
Committee Members: Ruth Baum, Edythe Broad,
Elaine Terner Cooper, Dimitris Daskalopoulos,
Harry David, Gail May Engelberg, Shirley Fiterman,
Nicki Harris, Dakis Joannou, Linda Macklowe,
Peter Norton, Willem Peppler, Tonino Perna,
Elizabeth Richebourg Rea, Simonetta Seragnoli,
David Teiger, and Elliot K. Wolk, with additional
funds contributed by the Photography Committee.
2002.66

NAN GOLDIN
Ivy wearing a fall, Boston, 1973
Gelatin-silver print, Edition 9/18
19 7/8 x 15 7/8 inches (50.5 x 40.3 cm)
Solomon R. Guggenheim Museum, New York
Purchased with funds contributed by the
International Director's Council and Executive
Committee Members: Ruth Baum, Edythe Broad,
Elaine Terner Cooper, Dimitris Daskalopoulos,
Harry David, Gail May Engelberg, Shirley Fiterman,
Nicki Harris, Dakis Joannou, Linda Macklowe,
Peter Norton, Willem Peppler, Tonino Perna,
Elizabeth Richebourg Rea, Simonetta Seragnoli,
David Teiger, and Elliot K. Wolk, with additional
funds contributed by the Photography Committee.
2002.67

NAN GOLDIN
Roommate with teacup, Boston, 1973
Gelatin-silver print, Edition 8/18
19 7/8 x 15 7/8 inches (50.5 x 40.3 cm)
Purchased with funds contributed by the
International Director's Council and Executive
Committee Members: Ruth Baum, Edythe Broad,
Elaine Terner Cooper, Dimitris Daskalopoulos,
Harry David, Gail May Engelberg, Shirley Fiterman,
Nicki Harris, Dakis Joannou, Linda Macklowe,
Peter Norton, Willem Peppler, Tonino Perna,
Elizabeth Richebourg Rea, Simonetta Seragnoli,
David Teiger, and Elliot K. Wolk, with additional
funds contributed by the Photography Committee.
2002.65

NAN GOLDIN
Trixie on the cot, NYC, 1979
Cibachrome print, mounted to Sintra, Edition 18/25
27 3/8 x 40 inches (69.5 x 101.6 cm)
Solomon R. Guggenheim Museum, New York
Purchased with funds contributed by the
International Director's Council and Executive
Committee Members: Ruth Baum, Edythe Broad,
Elaine Terner Cooper, Dimitris Daskalopoulos,
Harry David, Gail May Engelberg, Shirley Fiterman,
Nicki Harris, Dakis Joannou, Linda Macklowe,
Peter Norton, Willem Peppler, Tonino Perna,
Elizabeth Richebourg Rea, Simonetta Seragnoli,

David Teiger, and Elliot K. Wolk, with additional funds contributed by the Photography Committee. 2002.61

NAN GOLDIN
Vivienne in the green dress, NYC, 1980
Cibachrome print, mounted to Sintra, Edition 7/25
41 x 27 3/8 inches (104.1 x 69.5 cm)
Solomon R. Guggenheim Museum, New York
Purchased with funds contributed by the International Director's Council and Executive Committee Members: Ruth Baum, Edythe Broad, Elaine Terner Cooper, Dimitris Daskalopoulos, Harry David, Gail May Engelberg, Shirley Fiterman, Nicki Harris, Dakis Joannou, Linda Macklowe, Peter Norton, Willem Peppler, Tonino Perna, Elizabeth Richebourg Rea, Simonetta Seragnoli, David Teiger, and Elliot K. Wolk, with additional funds contributed by the Photography Committee. 2002.64

NAN GOLDIN
Bruce in his car, NYC, 1981
Cibachrome print, mounted on Sintra, Edition 20/25
30 x 40 inches (76.2 x 101.6 cm)
Solomon R. Guggenheim Museum, New York
Purchased with funds contributed by the International Director's Council and Executive Committee Members: Ruth Baum, Edythe Broad, Elaine Terner Cooper, Dimitris Daskalopoulos, Harry David, Gail May Engelberg, Shirley Fiterman, Nicki Harris, Dakis Joannou, Linda Macklowe, Peter Norton, Willem Peppler, Tonino Perna, Elizabeth Richebourg Rea, Simonetta Seragnoli, David Teiger, and Elliot K. Wolk, with additional funds contributed by the Photography Committee. 2002.69

NAN GOLDIN
Greer and Robert on the bed, NYC, 1982
Cibachrome print, mounted on Sintra, Exhibition print, Edition of 25
27 5/16 x 40 inches (69.4 x 101.6 cm)
Solomon R. Guggenheim Museum, New York
Gift of the artist and Matthew Marks Gallery. 2002.47

NAN GOLDIN
Suzanne on her bed, NYC, 1983
Cibachrome print, mounted on Sintra, Edition 15/25
27 5/16 x 40 inches (69.4 x 101.6 cm)
Solomon R. Guggenheim Museum, New York
Purchased with funds contributed by the International Director's Council and Executive Committee Members: Ruth Baum, Edythe Broad, Elaine Terner Cooper, Dimitris Daskalopoulos, Harry David, Gail May Engelberg, Shirley Fiterman, Nicki Harris, Dakis Joannou, Linda Macklowe, Peter Norton, Willem Peppler, Tonino Perna, Elizabeth Richebourg Rea, Simonetta Seragnoli, David Teiger, and Elliot K. Wolk, with additional funds contributed by the Photography Committee. 2002.70

NAN GOLDIN
Self-portrait with milagro, The Lodge, Belmont, MA, 1988
Cibachrome print, mounted on Sintra, Edition 8/25
27 1/4 x 40 inches (69.2 x 101.6 cm)
Solomon R. Guggenheim Museum, New York
Gift, Mr. Gerard Cohen. 2003.2

NAN GOLDIN
David Wojnarowicz at home, NYC, 1990
Cibachrome print, mounted on Sintra, Edition 15/25
30 x 40 inches (76.2 x 101.6 cm)
Solomon R. Guggenheim Museum, New York
Purchased with funds contributed by the International Director's Council and Executive Committee Members: Ruth Baum, Edythe Broad, Elaine Terner Cooper, Dimitris Daskalopoulos, Harry David, Gail May Engelberg, Shirley Fiterman, Nicki Harris, Dakis Joannou, Linda Macklowe, Peter Norton, Willem Peppler, Tonino Perna, Elizabeth Richebourg Rea, Simonetta Seragnoli, David Teiger, and Elliot K. Wolk, with additional funds contributed by the Photography Committee. 2002.71

NAN GOLDIN
Gina at Bruce's dinner party, NYC, 1991
Cibachrome print, mounted to museum board, Edition 20/25
27 3/8 x 40 inches (69.5 x 101.6 cm)
Solomon R. Guggenheim Museum, New York

Purchased with funds contributed by the International Director's Council and Executive Committee Members: Ruth Baum, Edythe Broad, Elaine Terner Cooper, Dimitris Daskalopoulos, Harry David, Gail May Engelberg, Shirley Fiterman, Nicki Harris, Dakis Joannou, Linda Macklowe, Peter Norton, Willem Peppler, Tonino Perna, Elizabeth Richebourg Rea, Simonetta Seragnoli, David Teiger, and Elliot K. Wolk, with additional funds contributed by the Photography Committee. 2002.60

NAN GOLDIN
Kim in rhinestones, Paris, 1991
Cibachrome print, mounted on Sintra, Edition 11/25
40 1/16 x 27 3/8 inches (101.8 x 69.5 cm)
Solomon R. Guggenheim Museum, New York
Purchased with funds contributed by the International Director's Council and Executive Committee Members: Ruth Baum, Edythe Broad, Elaine Terner Cooper, Dimitris Daskalopoulos, Harry David, Gail May Engelberg, Shirley Fiterman, Nicki Harris, Dakis Joannou, Linda Macklowe, Peter Norton, Willem Peppler, Tonino Perna, Elizabeth Richebourg Rea, Simonetta Seragnoli, David Teiger, and Elliot K. Wolk, with additional funds contributed by the Photography Committee. 2002.63

NAN GOLDIN
Siobhan in the woods, Provincetown, 1991
Cibachrome print, mounted on Sintra, Edition 6/25
27 3/8 x 40 inches (69.5 x 101.6 cm)
Solomon R. Guggenheim Museum, New York
Purchased with funds contributed by the International Director's Council and Executive Committee Members: Ruth Baum, Edythe Broad, Elaine Terner Cooper, Dimitris Daskalopoulos, Harry David, Gail May Engelberg, Shirley Fiterman, Nicki Harris, Dakis Joannou, Linda Macklowe, Peter Norton, Willem Peppler, Tonino Perna, Elizabeth Richebourg Rea, Simonetta Seragnoli, David Teiger, and Elliot K. Wolk, with additional funds contributed by the Photography Committee. 2002.72

NAN GOLDIN
Gilles and Gotscho at home, Paris, 1992
Cibachrome print, Edition 6/25
30 x 40 inches (76.2 x 101.6 cm)
Solomon R. Guggenheim Museum, New York
Purchased with funds contributed by the
International Director's Council and Executive
Committee Members: Ruth Baum, Edythe Broad,
Elaine Terner Cooper, Dimitris Daskalopoulos,
Harry David, Gail May Engelberg, Shirley Fiterman,
Nicki Harris, Dakis Joannou, Linda Macklowe,
Peter Norton, Willem Peppler, Tonino Perna,
Elizabeth Richebourg Rea, Simonetta Seragnoli,
David Teiger, and Elliot K. Wolk, with additional
funds contributed by the Photography Committee.
2002.74

NAN GOLDIN
Yogo in the mirror, Bangkok, 1992
Cibachrome print, mounted on Sintra, Edition 5/25
27 3/8 x 40 inches (69.5 x 101.6 cm)
Solomon R. Guggenheim Museum, New York
Purchased with funds contributed by the
International Director's Council and Executive
Committee Members: Ruth Baum, Edythe Broad,
Elaine Terner Cooper, Dimitris Daskalopoulos,
Harry David, Gail May Engelberg, Shirley Fiterman,
Nicki Harris, Dakis Joannou, Linda Macklowe,
Peter Norton, Willem Peppler, Tonino Perna,
Elizabeth Richebourg Rea, Simonetta Seragnoli,
David Teiger, and Elliot K. Wolk, with additional
funds contributed by the Photography Committee.
2002.73

NAN GOLDIN
Joey in my bathtub, Sag Harbor, 1999
Cibachrome print, mounted on Sintra, Edition 8/15
30 x 40 inches (76.2 x 101.6 cm)
Solomon R. Guggenheim Museum, New York
Purchased with funds contributed by the
International Director's Council and Executive
Committee Members: Ruth Baum, Edythe Broad,
Elaine Terner Cooper, Dimitris Daskalopoulos,
Harry David, Gail May Engelberg, Shirley Fiterman,
Nicki Harris, Dakis Joannou, Linda Macklowe,
Peter Norton, Willem Peppler, Tonino Perna,
Elizabeth Richebourg Rea, Simonetta Seragnoli,
David Teiger, with additional

funds contributed by the Photography Committee.
2002.62

DOUGLAS GORDON
Tattoo (for Reflection), 1997
C-print, Edition 9/11
27 1/4 x 27 1/4 inches (69.9 x 69.9 cm)
Solomon R. Guggenheim Museum, New York
Purchased with funds contributed by the
Photography Committee. 2002.32

DOUGLAS GORDON
through a looking glass, 1999
Two-channel video installation with sound,
00:60:00, Edition 3/3; dimensions vary with
installation
Solomon R. Guggenheim Museum, New York
Purchased with funds contributed by the
International Director's Council and Executive
Committee Members: Edythe Broad, Henry Buhl,
Elaine Terner Cooper, Gail May Engelberg, Linda
Fischbach, Ronnie Heyman, Dakis Joannou, Cindy
Johnson, Barbara Lane, Linda Macklowe, Peter
Norton, Willem Peppler, Denise Rich, Simonetta
Seragnoli, David Teiger, Ginny Williams, Elliot K.
Wolk. 99.5304

KATY GRANNAN
Untitled (from *The Poughkeepsie Journal*), 1999
C-print, mounted on paper, Edition 2/6
47 5/8 x 37 15/16 inches (121 x 96.4 cm)
Solomon R. Guggenheim Museum, New York
Purchased with funds contributed by the
Photography Committee. 2000.73

KATY GRANNAN
Untitled (from *The Poughkeepsie Journal*) 1999
C-print mounted on paper, Edition 2/6
47 1/2 x 38 inches (120.7 x 96.5 cm)
Solomon R. Guggenheim Museum, New York
Gift, Mr. and Mrs. Nicholas Rohatyn. 2000.103

ANDREAS GURSKY
Singapore Stock Exchange, 1997
Cibachrome print, laminated to Plexiglas, Edition
6/6
66 7/8 x 106 1/4 inches (169.9 x 269.9 cm)
Solomon R. Guggenheim Museum, New York

Purchased with funds contributed by the
Photography Committee. 98.4627

ANDREAS GURSKY
Library, 1999
Cibachrome print, laminated to Plexiglas,
Edition 2/6
79 x 142 inches (200.7 x 360.7 cm)
Solomon R. Guggenheim Museum, New York
Purchase with funds contributed by the
Photography Committee. 99.5305

ANDREAS GURSKY
Madonna I, 2001
Cibachrome print, laminated to Plexiglas,
Edition 3/6
111 x 81 5/8 inches (281.9 x 207.3 cm)
Collection Glenn Fuhrman, New York

ANN HAMILTON
untitled (the capacity of absorption), 1988/1993
Color-toned video and LCD screen, silent, 00:30:00,
Edition 3/9
3 1/2 x 4 1/2 inches (8.9 x 11.4 cm)
Solomon R. Guggenheim Museum, New York
Gift, Peter Norton Family Foundation. 94.4260

ANN HAMILTON
*untitled (dissections . . . they said it was an
experiment)*, 1988/1993
Color-toned video and LCD screen, silent, 00:30:00,
Edition 3/9
3 1/2 x 4 1/2 inches (8.9 x 11.4 cm)
Solomon R. Guggenheim Museum, New York
Gift, Peter Norton Family Foundation. 94.4261

ANN HAMILTON
untitled (linings), 1990/1993
Color-toned video and LCD screen, silent, 00:30:00,
Edition 3/9
3 1/2 x 4 1/2 inches (8.9 x 11.4 cm)
Solomon R. Guggenheim Museum, New York
Gift, Ginny Williams Family Foundation. 94.4259

ANN HAMILTON
untitled (aleph), 1992/1993
Color-toned video and LCD screen with sound,
00:30:00, Edition 3/9

3 1/2 x 4 1/2 inches (8.9 x 11.4 cm)
Solomon R. Guggenheim Museum, New York
Gift, Ginny Williams Family Foundation. 94.4258

ANTHONY HERNANDEZ
Rome #1, 1999
Cibachrome print, Edition 4/5
40 x 40 inches (101.6 x 101.6 cm)
Solomon R. Guggenheim Museum, New York
Promised gift, David Teiger. 2001.10

ANTHONY HERNANDEZ
Rome #17, 1999
Cibachrome print, A.P., Edition of 5
39 3/8 x 39 1/4 inches (100 x 99.7 cm)
Solomon R. Guggenheim Museum, New York
Purchased with funds contributed by the
Photography Committee. 2000.125

ANTHONY HERNANDEZ
Rome #25, 1999
Cibachrome print, A.P., Edition of 5
47 x 46 1/2 inches (119.4 x 118.1 cm)
Solomon R. Guggenheim Museum, New York
Purchased with funds contributed by the
Photography Committee. 2000.126

CANDIDA HÖFER
Deichmanske Bibliothek Oslo II, 2000
C-print, laminated to Plexiglas, Edition 6/6
47 1/4 x 47 1/4 inches (120 x 120 cm)
Solomon R. Guggenheim Museum, New York
Purchased with funds contributed by the Harriet
Ames Charitable Trust. 2000.122

PIERRE HUYGHE
One Million Kingdoms, 2001
Video installation with sound, 00:07:00, Edition 5/6;
dimensions vary with installation
Solomon R. Guggenheim Museum, New York
Purchased by exchange with funds contributed by
the International Director's Council and Executive
Committee Members: Ann Ames, Edythe Broad,
Elaine Terner Cooper, Dimitris Daskalopoulos,
Harry David, Nicki Harris, Ronnie Heyman, Dakis
Joannou, Barbara Lane, Linda Macklowe, Peter
Norton, Tonino Perna, Simonetta Seragnoli, David
Teiger, Elliot K. Wolk. 2002.14

WILLIAM KENTRIDGE
Felix in Exile, 1994
Video with sound, 00:08:43, Edition 7/10;
dimensions vary with installation
Solomon R. Guggenheim Museum, New York
Purchased with funds contributed by the Peter
Norton Family Foundation and by the International
Director's Council and Executive Committee
Members: Ann Ames, Edythe Broad, Henry Buhl,
Elaine Terner Cooper, Dimitris Daskalopoulos,
Harry David, Gail May Engelberg, Linda Fischbach,
Ronnie Heyman, Dakis Joannou, Cindy Johnson,
Barbara Lane, Linda Macklowe, Peter Norton,
Willem Peppler, Denise Rich, Simonetta Seragnoli,
David Teiger, Ginny Williams, Elliot K. Wolk.
2000.117

WILLIAM KENTRIDGE
History of the Main Complaint, 1996
Video with sound, 00:05:50, Edition 7/10;
dimensions vary with installation
Solomon R. Guggenheim Museum, New York
Purchased with funds contributed by the Peter
Norton Family Foundation and by the International
Director's Council and Executive Committee
Members: Ann Ames, Edythe Broad, Henry Buhl,
Elaine Terner Cooper, Dimitris Daskalopoulos,
Harry David, Gail May Engelberg, Linda Fischbach,
Ronnie Heyman, Dakis Joannou, Cindy Johnson,
Barbara Lane, Linda Macklowe, Peter Norton,
Willem Peppler, Denise Rich, Simonetta Seragnoli,
David Teiger, Ginny Williams, Elliot K. Wolk.
2000.118

GLENN LIGON
Notes on the Margin of the Black Book, 1991–93
Off-set prints and text
91 off-set prints, framed: 11 1/2 x 11 1/2 inches
(27.9 x 28.6 cm) each; 78 text pages, framed:
5 1/4 x 7 1/4 inches (13.3 x 18.4 cm) each
Solomon R. Guggenheim Museum, New York
Partial and promised gift, The Bohen Foundation.
2001.180

IÑIGO MANGLANO-OVALLE
Glenn, Dario, and Tyrone (from *The Garden of
Delights*), 1998
Three C-prints, mounted on Plexiglas and

laminated to Plexiglas, Edition 1/3
60 x 23 x 1 1/4 inches (152.4 x 58.4 x 3.2 cm) each;
60 1/16 x 75 x 1 1/4 inches (152.6 x 290.5 x 3.2 cm)
overall
Solomon R. Guggenheim Museum, New York
Partial and promised gift, The Bohen Foundation.
2001.185

IÑIGO MANGLANO-OVALLE
Byron, Lisa, and Emmitt (from *The Garden of
Delights*), 1998
Three C-prints, mounted on Plexiglas and
laminated to Plexiglas, Edition 1/3
60 1/16 x 23 x 1 1/4 inches (152.6 x 58.4 x 3.2 cm)
each; 60 1/16 x 75 x 1 1/4 inches (152.6 x 290.5 x
3.2 cm) overall
Solomon R. Guggenheim Museum, New York
Partial and promised gift, The Bohen Foundation.
2001.186

IÑIGO MANGLANO-OVALLE
Lester, Hamza, and Sonny (from *The Garden of
Delights*), 1998
Three C-prints, mounted on Plexiglas and
laminated to Plexiglas, Edition 1/3
60 1/16 x 23 x 1 1/4 inches (152.6 x 58.4 x 3.2 cm)
each; 60 1/16 x 75 x 1 1/4 inches (152.6 x 290.5 x
3.2 cm) overall
Solomon R. Guggenheim Museum, New York
Partial and promised gift, The Bohen Foundation.
2001.187

IÑIGO MANGLANO-OVALLE
Kerry, Cheryl, and Sydney (from *The Garden of
Delights*), 1998
Three C-prints, mounted on Plexiglas and
laminated to Plexiglas, Edition 1/3
60 1/16 x 23 x 1 1/4 inches (152.6 x 58.4 x 3.2 cm)
each; 60 1/16 x 75 x 1 1/4 inches (152.6 x 290.5 x
3.2 cm) overall
Solomon R. Guggenheim Museum, New York
Partial and promised gift, The Bohen Foundation.
2001.188

IÑIGO MANGLANO-OVALLE
Climate, 2000
Three-channel video installation with
sound, 00:23:35, Edition 1/3; dimensions

vary with installation
Solomon R. Guggenheim Museum, New York
Partial and promised gift, The Bohen Foundation
2001.190

ANNETTE MESSAGER
My Vows, 1990
Gelatin-silver prints and string
Approx. 140 x 73 inches (355.6 x 185.4 cm)
Solomon R. Guggenheim Museum, New York
Purchased with funds contributed by the Peter
Norton Family Foundation. 93.4237

MARIKO MORI
Entropy of Love, 1996
Glass with photo interlayer
120 1/16 x 240 3/16 x 13/16 inches (305 x
610 x 2 cm)
Courtesy The Dakis Joannou Collection, Athens

MARIKO MORI
Miko No Inori, 1996
Video with sound, 00:29:23, Edition 20/100
Courtesy The Dakis Joannou Collection, Athens

MARIKO MORI
Burning Desire, 1996–98
Glass with photo interlayer
120 1/16 x 240 3/16 x 13/16 inches
(305 x 610 x 2 cm)
Courtesy The Dakis Joannou Collection, Athens

MARIKO MORI
Mirror of Water, 1996–98
Glass with photo interlayer
120 1/16 x 240 3/16 x 13/16 inches (305 x
610 x 2 cm)
Courtesy The Dakis Joannou Collection, Athens

MARIKO MORI
Pureland, 1997
Glass with photo interlayer
120 1/16 x 240 3/16 x 13/16 inches (305 x
610 x 2 cm)
Courtesy The Dakis Joannou Collection, Athens

SHIRIN NESHAT
Passage, 2001
35-mm film with sound, 00:11:40, Edition 5/6
Solomon R. Guggenheim Museum, New York
Purchased with funds contributed by Dakis
Joannou and by the International Director's
Council and Executive Committee Members: Ann
Ames, Edythe Broad, Elaine Terner Cooper,
Dimitris Daskalopoulos, Harry David, Ulla Dreyfus-
Best, Gail May Engelberg, Nicki Harris, Ronnie
Heyman, Dakis Joannou, Barbara Lane, Linda
Macklowe, Peter Norton, Willem Peppler, Tonino
Perna, Elizabeth Rea Richebourg, Denise Rich,
Simonetta Seragnoli, David Teiger, Elliot K. Wolk.
2001.70

RIKA NOGUCHI
A Prime #14, 1999
C-print, Edition 1/5
26 x 37 1/4 inches (66 x 94.6 cm)
Solomon R. Guggenheim Museum, New York
Gift, The Bohen Foundation. 2003.25

RIKA NOGUCHI
Dreaming of Babylon 12, 1999–2000
C-print, Edition 1/7
27 3/4 x 27 3/4 inches (70.5 x 70.5 cm)
Solomon R. Guggenheim Museum, New York
Gift, The Bohen Foundation. 2003.26

RIKA NOGUCHI
Dreaming of Babylon 15, 1999–2000
C-print, Edition 1/7
27 3/4 x 27 3/4 inches (70.5 x 70.5 cm)
Solomon R. Guggenheim Museum, New York
Gift, The Bohen Foundation. 2003.27

RIKA NOGUCHI
Dreaming of Babylon 16, 1999–2000
C-print, Edition 1/7
27 3/4 x 27 3/4 inches (70.5 x 70.5 cm)
Solomon R. Guggenheim Museum, New York
Gift, The Bohen Foundation. 2003.28

CATHERINE OPIE
Dyke, 1993
Chromogenic print, A.P. 1/2, Edition of 8
40 x 30 inches (101.6 x 76.2 cm)

Solomon R. Guggenheim Museum, New York
Purchased with funds contributed by the
Photography Committee. 2003.69

CATHERINE OPIE
Self-Portrait/Pervert, 1994
Chromogenic print, A.P. 2/2, Edition of 8
40 x 30 inches (101.6 x 76.2 cm)
Solomon R. Guggenheim Museum, New York
Purchased with funds contributed by the
Photography Committee. 2003.68

CATHERINE OPIE
Melissa & Lake, Durham, North Carolina, 1998
C-print, laminated to Sintra, Edition 3/5
39 3/4 x 49 3/4 inches (100.9 x 126.4 cm)
Solomon R. Guggenheim Museum, New York
Purchased with funds contributed by the
Photography Committee. 2000.71

GABRIEL OROZCO
Dos Parejas (*Two Couples*), 1990
Cibachrome print, A.P. 1/1, Edition of 5
15 7/8 x 18 5/8 (40.3 x 47.3 cm)
Solomon R. Guggenheim Museum, New York
Purchased with funds contributed by the
Photography Committee. 98.4636

GABRIEL OROZCO
Pulpo (*Octopus*), 1991
Cibachrome print, Edition 2/5
19 15/16 x 15 15/16 inches (50.6 x 40.5 cm)
Solomon R. Guggenheim Museum, New York
Purchased with funds contributed by the Young
Collectors Council. 99.5311

GABRIEL OROZCO
Mi Oficina II (*My Office II*), 1992
Cibachrome print, A.P. 1/1, Edition of 5
15 15/16 x 19 15/16 inches (40.5 x 50.5 cm)
Solomon R. Guggenheim Museum, New York
Purchased with funds contributed by the Young
Collectors Council. 99.5310

GABRIEL OROZCO
Pelota en agua (*Ball on Water*), 1994
Cibachrome print, A.P. 1/1, Edition of 5
15 7/8 x 19 7/8 inches (40.3 x 50.5 cm)

Solomon R. Guggenheim Museum, New York
Purchased with funds contributed by the
Photography Committee. 98.4632

GABRIEL OROZCO
Comedor en Tepoztlán (Dining Room in Tepoztlán),
1995
Cibachrome print, Edition 2/5
15 15/16 x 19 13/16 inches (40.5 x 50.3 cm)
Solomon R. Guggenheim Museum, New York
Purchased with funds contributed by the
Photography Committee. 98.4634

GABRIEL OROZCO
Cow in Bhuj, 1996
Cibachrome print, Edition 4/5
12 1/8 x 18 1/2 inches (30.8 x 47 cm)
Solomon R. Guggenheim Museum, New York
Gift, Stafford R. Broumand. 2000.136

GABRIEL OROZCO
Parachute in Iceland (East), 1996
Cibachrome print, Edition 1/5
15 7/8 x 19 7/8 inches (40.3 x 50.5 cm)
Solomon R. Guggenheim Museum, New York
Purchased with funds contributed by the
Photography Committee. 98.4635

GABRIEL OROZCO
Comedor Blanco (White Dining Room), 1998
Cibachrome print, Edition 1/5
15 7/8 x 20 inches (40.3 x 50.8 cm)
Solomon R. Guggenheim Museum, New York
Purchased with funds contributed by the
Photography Committee. 98.4633

GABRIEL OROZCO
Nike Town, 1998
Cibachrome print, Edition 5/5
15 7/8 x 20 inches (40.4 x 50.8 cm)
Solomon R. Guggenheim Museum, New York
Purchased with funds contributed by the
Photography Committee. 99.5270

JOHN PILSON
À la claire fontaine, 2000
Eight-channel video installation with
sound, 00:02:35, Edition 3/4; dimensions

vary with installation
Solomon R. Guggenheim Museum, New York
Purchased with funds contributed by the Young
Collectors Council. 2001.73

PIPILOTTI RIST
Sip My Ocean, 1996
Single-channel video installation, shown using two
projectors, with sound, 00:08:00, Edition 3/3;
dimensions vary with installation
Solomon R. Guggenheim Museum, New York
Purchased with funds contributed by Hugo Boss on
the occasion of the Hugo Boss Prize 1998 and by
the International Director's Council and Executive
Committee Members: Edythe Broad, Elaine Terner
Cooper, Linda Fischbach, Ronnie Heyman, J.
Tomilson Hill, Dakis Joannou, Cindy Johnson,
Barbara Lane, Linda Macklowe, Brian McIver,
Peter Norton, Willem Peppler, Alain-Dominique
Perrin, Rachel Rudin, David Teiger, Ginny Williams,
Elliot K. Wolk. 98.5226

PIPILOTTI RIST
Atmosphere & Instinct, 1998
Video installation with sound, 00:02:15, Edition 2/3;
dimensions vary with installation
Solomon R. Guggenheim Museum, New York
Partial and promised gift, The Bohen Foundation.
2001.237

MICHAL ROVNER
One-Person Game Against Nature I #32, 1992
Chromogenic print, Edition 6/7
39 5/16 x 38 7/8 inches (99.9 x 98.7 cm)
Solomon R. Guggenheim Museum, New York
Partial and promised gift, The Bohen Foundation.
2001.244

MICHAL ROVNER
One-Person Game Against Nature I #33, 1992
Chromogenic print, Edition 5/7
39 5/16 x 38 7/8 inches (99.9 x 98.7 cm)
Solomon R. Guggenheim Museum, New York
Partial and promised gift, The Bohen Foundation.
2001.245

MICHAL ROVNER
One-Person Game Against Nature I #34, 1992

Chromogenic print, Edition 4/7
39 5/16 x 38 7/8 inches (99.9 x 98.7 cm)
Solomon R. Guggenheim Museum, New York
Partial and promised gift, The Bohen Foundation.
2001.246

MICHAL ROVNER
One-Person Game Against Nature I #35, 1992
Chromogenic color print, Edition 4/7
39 5/16 x 38 7/8 inches (99.9 x 98.7 cm)
Solomon R. Guggenheim Museum, New York
Partial and promised gift, The Bohen Foundation.
2001.247

MICHAL ROVNER
China, 1995
Four C-prints, Edition 1/8
40 x 160 x 3 inches (101.6 x 406.4 x 7.6 cm) overall
Solomon R. Guggenheim Museum, New York
Partial and promised gift, The Bohen Foundation.
2001.250

THOMAS RUFF
Portrait (M. Roeser), 1999
C-print, Edition 3/4
79 3/8 x 61 5/8 inches (201.6 x 156.5 cm)
Solomon R. Guggenheim Museum, New York
Purchased with funds contributed by the
Photography Committee. 2001.31

THOMAS RUFF
h.l.k. 01, 2000
C-print, Edition of 5
51 3/16 x 72 13/16 inches (130 x 185 cm)
Collection Jennifer and David Stockman

ANRI SALA
Nocturnes, 1999
Video installation with sound, 00:11:28, A.P. 1/2,
Edition of 6; dimensions vary with installation
Solomon R. Guggenheim Museum, New York
Purchased with funds contributed by the
International Director's Council and Executive
Committee Members: Ruth Baum, Edythe Broad,
Elaine Terner Cooper, Dimitris Daskalopoulos,
Harry David, Gail May Engelberg, Shirley Fiterman,
Nicki Harris, Dakis Joannou, Linda Macklowe,
Peter Norton, Tonino Perna, Elizabeth Richebourg

Rea, Mortimer Sackler, Jr., Simonetta Seragnoli, David Teiger, Elliot K. Wolk. 2003.58

JÖRG SASSE
2637, 2000
Lambda print, mounted on Sintra and laminated to Plexiglas, A.P. 1/1, Edition of 6
70 15/16 x 48 1/4 x 3/4 inches (180.2 x 122.6 x 1.9 cm)
Solomon R. Guggenheim Museum, New York
Purchased with funds contributed by the Harriet Ames Charitable Trust. 2002.18

JÖRG SASSE
8246, 2000
Lambda print, mounted on Sintra and laminated to Plexiglas, A.P. 1/1, Edition of 6
40 5/8 x 63 x 3/4 inches (103.2 x 160 x 1.9 cm)
Solomon R. Guggenheim Museum, New York
Purchased with funds contributed by the Harriet Ames Charitable Trust. 2002.19

SIMON STARLING
HOME-MADE EAMES (FORMERS, JIGS & MOLDS), 2002
Four C-prints, Edition 3/10
30 x 39 inches (76.2 x 99.1 cm) each
Solomon R. Guggenheim Museum, New York
Purchased with funds contributed by Jerome and Ellen Stern and by Rosa and Carlos de la Cruz. T25.2003

THOMAS STRUTH
Milan Cathedral (Interior), 1998
Cibachrome print, laminated to Plexiglas, Edition 4/10
73 1/4 x 91 inches (186 x 231.3 cm)
Solomon R. Guggenheim Museum, New York
Purchased with funds contributed by the Harriet Ames Charitable Trust and by the International Director's Council and Executive Committee Members: Edythe Broad, Henry Buhl, Elaine Terner Cooper, Gail May Engelberg, Linda Fischbach, Ronnie Heyman, Dakis Joannou, Cindy Johnson, Barbara Lane, Linda Macklowe, Peter Norton, Willem Peppler, Denise Rich, Simonetta Seragnoli, David Teiger, Ginny Williams, Elliot K. Wolk. 99.5301

THOMAS STRUTH
The Richter Family I, Cologne, 2002
Cibachrome print, laminated to Plexiglas, Edition 2/10
52 1/2 x 75 1/2 inches (133.4 x 191.8 cm)
Solomon R. Guggenheim Museum, New York
Purchased with funds contributed by the Harriet Ames Charitable Trust and by the International Director's Council and Executive Committee Members: Edythe Broad, Elaine Terner Cooper, Dimitris Daskalopoulos, Harry David, Nicki Harris, Ronnie Heyman, Dakis Joannou, Barbara Lane, Linda Macklowe, Peter Norton, Tonino Perna, Simonetta Seragnoli, David Teiger, Elliot K. Wolk. 2002.36

SAM TAYLOR-WOOD
Soliloquy I, 1998
2 C-prints, Edition 4/6
82 1/4 x 101 x 2 inches (208.9 x 256.5 x 5.1 cm) overall
Solomon R. Guggenheim Museum, New York
Partial and promised gift, David Teiger. 2000.104

SAM TAYLOR-WOOD
Soliloquy II, 1998
2 C-prints, Edition 2/6
82 1/4 x 101 x 2 inches (208.9 x 256.5 x 5.1 cm) overall
Solomon R. Guggenheim Museum, New York
Partial and promised gift, The Bohen Foundation. 2001.285

SAM TAYLOR-WOOD
Soliloquy III, 1998
2 C-prints, Edition 4/6
88 x 101 x 2 inches (223.5 x 256.5 x 5.1 cm) overall
Solomon R. Guggenheim Museum, New York
Partial and promised gift, David Teiger. 2000.105

SAM TAYLOR-WOOD
Soliloquy IV, 1998
2 C-prints, Edition 2/6
88 x 101 x 2 inches (223.5 x 256.5 x 5.1 cm) overall
Solomon R. Guggenheim Museum, New York
Partial and promised gift, The Bohen Foundation. 2001.286

SAM TAYLOR-WOOD
Soliloquy V, 1998
2 C-prints, Edition 4/6
88 x 101 x 2 inches (223.5 x 256.5 x 5.1 cm) overall
Solomon R. Guggenheim Museum, New York
Partial and promised gift, David Teiger. 2000.106

DIANA THATER
Late and Soon, Occident Trotting, 1993
Single-channel video installation, shown using four projectors, silent, 00:30:00, Edition 1/1, 1 A.P.; dimensions vary with installation
Solomon R. Guggenheim Museum, New York
Partial and promised gift, The Bohen Foundation. 2001.288

WOLFGANG TILLMANS
Guggenheim/New York Installation 1991–2000, 2002
Includes:

Adam, head down, 1991
Off-set print
7 x 5 inches (17.8 x 12.7 cm)
Solomon R. Guggenheim Museum, New York
Gift of the artist. 2002.51.2

Adam, redeye, 1991
C-print, Edition 2/3
24 x 20 inches (61 x 50.8 cm)
Solomon R. Guggenheim Museum, New York
Purchased with funds contributed by the Photography Committee. 2001.33.12

grey jeans over stair post, 1991
C-print, Edition 3/3
20 x 24 inches (50.8 x 61 cm)
Solomon R. Guggenheim Museum, New York
Purchased with funds contributed by the Photography Committee. 2001.33.2

Lutz wanking, 1991
Off-set print
6 x 4 inches (15.2 x 10.2 cm)
Solomon R. Guggenheim Museum, New York
Gift of the artist. 2002.51.3

Techno, 1991
Off-set print
12 x 18 1/2 inches (30.5 x 47 cm)
Solomon R. Guggenheim Museum, New York
Gift of the artist. 2002.51.1

Christos, 1992
Off-set print
6 x 4 inches (15.2 x 10.2 cm)
Solomon R. Guggenheim Museum, New York
Gift of the artist. 2002.51.4

from acropolis now, 1992
Off-set print
12 x 9 1/4 inches (30.5 x 23.5 cm)
Solomon R. Guggenheim Museum, New York
Gift of the artist. 2002.51.6

From like brother, like sister, 1992
Off-set print
12 x 18 1/2 inches (30.5 x 47 cm)
Solomon R. Guggenheim Museum, New York
Gift of the artist. 2002.51.5

Lutz & Alex holding cock, 1992
C-print
16 x 12 inches (40.6 x 30.5 cm)
Solomon R. Guggenheim Museum, New York
Gift of the artist. 2002.51.17

Lutz & Alex holding cock, 1992
C-print, Edition 10/10
16 x 12 inches (40.6 x 30.5 cm)
Solomon R. Guggenheim Museum, New York
Purchased with funds contributed by the
Photography Committee. 2001.33.7

outside Planet, view, 1992
C-print, Edition 3/10
16 x 12 inches (40.6 x 30.5 cm)
Solomon R. Guggenheim Museum, New York
Purchased with funds contributed by the
Photography Committee. 2002.54

Andy on Baker Street, 1993
C-print, Edition 3/10
16 x 12 inches (40.6 x 30.5 cm)
Solomon R. Guggenheim Museum, New York

Purchased with funds contributed by the
Photography Committee. 2001.33.8

Bernadette & Thuy, 1993
C-print
6 x 4 inches (15.2 x 10.2 cm)
Solomon R. Guggenheim Museum, New York
Gift of the artist. 2002.51.7

Whatever happened to the peace movement, 1993
Off-set print
12 x 18 1/2 inches (30.5 x 47 cm)
Solomon R. Guggenheim Museum, New York
Gift of the artist. 2002.51.8

indian corn & pomegranate, 1994
C-print, Edition 5/10
12 x 16 inches (30.5 x 40.6 cm)
Solomon R. Guggenheim Museum, New York
Purchased with funds contributed by the
Photography Committee. 2001.33.10

like praying, I and II, 1994
Two C-prints, Edition 1/1 (exhibition copy,
Inkjet print)
54 x 82 3/16 inches (137.2 x 208.8 cm) each
Solomon R. Guggenheim Museum, New York
Purchased with funds contributed by the
International Director's Council and Executive
Committee Members: Ann Ames, Edythe Broad,
Elaine Terner Cooper, Dimitris Daskalopoulos,
Harry David, Ulla Dreyfus-Best, Gail May
Engelberg, Nicki Harris, Ronnie Heyman, Dakis
Joannou, Cindy Johnson, Barbara Lane, Linda
Macklowe, Peter Norton, Willem Peppler, Denise
Rich, Elizabeth Richebourg Rea, Simonetta
Seragnoli, David Teiger, Elliot K. Wolk. 2001.26.1, .2

AA Breakfast, 1995
Off-set print
4 x 6 inches (10.2 x 15.2 cm)
Solomon R. Guggenheim Museum, New York
Gift of the artist. 2002.51.13

Deer Hirsch, 1995
C-print, Edition 2/10
12 x 16 inches (30.5 x 40.6 cm)
Solomon R. Guggenheim Museum, New York

Purchased with funds contributed by the
Photography Committee. 2001.33.9

geese/boy, 1995
Off-set print
4 x 6 inches (10.2 x 15.2 cm)
Solomon R. Guggenheim Museum, New York
Gift of the artist. 2002.51.12

Hallenbad, Detail, 1995
C-print, Edition 2/3
24 x 20 inches (61 x 50.8 cm)
Solomon R. Guggenheim Museum, New York
Purchased with funds contributed by the
Photography Committee. 2001.33.3

Haselmaus, 1995
Off-set print
6 x 4 inches (15.2 x 10.2 cm)
Solomon R. Guggenheim Museum, New York
Gift of the artist. 2002.51.9

Haselmaus, 1995
Off-set print
16 1/2 x 12 inches (41.9 x 30.5 cm)
Solomon R. Guggenheim Museum, New York
Gift of the artist. 2002.51.10

police helicopter, 1995
C-print, Edition 8/10
12 x 16 inches (30.5 x 40.6 cm)
Solomon R. Guggenheim Museum, New York
Purchased with funds contributed by the
Photography Committee. 2001.33.6

Rachel Auburn & son, 1995
Off-set print
12 x 8 1/4 inches (30.5 x 21 cm)
Solomon R. Guggenheim Museum, New York
Gift of the artist. 2002.51.11

rat, disappearing, 1995
C-print, Edition 3/3
24 x 20 inches (61 x 50.8 cm)
Solomon R. Guggenheim Museum, New York
Purchased with funds contributed by the
Photography Committee. 2001.33.1

Soldier, gangway, 1995
C-print
12 3/4 x 8 5/8 inches (32.4 x 21.9 cm)
Solomon R. Guggenheim Museum, New York
Gift of the artist. 2002.51.16

Alex, 1997
Off-set print
6 x 4 inches (15.2 x 10.2 cm)
Solomon R. Guggenheim Museum, New York
Gift of the artist. 2002.51.14

lily, 1997
Inkjet print, Edition 1/1
78 3/4 x 53 15/16 inches (200 x 137 cm)
Solomon R. Guggenheim Museum, New York
Purchased with funds contributed by the
International Director's Council and Executive
Committee Members: Ruth Baum, Edythe Broad,
Elaine Terner Cooper, Dimitris Daskalopoulos,
Harry David, Gail May Engelberg, Shirley Fiterman,
Nicki Harris, Dakis Joannou, Linda Macklowe,
Peter Norton, Tonino Perna, Elizabeth Richebourg
Rea, Mortimer Sackler, Jr., Simonetta Seragnoli,
David Teiger, Elliot K. Wolk. 2003.64

Minato-Mirai-21, 1997
C-print, Edition 3/3
24 x 20 inches (61 x 50.8 cm)
Solomon R. Guggenheim Museum, New York
Purchased with funds contributed by the
Photography Committee. 2001.33.5

socks on radiator, 1998
C-print, Edition 2/3
24 x 20 inches (61 x 50.8 cm)
Solomon R. Guggenheim Museum, New York
Purchased with funds contributed by the
Photography Committee. 2001.33.11

Still life Grays Inn Road II, 1999
C-print, Edition 7/10
12 x 16 inches (30.5 x 40.6 cm)
Solomon R. Guggenheim Museum, New York
Purchased with funds contributed by the
Photography Committee. 2001.33.4

Irm Hermann, 2000
Inkjet print, Edition 1/1
77 x 53 inches (195.6 x 134.6 cm)
Solomon R. Guggenheim Museum, New York
Purchased with funds contributed by the
International Director's Council and Executive
Committee Members: Ruth Baum, Edythe Broad,
Elaine Terner Cooper, Dimitris Daskalopoulos,
Harry David, Gail May Engelberg, Shirley Fiterman,
Nicki Harris, Dakis Joannou, Linda Macklowe,
Peter Norton, Willem Peppler, Tonino Perna,
Elizabeth Richebourg Rea, Simonetta Seragnoli,
David Teiger, Elliot K. Wolk. 2002.57

Volker, standing, 2000
Off-set print
6 x 4 inches (15.2 x 10.2 cm)
Solomon R. Guggenheim Museum, New York
Gift of the artist. 2002.51.15

KARA WALKER
Insurrection! (Our Tools Were Rudimentary, Yet We Pressed On), 2000
Cut paper silhouettes and light projections
Dimensions vary with installation
Solomon R. Guggenheim Museum, New York
Purchased with funds contributed by the
International Director's Council and Executive
Committee Members: Ann Ames, Edythe Broad,
Henry Buhl, Elaine Terner Cooper, Dimitris
Daskalopoulos, Harry David, Gail May Engelberg,
Ronnie Heyman, Dakis Joannou, Cindy Johnson,
Barbara Lane, Linda Macklowe, Peter Norton,
Willem Peppler, Tonino Perna, Denise Rich,
Simonetta Seragnoli, David Teiger, Ginny Williams,
Elliot K. Wolk. 2000.68

JANE AND LOUISE WILSON
Star City, 2000
Four-channel video installation with sound,
00:08:36, Edition 2/4, dimensions vary with
installation
Solomon R. Guggenheim Museum, New York
Partial and promised gift, The Bohen Foundation.
2001.296

SELECTED READINGS

MARINA ABRAMOVIĆ

Iles, Chrissie, ed. *Marina Abramović: Objects, Performance, Video, Sound* (exh. cat.). Oxford: Museum of Modern Art, 1995.

Kaplan, Janet. "Deeper and Deeper: Interview with Marina Abramović." *Art Journal* (New York) 58, no. 2 (summer 1998), pp. 6–21.

McEvilley, Thomas, Hans-Ulrich Obrist, Bojana Pejic, et al. *Marina Abramović, Artist Body: Performances 1969–1998* (exh. cat., Kunstmuseum Bern). Milan: Charta, 1998.

FRANCIS ALŸS

Davila, Thierry, and Maurice Fréchuret. *Francis Alÿs* (exh. cat., Musée Picasso, Antibes). Paris: Reunion des Musées Nationaux, 2001.

Dueñas, Issa Maria Benitez. "Francis Alÿs: Hypotheses for a Walk." *Art Nexus* (Bogota, Colombia) no. 35 (Feb.–April 2000), pp. 48–53.

Francis Alÿs: Walks = Paseos (exh. cat.). Guadalajara, Jalisco, Mexico: Museo de Arte Moderna, 1997.

Lampert, Catherine, ed. *The Prophet and the Fly*. Madrid: Turner, 2002.

JANINE ANTONI

Cameron, Dan, Amy Cappellazzo, et al. *Janine Antoni*. Küsnacht, Switzerland: Ink Tree Edition, 2000.

Horodner, Stuart. "Janine Antoni." *Bomb* (New York) no. 66 (winter 1999), pp. 48–54.

Princenthal, Nancy. "Janine Antoni: Mother's Milk." *Art in America* (New York) 89, no. 9 (Sept. 2001), pp. 124–28.

MATTHEW BARNEY

"Collaboration Matthew Barney." *Parkett* (Zurich) no. 45 (1995), pp. 29–73. Special issue with essays by Norman Bryson, Thyrza Nichols Goodeve, Michel Onfray, and Keith Seward.

Goodeve, Thyrza Nichols. "Travels in Hypertrophia." *Artforum* (New York) 33, no. 9 (May 1995), pp. 66–71.

Spector, Nancy. *Matthew Barney: The Cremaster Cycle* (exh. cat.). New York: Guggenheim Museum, 2002. With Glossary by Neville Wakefield.

UTA BARTH

Conkelton, Sheryl, Russell Furguson, and Timothy Martin. *Uta Barth: In Between Places* (exh. cat.). Seattle: Henry Art Gallery, 2000.

Kim, Soo Jin. "Undoing Space." *Art & Design* (London) 11, no. 11/12 (Nov.–Dec. 1997), pp. 47–57.

Smith, Elizabeth A. T. *Uta Barth* (exh. cat.). Los Angeles: The Museum of Contemporary Art, 1995 (reprinted by St. Ann's Press, London, 2002).

OLIVER BOBERG

Johnson, Ken. "Art in Review: Oliver Boberg at Paul Morris." *New York Times*, Nov. 19, 1999, Arts and Leisure, p. E41.

Loke, Margarett. "Manipulated Images Toy with Facets of What Is." *New York Times*, July 28, 2000, Arts and Leisure, p. E30.

Mangini, Elizabeth, and Renate Puvogel. *Oliver Boberg: Arbeiten/Works, 1997–99*. Vienna: Eikon (Sonderdruck #4), 1999.

Nash, Richard Eoin. "Follies and Falsities: Architectural Photography." *Performing Arts Journal* (Baltimore) 23, no. 68 (May 2001), pp. 71–74.

JEFF BURTON

Hickey, Dave. *Dreamland: Photographs by Jeff Burton*. New York: Powerhouse Cultural Entertainment, Inc., 2001.

Jeff Burton: Untitled. New York: Composite Press, 1998.

JAMES CASEBERE

Asylum: James Casebere (exh. cat.). Santiago de Compostela, Spain: Xunta de Galicia, 1999.

Berger, Maurice, and Andy Grundberg. *James Casebere: Model Culture, Photographs 1975–1996* (exh. cat.). San Francisco: The Friends of Photography, 1996.

Köhler, Michael, ed. *Constructed Realities: The Art of Staged Photography*. Zurich: Edition Stemmle, 1995.

Vidler, Anthony, Christopher Zhong-Yuan Zhang, and Jeffrey Eugenides. *James Casebere: The Spatial Uncanny* (exh. cat.). Milan: Charta; New York: Sean Kelly Gallery, 2001.

PATTY CHANG

Cohen, Margaret. "The Love Mechanics: New Feminist Art." *Flash Art* (Milan) 33, no. 213 (summer 2000), pp. 90–93.

Wei, Lilly. "Patty Chang at Jack Tilton/Anna Kustera." *Art in America* (New York) 90, no. 6 (June 2002), pp. 121–22.

MILES COOLIDGE

Fogle, Douglas. *Stills: Emerging Photography in the 1990s* (exh. cat.). Minneapolis, Minn.: Walker Art Center, 1997.

Molesworth, Helen. "Nowheresville." *Frieze* (London) no. 44 (Feb. 1999), pp. 57–59.

Sightings: New Photographic Art (exh. cat.). London: Institute of Contemporary Art, 1998.

GREGORY CREWDSON
Crewdson, Gregory. *Dream of Life*. Salamanca, Spain: Ediciones Universidad de Salamanca, 1999.

Crewdson, Gregory. *Twilight*, with an essay by Rick Moody. New York: Harry N. Abrams, 2002.

Schorr, Collier. "Close Encounters." *Frieze* (London) no. 21 (March–April 1995), pp. 44–47.

THOMAS DEMAND
Bonami, Francesco, and Régis Durand. *Thomas Demand* (exh. cat., Fondation Cartier, Paris). London: Thames and Hudson, 2000.

Gaensheimer, Susanne, Neville Wakefield, et al. *Thomas Demand* (exh. cat., Lenbachhaus, Munich; Louisiana Museum, Humlebæk, Denmark). Munich: Shirmer/Mosel, 2002.

Princenthal, Nancy. "Thomas Demand." *Art/Text* (Los Angeles) no. 67 (Nov. 1999–Jan. 2000), pp. 64–69.

Sobel, Dean. *Thomas Demand Catalogue and Exhibition: 2001/2002*. Aspen, Colo.: Aspen Art Museum, 2001.

RINEKE DIJKSTRA
Bishop, Claire. "Rineke Dijkstra: The Naked Immediacy of Photography." *Flash Art* (Milan) 31, no. 203 (Nov.–Dec. 1998), pp. 86–89.

Dijkstra, Rineke. *Rineke Dijkstra: The Buzzclub, Liverpool, UK/ Mysteryworld, Zaandam, NL* (exh. cat.). Hannover: Sprengel Museum, 1998.

Morgan, Jessica, and Katy Siegel. *Rineke Dijkstra: Portraits* (exh. cat.). Boston: Institute of Contemporary Art, 2001.

TRICIA DONNELLY
Miller, John. "Openings: Trisha Donnelly." *Artforum* (New York) 40, no. 11 (summer 2002), pp. 164–65.

Hoffmann, Jens. "Trisha Donnelly." *Flash Art* (Milan) 34 (35?), no. 223 (March–April 2002), p. 97.

Spector, Nancy. "Trisha Donnelly." *Cream 3*. London: Phaidon, 2003, pp. 120–23.

STAN DOUGLAS
Fiske, John, and Scott Watson. *Monodramas and Loops* (exh. cat.). Vancouver: Fine Arts Gallery, University of British Columbia, 1992.

Hixson, Kathryn. "An Interview with Stan Douglas." *New Art Examiner* (Chicago) 28, no. 4 (Dec. 2000/Jan. 2001), pp. 22–26.

Van Assche, Christine, Jean Christophe Royaux, and Peter Cully. *Stan Douglas* (exh. cat.). Paris: Centre Georges Pompidou, 1993.

Watson, Scott, Diana Thater, and Diana J. Clover. *Stan Douglas*. London: Phaidon, 1998.

OLAFUR ELIASSON
Grynsztejn, Madeleine, Daniel Birnbaum, and Michael Speaks. *Olafur Eliasson*. New York: Phaidon, 2002.

The Mediated Motion: Olafur Eliasson (exh. cat., Kunsthaus Bregenz). Cologne: Walther König, 2001.

Morgan, Jessica. *Olafur Eliasson: Your Only Real Thing Is Time* (exh. cat., Institute of Contemporary Art, Boston). Ostfildern-Ruit: Hatje Cantz, 2001.

ELGER ESSER
Hoffman, Barbara. *When Season Becomes Form* (exh. cat.). Cologne: Kulturallianzen, 1998.

Olivo Barbieri / Elger Esser: Cityscapes/Landscapes. Cinisello Balsamo, Milan: Silvana, 2002.

Pfab, Rupert, and Georg Elben. *Elger Esser: Vedutas and Landscapes, 1996–2000*. Munich: Schirmer/Mosel, 2000.

Van Sinderen, Wim. *Friesland Is . . .* (exh. cat.). Leeuwarden, Netherlands: Fries Museum, 2000.

THOMAS FLECHTNER
Dykstra, Jean. "Photo Book Beat." *Art on Paper* (New York) 6, no. 5 (May–June 2002), pp. 94–95.

Flechtner, Thomas. *Snow*. Baden, Switzerland: Lars Müller, 2002. Text by G. Seligman.

PETER FISCHLI AND DAVID WEISS
Armstrong, Elizabeth, Arthur Danto, and Boris Groys. *Peter Fischli and David Weiss: In a Restless World* (exh. cat.). Minneapolis, Minn.: Walker Art Center, 1996.

Bossé, Laurence, and Boris Groys. *Peter Fischli and David Weiss* (exh. cat.). Cologne: Verlag der Buchhandlung Walther König; Paris: Musée d'Art Moderne de la Ville de Paris, 1998.

"Collaboration Peter Fischli/David Weiss." *Parkett* (Zurich) no. 17 (1988), pp. 20–87. Special issue with essays by Bernhard Johannes Blume, Germano Celant, Bice Curiger, Patrick Frey, Karen Marta, Jeanne Silverthorne, and Sidra Stich.

ANNA GASKELL
Anna Gaskell: By Proxy (exh. cat.). Aspen, Colo.: Aspen Art Museum, 2000.

Anna Gaskell: Future's Eve (exh. cat.). San Francisco: New Langton Arts, 2001.

Avgikos, Jan. "Anna Gaskell's Girl Art." *Parkett* (Zurich) no. 59 (2000), pp. 168–76.

Spector, Nancy. "The Fiction of Fiction: An Exquisite Unease." In *Anna Gaskell*, with a story by Thom Jones. New York: Powerhouse Books, 2001.

NAN GOLDIN
Armstrong, David, Hans Werner Holzwarth, and Elizabeth Sussman. *Nan Goldin: I'll Be Your Mirror* (exh. cat.). New York: Whitney Museum of American Art; Zurich: Scalo, 1996.

Blessing, Jennifer. *Rrose Is a Rrose Is a Rrose: Gender Performance in Photography* (exh. cat.). New York: Guggenheim Museum, 1997.

Goldin, Nan. *The Ballad of Sexual Dependency*. With essays by Marvin Heiferman, Mark Holborn, and Suzanne Fletcher. New York: Aperture Foundation, 1986.

Goldin, Nan. *The Other Side*. London: Thames and Hudson; Zurich: Scalo, 1992.

DOUGLAS GORDON
Bellour, Raymond, Oscar van den Boogaard, et al. *Douglas Gordon* (exh. cat.) Lisbon: Centro Cultural de Belem, 1998.

"Collaboration Douglas Gordon." *Parkett* (Zurich) no. 49 (1997), pp. 37–73. Essays by Richard Flood, Tobia Bezzola, Russell Ferguson, and a correspondence between Douglas Gordon and Liam Gillick.

Ferguson, Russell, Michael Darling, et al. *Douglas Gordon* (exh. cat.). Los Angeles: Museum of Contemporary Art; Cambridge, Mass.: MIT Press, 2001.

Hartley, Hal, and Amy Taubin. *through a looking glass* (exh. broch.). New York: Gagosian Gallery, 1999.

KATY GRANNAN
Another Girl, Another Planet (exh. cat.). New York: Lawrence Rubin Greenberg Van Doren Fine Art, 1999. Text by A. M. Holmes.

Katy Grannan: Dream America (exh. cat.). New York: Lawrence Rubin Greenberg Van Doren Fine Art, 2000. Intro by Jeanne Greenberg Rohatyn.

Siegel, Katy. "Another Girl, Another Planet." *Artforum* (New York) 38, no. 1 (Sept. 1999), p. 161.

ANDREAS GURSKY
Andreas Gursky: Images (exh. cat.). Liverpool: Tate Gallery, 1995.

Bryson, Norman. "The Family Firm: Andreas Gursky and German Photography." *Art/Text* (Los Angeles) no. 67 (Nov. 1999–Jan. 2000), pp. 76–81.

Galassi, Peter. *Andreas Gursky* (exh. cat.). New York: Museum of Modern Art, 2001.

Syring, Marie Luise, ed. *Andreas Gursky: Fotografien 1984 bis heute* (exh. cat., Kunsthalle Düsseldorf). Munich: Schirmer/Mosel, 1998.

ANN HAMILTON
Cooke, Lynne, and Karen Kelly, eds. *Ann Hamilton: Tropos* (exh. cat.). New York: Dia Center for the Arts, 1995.

Nesbitt, Judith, ed. *Ann Hamilton: Mneme* (exh. cat.). Liverpool: Tate Gallery, 1994.

Rogers, Sara J. *The Body and the Object: Ann Hamilton, 1984–1996* (exh. cat.). Columbus, Ohio: Wexner Center for the Arts, 1996.

Stewart, Susan. *Ann Hamilton* (exh. cat.). San Diego: Museum of Contemporary Art, 1991.

ANTHONY HERNANDEZ
Baltz, Lewis. *Anthony Hernandez: Landscapes for the Homeless* (exh. cat.). Hannover: Sprengel Museum, 1995.

Butler, Cornelia, Lee Weng Choy, and Francis Pound. *Flight Patterns* (exh. cat.). Los Angeles: Museum of Contemporary Art, 2000.

Rugoff, Ralph. *Anthony Hernandez: Pictures for Rome, 1998–2000*. Los Angeles: Smart Art Press, 2001.

CANDIDA HÖFER
Ganteführer-Trier, Anne, Barbara Hofmann, et al. *Candida Höfer Photographie* (exh. cat., Photographische Sammlung/SK Stiftung Kultur, Cologne). Munich: Schirmer/Mosel, 1999.

Guzman, Antonio. "Candida Höfer: From Archives to Metaphors." *Art Press* (Paris) no. 199 (Feb. 1995), pp. 47–50.

Rooms: Lucinda Devlin, Andreas Gursky, Candida Höfer (exh. cat., Kunsthaus Bregenz). Cologne: Walther König, 1998.

PIERRE HUYGHE
Van Assche, Christine, and Jean-Charles Masséra. *The Third Memory: Pierre Huyghe* (exh. cat.) Paris: Centre Georges Pompidou; Chicago: Renaissance Society at the University of Chicago, 2000.

Millet, Catherine. "Pierre Huyghe: Skinned Flicks." *Art Press* (Paris) no. 227 (Sept. 1997), pp. 26–27.

Pierre Huyghe: The Trial (exh. cat.) Munich: Kunstverein; Zurich: Kunsthalle, 2000.

Villaseñor, Maria-Christina. "Expansive Terrains: Pierre Huyghe." *The Hugo Boss Prize 2002.* New York: Guggenheim Museum, 2001, pp. 65–69.

WILLIAM KENTRIDGE
Cameron, Dan, Neal Benezra, et al. *William Kentridge* (exh. cat.). Chicago: Museum of Contemporary Art; New York: New Museum of Contemporary Art, 2001.

Christov-Bakargiev, Carolyn. *William Kentridge* (exh. cat.). Brussels: Palais des Beaux-Arts, 1998.

Enwezor, Okwui. "Truth and Responsibility: A Conversation with William Kentridge." *Parkett* (Zurich) no. 54 (1998/1999), pp. 165–70.

GLENN LIGON
English, Darby. *Question Marks and Futures Already Alive: Glenn Ligon and Kara Walker, Together for the First Time* (exh. broch.). New York: Brent Sikkema Gallery, 1999.

Golden, Thelma. *Glenn Ligon: Stranger* (exh. cat.). New York: The Studio Museum in Harlem, 2001.

Ilesanmi, Olukemi, and Wayne Koestenbaum. *Coloring: New Work by Glenn Ligon* (exh. cat.). Minneapolis, Minn.: Walker Art Center, 2001.

Meyer, Richard, Thelma Golden, et. al. *Glenn Ligon: Unbecoming* (exh. cat.). Philadelphia: Institute of Contemporary Art, University of Pennsylvania, 1998.

IÑIGO MANGLANO-OVALLE
Hofmann, Irene, Anna Novakov, and Michael Rush. *Iñigo Manglano-Ovalle* (exh. cat.). Bloomfield Hills, Mich.: Cranbrook Art Museum, 2001.

Platt, Ron. *Iñigo Manglano-Ovalle: The Garden of Delights* (exh. cat.). Winston-Salem, N.C.: Southeastern Center for Contemporary Art, 1998.

Pollack, Barbara. "Chromosomes and the Sublime." *Artnews* (New York) 99, no. 11 (Dec. 2000), pp. 132–35.

ANNETTE MESSAGER
Conkleton, Sheryl, and Carol S. Eliel. *Annette Messager* (exh. cat.). Los Angeles: Los Angeles County Museum of Art; New York: The Museum of Modern Art, 1995.

Lebovici, Elisabeth. *Annette Messager: Faire Parade, 1971–1995* (exh. cat.). Paris: Musée d'Art Moderne de la Ville de Paris, 1995.

Leoff, Natasha. "Annette Messager." *Journal of Contemporary Art* (New York) 7, no. 2 (winter 1995), pp. 5–11.

MARIKO MORI
Bryson, Norman. "Cute Futures: Mariko Mori's Techno-Enlightenment." *Parkett* (Zurich) no. 54 (1998/1999), pp. 76–80.

Celant, Germano, and Shin'Ichi Nakazawa. *Mariko Mori: Dream Temple* (exh. cat.). Milan: Fondazione Prada, 1999.

Fouser, Robert. "Mariko Mori: Avatar of a Feminine God." *Art/Text* (Los Angeles) no. 60 (Feb.–Apr. 1998), pp. 34–36.

Molon, Dominic, Lisa Corrin, et al. *Mariko Mori* (exh. cat.). Chicago: Museum of Contemporary Art; London: Serpentine Gallery, 1998.

SHIRIN NESHAT
Camhi, Leslie. "Lifting the Veil." *Artnews* (New York) 99, no. 2 (Feb. 2000), pp. 148–51.

Gagnon, Paulette, Atom Egoyan, and Shoja Azari. *Shirin Neshat* (exh. cat.). Montreal: Musée d'Art Contemporain de Montréal, 2001.

Jones, Ronald. "Sovereign Remedy." *Artforum* (New York) 38, no. 2 (Oct. 1999), pp. 111–13.

Wallach, Amei. "Shirin Neshat: Islamic Counterpoints." *Art in America* (New York) 89, no. 10 (Oct. 2001), pp. 136–43, 189.

RIKA NOGUCHI
Mami, Kataoka, ed. *Under Construction: New Dimensions of Asian Art.* Tokyo: The Japan Foundation Asia Center, 2002.

Masuda, Rei, and Mika Kuraya, eds. *Photography Today 2: [sáit] site/sight.* Tokyo: The National Museum of Modern Art, 2001.

Schwendener, Martha. "Rika Noguchi." *Artforum* (New York) 39, no. 10 (May 2001), pp. 175–76.

CATHERINE OPIE
Blessing, Jennifer. *Rrose Is a Rrose Is a Rrose: Gender Performance in Photography* (exh. cat.). New York: Guggenheim Museum, 1997.

Bush, Kate, Joshua Decter, and Russell Ferguson. *Catherine Opie.* London: The Photographer's Gallery, 2000.

Fogle, Douglas. *Catherine Opie: Skyways and Icehouses* (exh. cat.). Minneapolis, Minn.: Walker Art Center, 2002.

GABRIEL OROZCO
Birnbaum, Daniel, Kasper König, and Angelica Nollert. *Gabriel Orozco: Chacahua* (exh. cat.). Frankfurt am Main: Portikus, 2000.

Buchloh, Benjamin H. D., and Alma Ruiz. *Gabriel Orozco* (exh. cat.). Los Angeles: Los Angeles Museum of Contemporary Art, 2000.

Burgi, Bernhard, Bettina Marbach, and Benjamin H. D. Buchloh. *Gabriel Orozco* (exh. cat.). Zurich: Kunsthalle Zurich, 1996.

Orozco, Gabriel, and Ann Temkin. *Gabriel Orozco: Photogravity* (exh. cat.). Philadelphia: Philadelphia Museum of Art, 1999.

JOHN PILSON
Huberman, Anthony. "John Pilson." *Flash Art* (Milan) 34, no. 217 (March/April 2001), p. 107.

Spector, Nancy. "John Pilson." *Cream 3*. London: Phaidon, 2003, pp. 292–95.

Stephanson, Anders. "John Pilson." *Artforum* (New York) 39, no. 8 (April 2001), pp. 128–29.

PIPILOTTI RIST
Schmitz, Britta, Gerald Matt, et al. *Pipilotti Rist: Remake of the Weekend* (exh. cat., National Galerie im Hamburger Bahnhof-Museum für Gegenwart, Berlin, and Kunsthalle Wien). Cologne: Oktagon, 1998.

Molon, Dominic. *Pipilotti Rist: Sip My Ocean* (exh. cat.). Chicago: Museum of Contemporary Art, 1996.

Obrist, Hans-Ulrich, Peggy Phelan, and Elisabeth Bronfen. *Pipilotti Rist*. London: Phaidon, 2001.

Spector, Nancy. "The Mechanics of Fluids." *Parkett* (Zurich) no. 48 (Dec. 1996), pp. 83–91.

MICHAL ROVNER
Nessel, Jennifer. "Ghostly Visions." *Artnews* (New York) no. 99 (summer 2000), pp. 138, 140.

Perez, Nissan. *Michal Rovner: One-Person Game against Nature* (exh. cat.). Jerusalem: The Israel Museum, 1994.

Wolf, Sylvia, Michael Rush, et al. *Michal Rovner: The Space Between* (exh. cat.). New York: Whitney Museum of American Art, 2002.

THOMAS RUFF
Hürzeler Herzog, Catherine. "Thomas Ruff: Subjective Propaganda, An Interview." Trans. Catherine Schelbert. *Parachute* (Montreal) no. 95 (July–Sept., 1999), pp. 28–35.

Schwabsky, Barry. "The End of Objectivity: Thomas Ruff, from *Portraits* to *Other Portraits*." *On Paper* (New York) 1, no. 3 (Jan.–Feb., 1997), pp. 22–25.

Winzen, Matthias, ed. *Thomas Ruff: 1979 to the Present* (exh. cat., Staatliche Kunsthalle Baden-Baden). Cologne: König, 2001.

ANRI SALA
"Anri Sala: Unfinished Histories. An Interview with Anri Sala by Massimiliano Gioni and Michele Robecchi." *Flash Art* (Milan) no. 219 (July–Sept. 2001), pp. 104–07.

Heiser, Jörg. "Anri Sala: Reverse of the Real." *The Hugo Boss Prize 2002*. New York: Guggenheim Museum, 2002.

Verwoert, Jan. "Mother Country." *Frieze* (London) no. 67 (May 2002), pp. 78–81.

JÖRG SASSE
Burgi, Bernhard, et al. *Jorg Sasse* (exh. cat.). Paris: Musée d'Art Moderne de la Ville Paris, 1997.

Israel, Nico. "Jörg Sasse," *Artforum* (New York) 40, no. 6 (Feb. 2002), p. 130.

Levi-Strauss, David. "Jörg Sasse," *Artforum* (New York) 38, no. 2 (Oct. 1999), pp. 144–45.

Nollert, Angelika. *Jörg Sasse* (exh. cat.). Frankfurt: Portikus, 1998.

SIMON STARLING
Here + Now: Scottish Art, 1990–2001 (exh. cat.). Dundee: Dundee Contemporary Arts, 2001.

Selvaratnam, Troy. "The Starling Variations." *Parkett* (Zurich) no. 67 (2003), pp. 6–14.

Starling, Simon. *Djungel* (exh. cat.). Essay by Katrina M. Brown. Dundee: Dundee Contemporary Arts, 2002.

Tufnell, Rob. "Made in Scotland." *Tema Celeste* (Milan) no. 95 (Jan./Feb. 2003), pp. 48–53.

THOMAS STRUTH
Belting, Hans. *Thomas Struth: Museum Photographs* (exh. cat., Hamburger Kunsthalle, Hamburg). Munich: Schirmer/Mosel, 1998.

Eklund, Douglas, Charles Wylie, et al. *Thomas Struth: 1977–2002* (exh. cat.). Dallas: Dallas Museum of Art; New Haven, Conn.: Yale University Press, 2002.

Weski, Thomas, Norman Bryson, and Benjamin H. D. Buchloh. *Thomas Struth: Portraits* (exh. cat., Sprengel Museum, Hannover). Munich: Schirmer/Mosel, 1997.

"Collaboration Thomas Struth." *Parkett* (Zurich) no. 50 (1997), pp. 137–74. Special issue with essays by Norman Bryson, James Lingwood, Kiyoshi Okutsu, and Peter Schjeldahl.

SAM TAYLOR-WOOD

Bracewell, Michael, Jeremy Miller, and Clare Carolin. *Sam Taylor-Wood* (exh. cat., Hayward Gallery, London). Göttingen: Steidl, 2002.

Celant, Germano, ed. *Sam Taylor-Wood* (exh. cat.). Essays by Michael Bracewell, Bruce W. Ferguson, and Nancy Spector, and interview with the artist by Germano Celant. Milan: Fondazione Prada, 1998.

Hentschel, Martin, ed. *Third Party: Sam Taylor-Wood* (exh. cat., Württembergischer Kunstverein Stuttgart). Ostfildern-Ruit: Hatje Cantz, 2000.

DIANA THATER

Avgikos, Jan. "Sense Surround: Diana Thater's Screen Scenes." *Artforum* (New York) 34, no. 9 (May 1996), pp. 74–77, 118.

Cooke, Lynne. *Knots + Surfaces: Diana Thater* (exh. cat.). New York: Dia Center for the Arts, 2002.

Lunenfeld, Peter. "Diana Thater: Constraint Decree." *Art/Text* (Los Angeles) no. 62 (Aug.–Oct. 1998), pp. 66–72.

Thater, Diana. *China* (exh. cat.). Chicago: Renaissance Society at the University of Chicago, 1996.

WOLFGANG TILLMANS

Halley, Peter, Jan Verwoert, and Midori Matsuri. *Wolfgang Tillmans*. London: Phaidon, 2002.

Riemschneider, Burkhard, ed. *Wolfgang Tillmans*. Cologne: Benedikt Taschen, 1995.

Zdenek, Felix, ed. *Wolfgang Tillmans: View from Above* (exh. cat., Deichtorhallen Hamburg). Ostfildern-Ruit: Hatje Cantz, 2001.

KARA WALKER

Cameron, Dan. "Kara Walker: Rubbing History the Wrong Way." *Art on Paper* (New York) 2, no. 1 (Sept.–Oct. 1997), pp. 10–14.

English, Darby. *Question Marks and Futures Already Alive: Glenn Ligon and Kara Walker, Together for the First Time* (exh. broch.). New York: Brent Sikkema Gallery, 1999.

Ackermann, Marion, Arianne Grigoteit, et al. *Kara Walker* (exh. cat.). Frankfurt am Main, Germany: Deutsche Bank AG, 2002.

Berry, Ian, Darby English, Michele Wallace, et al. *Kara Walker: Narratives of a Negress* (exh. cat.). Saratoga Springs, N.Y.: Frances Young Tang Teaching Museum and Art Gallery at Skidmore College and the Williams College Museum of Art; Cambridge, Mass.: MIT Press, 2003.

JANE AND LOUISE WILSON

Corrin, Lisa, and Peter Schjeldahl. *Jane and Louise Wilson: Stasi City, Gamma, Parliament, Las Vegas, Graveyard Time* (exh. cat.). London: Serpentine Gallery, 1999.

Schwabsky, Barry. "Jane and Louise Wilson." *Artforum* (New York) 37, no. 9 (May 1999), p. 187.

Williams, Gilda. "Jane and Louise Wilson in Light of the Gothic Tradition." *Parkett* (Zurich) no. 58 (2000), pp. 15–18.

PROJECT TEAM

CURATORIAL
Lisa Dennison
Deputy Director and Chief Curator
Nancy Spector
Curator of Contemporary Art
Joan Young
Assistant Curator

Louis Croquer
Hilla Rebay Fellow
Vivian Li and Jessica Theaman
Interns

ART SERVICES AND PREPARATIONS
David Bufano
Chief Preparator
Jeffrey Clemens
Associate Preparator
Derek DeLuco
Technical Specialist
Elisabeth Jaff
Associate Preparator for Paper
Paul Kuranko
Multimedia Support Specialist
Karen Meyerhoff
Managing Director for Collections, Exhibitions, and Design
Scott Wixon
Manager of Art Services and Preparations
Hans Aurandt
Pat Holden
Liza Martin
Chris O'Neil
Chris Williams

CONSERVATION
Mara Guglielmi
Paper Conservator
Caitlin Jones
Daniel Langlois Fellow
Carol Stringari
Senior Conservator, Contemporary Art

EXHIBITION DESIGN
Ana Luisa Leite
Manager of Exhibition Design
Dan Zuzunaga
Exhibition Design Assistant

GLOBAL PROGRAMS, BUDGETING AND PLANNING
Hannah Blumenthal
Financial Analyst for Museum Affiliates
Christina Kallergis
Senior Financial Analyst, Budgeting and Planning
Pater Lau
Financial Analyst Assistant

INTEGRATED INFORMATION AND MANAGEMENT
Danielle Uchitelle
Information Technology
Lynn Underwood
Director of Integrated Information and Management

PHOTOGRAPHY
Kim Bush
Photography and Permissions Manager
David M. Heald
Director of Photographic Services and Chief Photographer
Ellen Labenski
former Associate Photographer

PUBLICATIONS
Anthony Calnek
Deputy Director for Communications and Publishing
Meghan Dailey
Associate Editor
Elizabeth Franzen
Managing Editor
Elizabeth Levy
Director of Publications
Carey Anne Schaefer
Assistant Editor
Melissa Secondino
Assistant Production Manager
Christine Sullivan
Designer
Edward Weisberger
Editor

REGISTRAR
Meryl Cohen
Director of Registration and Art Services
Janet Hawkins
Consulting Registrar
Jill Kohler
Associate Registrar for Collections Management